Conceptual Art

Conceptual Art

An American Perspective

by
ROBERT C. MORGAN

with a foreword by
MICHAEL KIRBY

McFarland & Company, Inc., Publishers
Jefferson, North Carolina, and London

British Library Cataloguing-in-Publication data are available

Library of Congress Cataloguing-in-Publication Data

Morgan, Robert C., 1943–
 Conceptual art : an American perspective / by Robert C. Morgan.
 p. cm.
 Includes bibliographical references and index. ∞
 ISBN 0-89950-950-9 (lib. bdg. : 50# alk. paper)
 1. Conceptual art—United States. I. Title.
 N6512.5.C64M67 1994
 709'.04'075—dc20 93-45387
 CIP

Manufactured in the United States of America

McFarland & Company, Inc., Publishers
 Box 611, Jefferson, North Carolina 28640

To Doug—
who makes what is unknown visible—
and
To Bob—
who makes what is known invisible—
for their inspiration and encouragement
to make this book a reality

Acknowledgments

I wish to thank professors David Ecker, Angiola Churchill, and Michael Kirby at New York University for hours spent with me at the outset of this project when I was a doctoral student in the late seventies. Their interest in my research in Conceptual Art continued well after I had left the institution and moved into my professional career. I wish to extend heartfelt gratitude to them for giving me the necessary tools to do this work.

There are many who have assisted with the preparation of the manuscript. They include Diane Hewitt, who transcribed the taped interviews; Janice Schneider, who did the original typing; Kathleen Cullen, Jeanne Kiernan, and my secretary in Rochester, Mrs. Geraldine Frey. I would also like to thank my colleague Richard Kostelanetz for his advice and continuing support of my work.

The following magazines have been cooperative in the reprinting of material which appeared earlier in various forms: *Real Life Magazine* for the interviews with Hans Haacke and Lawrence Weiner, *The Journal of Contemporary Art* for the interview with Allan Kaprow, *Arts Magazine* for material taken from two articles ("Idea, Concept, System," September 1989 and "What Is Conceptual Art—Post or Neo?," March 1988), and the *LAICA Journal* for material taken from "Conceptual Art and the Continuing Quest for a New Social Context," June-July 1979).

Finally, I would like to thank all of the artists with whom I spent countless hours in conversation and whose work is, of course, the fundamental impetus and purpose for doing this book.

Contents

Foreword
(by Michael Kirby)

In 1966, I gave a lecture on Happenings at the Kansas City Art Institute. In the question period that followed, one of the young members of the audience — I assume he was a student — asked a question that made me hesitate before answering. "How can we make a work of art," he said very seriously, "that has no physical substance?" He spoke as if he himself wanted to do just that. Of course, I can no longer remember the exact words, but the question — and the thought — was precise and clear. I was momentarily shocked. The audience was shocked, too. They immediately became very attentive. The student had just "scored" a lot of "points" very quickly — with his fellow students as well as with the teachers. His listeners, being artists, knew a useful question when they heard one.

My shock came not because the question was new to me. If I had not been so familiar with it in all its various forms and possible phrasings, I would not have been shocked. (Nobody would be shocked today, but this was 1966.) I had somehow assumed, however, that it was a New York question, that it belonged in a very private way to some of the artists in the art center of the world. Yet here it was being asked, very precisely and intelligently, by an art student in the Midwest.

"I wish I knew," I said. "Everybody is trying to answer that question." The "everybody," of course, was hyperbole. I meant my friends. "I would like to answer it," I said.

Of course the student had alluded to what would come to be called *Conceptual Art*. One might define Conceptual Art as art that strives toward the absence of physicality while it knows that this is impossible. Or, to avoid the problem of impossibility, one might take off from the student's definition and . . . Well, I'm not going to discuss various definitions of Conceptual Art here. I leave that up to Robert Morgan. But I would like to say something about that good idea that everyone recognized and why it was good.

Two of the first exhibitions of Pop Art — at least the first ones I

remember, and I went to galleries a lot in the 1960s — were by Wayne Thiebaut and Roy Lichtenstein. At both of those exhibits, when I walked in the gallery not knowing what to expect, I laughed out loud, surprising myself. Nothing like that had happened to me before, and it has not happened since. It was not that I felt these shows were humorous. Not at all. This was laughter of sudden relief. It indicated to me just how oppressive the domination of Abstract Expressionism had been in the art world and on my own emotions in particular. When the domination was suddenly destroyed and another possibility was there with authority and strength, I felt relieved, and a laugh burst out.

Pop Art was a widening of the possibilities. Conceptual Art was a further widening of the possibilities. Here, we can put aside the old model of one "ism" reacting against the previous one and replacing it in history. That model had some usefulness, but we all know it was usually not literally true. Expressionism was not replaced by Futurism or Dada. In the twenties many "isms" existed in good health simultaneously. As the number of artists in New York began to increase, the possibilities of what you were "allowed" to do also increased.

So the first point is that Conceptual Art gave the thinking artist a way to use his mind. Let me grossly overgeneralize to make my point and say that Abstract Expressionism dealt with the unconscious and the emotions and Pop Art dealt with irrational and satirical perceptions of the everyday American culture. One was inner-directed, the other outer-directed. Both of them denied the mind, denied systematic rational thought. If Pollock thought about what he was doing, he stopped doing it. Pop Art pretended to be dumb, to not think, so that it could glorify the dumbness in society. Nobody, until Conceptual Art, was saying that the artist could be primarily a thinker. So this appealed to artists who liked to think. A lot of artists like to think. That didn't mean that the others, who liked other things more than thinking, were left out. They could do the other things. But finally, there was a thinking person's art, and the spectrum of major, mainstream, possibilities was greater. That's why the student's question was such a good one, particularly at a school. It offered something to those who liked to think more than anything else.

Imagine a circle that represents the human personality. Shouldn't there be an art that exists for every degree of the circle, for every aspect of the personality? That's what Conceptual Art did. It filled in a major part of the circle that until then had been blank, unused.

That was a long time ago, when Conceptual Art was just begin-

ning. At any rate, it seems like a long time. Is Conceptual Art over now? Should we forget it? Is it still worth thinking about it, trying to understand it? Would it be worthwhile to read a book on the subject? Yes and no.

Yes, Conceptual Art is over, it's finished, it is no longer "hot" and viable, no longer of the moment. It had its moment, and that moment is not now. That won't matter to historians, of course. They are always involved with things that are over. But artists today can forget about Conceptual Art, isn't that right?

No, we must not forget. Yes, artists as well as historians should read Robert Morgan's book. Just as poststructuralism builds on Freudian analysis and could not exist without it, many possibilities exist for a post–Conceptual Art that builds on the work of the sixties and seventies. Just as the questioning student was able to formulate an absolute position that asked for something literally impossible, one can imagine an "impure" conceptualism that makes use of whatever we have learned from the past. One can imagine an art that is to some extent conceptual, that is conceptual in some, but not all, of its aspects. That's good Postmodern thinking. Let's use everything—with Conceptualism as one of those things—and see where it gets us. Of course, the exact proportions of the mix are up to the individual.

Introduction

During the late fifties and early sixties avant-garde artists in New York were involved with various crosscurrents of intermedia and multimedia activity. Such mediumistic disciplines as dance, music, theatre, poetry, typography, painting, sculpture, and related environments were being diffused and then transitionally fused in new and unexpected ways. Some of the major innovations of this period included John Cage's use of chance operations, Merce Cunningham's improvised dance theatre, Allan Kaprow's happenings, Claes Oldenburg's Ray Gun Theatre, Allen Ginsberg's energetic poetry readings, and George Maciunas' Fluxus events and multiples. Each of these hybrid activities emphasized a temporal involvement in art—one that was anticipated by such earlier avant-gardists as Filippo Marinetti, Hugo Ball, Theo van Doesburg, and Marcel Duchamp. By 1960 it had become apparent that some emerging artists—including Robert Rauschenberg and Jasper Johns—were interested in abdicating their allegiance to traditional forms of painting and sculpture in favor of more experimental forms.

This diversity of experimentation among avant-garde artists evolved in reaction to the dominance of gestural painting and formalism. In one sense Conceptual Art may be seen as a summation of these experimental avant-garde forms that emerged in the 1960s. By espousing the idea of "art"—while often excluding any direct manifestation of a physical art object—Conceptual Art became what could be perceived, in retrospect, as a naïve distillation of antiformalist rhetoric. Although never a movement in the strict sense, Conceptual Art achieved a considerable momentum in the New York art world by 1969 in combining its antiformalism with linguistic philosophy. A leading exponent, Joseph Kosuth, borrowed heavily from Wittgenstein and A.J. Ayer, and thereby tried to suspend the purely aesthetic concerns advocated by critics such as Clement Greenberg and Michael Fried. The attacks made by Conceptualists on Formalist aesthetics had a significant impact in widening the boundaries of contemporary art, as evidenced by the emergence of Pluralism in the 1970s.

By 1965, artists such as Mel Bochner and Joseph Kosuth were turn-ing away from conventional object-making and were starting to see "art" in terms of a language proposition. For those Conceptualists working in Great Britain and Europe—many of whom developed methods of reasoning concomitant to those in the United States—the proposition concerning the existence of art was the preeminent con-cern. Consequently, the art object became superfluous. This would in-clude the Art and Language group in Conventry, England, Daniel Buren and Bernar Venet in France, Giovanni Anselmo in Italy, Jan Dibbets in the Netherlands, and Klaus Rinke and Franz Erhard Walther in Germany, among others. Generally speaking, the existence of an art idea was dependent on "its occasion of receivership"—as stated by Lawrence Weiner; or it had to be reconstructed within the mind of the receiver or—as another artist, Douglas Huebler, put it— the percipient.

Rather than presenting the viewer with a material object, a paint-ing or sculpture, for instance, in traditional formal terms, the Concep-tualists presented statements to be read, usually accompanied by documentation intended as supportive evidence of the concept or system. Given this mediated approach to art, it could be said that the negotiation of the art object was an attempt to bring the raw material of everyday life back into the context of the art experience.

Another interpretation of Conceptual Art, advocated by Sol LeWitt in a seminal essay from 1967, accepts the language paradigm as an equivalent to the art without relinquishing the object. The dialectic between language and its physical realization enabled another dimension of art to exist in the mind of the viewer. The exten-sive use of the written document was not so much an issue in LeWitt's work as it became for those artists, such as Art and Language, who temporarily rejected the necessity of object-making altogether.

The elusiveness of opportunity for reading and viewing docu-ments in Conceptual Art was a constant hurdle among Formalist critics attempting to communicate these works to their audiences. Much of the problem stemmed from the assumption that criticism was contingent upon a single monolithic criterion of good or bad taste—and that one had to apply a consistent formal logic to the evaluation of all types of art. The critic Robert Hughes unwittingly put his finger on the problem in a review written for *Time* (December 18, 1972):

There are no aesthetic criteria for dealing with such works. If some artist shows a clutch of Polaroids of himself playing table tennis, this is called "information." But who is informed, and about what?

The expectation is that because these documents are meant to be "seen" they should therefore be interpreted in the formal sense as any other visual art object. Photographic documents, such as the non-credited work by Douglas Huebler, cited in the foregoing article, are not intended as fine art prints—in the same way, for example, that one might interpret a Stieglitz or a Paul Strand. Rather the Huebler documents are presented as evidence of a structure in which the concept is essentially nonmaterial and nonvisual; the Polaroids represent a documentation that functions as *internal* components. They are like nonvisual signs that point toward a specific referent; they function syntactically as if they were or could be within any language construct.

Each work of Conceptual Art is different, contingent upon the intentional predilection of each artist, and the documents differ according to their specifications and context. The purpose of this study is to examine the role of documentation in Conceptual Art by way of its signifying relationship to the idea of art.

In this way, one can begin to address the problems of Conceptual Art, and its history and influences, by way of a system of signs that refers to the function and operation of art as a viable system that incorporates ideas borrowed from social, political, and economic thought.

Given the currency of interest in cultural and multicultural premises as foundational in the history and theory of art, one cannot assume a monolithic structure in relation to any aesthetic criterion. Therefore, it is important to look at the idea of "art" from a structural anthropological point of view—a view concurrent with the history of Conceptual Art in its formative stages. One might refer to this viewpoint as culturally specific in that the cultural parameters of the *term* "art" may be investigated in order for the *idea* of art to have any currency, any possibility of transcendent value.

Only by coming to terms with fundamental issues such as geography, ethnocentricity, cultural traces, and socioeconomics—in addition to informational and critical theories—can the idea of "art" sustain a significance other than as an historical tradition separating East from West and North from South, or acknowledging various forms of artisanry as existing independently of "art." Even for artisanry

to be understood and appreciated and given its rightful place in culture, it is necessary that some set of criteria be formulated based on the structural parameters that are appropriate to that work. Clearly, Conceptual Art has a different set of criteria based on concerns that may or may not have some relationship to one another—but to determine if they do would require an investigation far different from that which served the present work.

The American, more specifically, the New York, bias evinced in this book may prevent it from being the last word in Conceptual Art. The book does, however, make an attempt to clarify some of the major issues that Conceptual Art has posed—to this viewer—since its inception in the 1960s. By focusing on the New York perspective it is hoped that new light will be shed on some of the theoretical incongruities and misunderstandings that have prevented an adequate reception for Conceptual Art.

The reader might also consider that early versions of most of this text date from 1978. The author's efforts to expand its relevance have taken the form of de-academicizing its somewhat overdetermined reception both in university art departments and in art galleries and museums. Conceptual Art does not require an academic context to be understood. It does demand some acquaintance with and acknowledgment of the pertinent history.

All of this is not to say that all Conceptual Art is good art. On the other hand, some clearly is.

One important difference between the reception of Conceptual Art in the seventies and in the nineties is that time has passed and with it a certain gathering and sifting process has begun to occur. Detecting the signs of this sifting can be tricky; mistakes could lead towards revisionism. Important works could drop through the scrim. In writing this text I have tried to capture what I believe to be important in the development of Conceptual Art from an American point of view. (A very different text could be written from a European perspective.) At the time of this writing, there is no American book written as a critical or theoretical account of the subject other than a substantial collection of writings by the artist Joseph Kosuth (Cambridge, Mass.: MIT Press, 1991), who was central to its historical development. The early anthologies produced by Ursula Meyer (*Conceptual Art*, 1972), Gregory Battcock (*Idea Art*, 1973), and Lucy Lippard (*Six Years: The Dematerialization of the Art Object*, 1973) have long been out of print.

The reader may detect in this book an implicit set of criteria in the author's interpretation of Conceptual Art. I dare say that the absence heretofore of an implicit or "personal" interpretation of the subject is precisely what has turned art audiences off. At this juncture it appears justifiable to pronounce that there is always a means for coming to terms with any viable cultural form, even Conceptual Art.

Robert C. Morgan
New York City
Fall 1993

Chapter I
From Dada to Data: Protoconceptual Artworks and Influences

Marcel Duchamp's influence on avant-garde art in New York, which began to appear in the late fifties, was both seminal and definitive. It was during this time and throughout the sixties that a number of artists openly challenged the omnipresence of Formalist art and criticism. As an alternative to Formalism, there was a growing interest in the idea of art as a distinct entity which could exist outside the containment and encapsulation of the material object. This concern gradually developed into a somewhat diffuse phenomena collectively known as "Conceptual Art" in 1966.[1] Duchamp's interest in the inherent language structure of art as manifested in his choice of "readymades" made his work an easily adaptable resource and primary antecedent for this study. In an interview with James Sweeney in 1946, Duchamp made the following observation:

> In art there is no such thing as perfection. And a creative lull occurs always when artists of a period are satisfied to pick up a predecessor's work where he dropped it and attempt to continue what he was doing. When on the other hand you pick up something from an earlier period and adapt it to your own work an approach can be creative. The result is not new; but it is new insomuch as it is a different approach.[2]

The force of Duchamp's argument suggests that the art object, as understood in traditional aesthetic terms, can no longer exist in isolation of its context—that what is significant in art is a matter of the language construct that supports the work. In order to get beyond the mystique of the art object, Duchamp began to think in terms of the machine—to think in terms of "readymade" objects wrought from the assembly line.

1

Duchamp's "Readymades" and the Nonaesthetic Judgment

The term "nonretinal" was conceived by Duchamp in reference to the nineteenth century French painter Gustave Courbet, in order to protest a growing decorative trend in French painting.[3] The word appears in his vocabulary as early as 1910 — shortly before he was to paint his cubist masterpiece, *Nude Descending a Staircase* (1912).[4] A few years later, Duchamp was to abandon the physical act of painting entirely. His rationale: "I was interested in ideas, not merely visual products.... I wanted to put painting once again at the service of the mind."[5] In 1913, he attached a bicycle wheel upside-down on a common stool; this gesture involved a minimum of construction and physical effort. His first real "readymade," according to critic Jack Burnham, came a year later; in this case, the construction was eliminated altogether.[6] Duchamp simply selected a rack for drying bottles — a manufactured item of the day — and brought it home to affix his signature.

"Nonretinal" art is perhaps best defined in the following statement where the artist assesses his method of selecting a "readymade":

> A point that I want very much to establish is that the choice of these "readymades" was never dictated by aesthetic delectation....
> The choice was based on a reaction of visual indifference with at the same time a total absence of good or bad taste ... in fact a complete anaesthesia.[7]

Throughout his work on the *Large Glass* (1915–1923),[8] generally recognized as his greatest achievement, Duchamp maintained a collection of fragmentary notes and diagrams which he kept in a box. These notations, lately published as *The Green Box*,[9] provide important clues and explanations to his thinking processes including certain "specifications" for the "readymades." He states:

> The *important thing then is just* this matter of timing, this snapshot effect, like a speech delivered on no matter what occasion but *at such and such an hour*. It is a kind of rendezvous.
> — Naturally inscribe that date, hour, minute, on the readymade as *information.*
> also the serial characteristic of the readymade.[10]

This notation is particularly crucial to the emphasis placed upon the role of documentation in Duchamp's selection process. The "information" is not in reference to the object but to the event. The object is deliberately abstracted or deemphasized. It merely becomes a focus for the artist's activity wherein another context of meaning may be directed.

The theorist and critic Octavio Paz offers the ensuing interpretation:

> The act of selection bears a certain resemblance to making a rendezvous and, for this reason, it contains an element of eroticism — a desparate eroticism without any illusions . . . without any element of surprise, an encounter in a time that is arid with indifference. The "ready-made" is not only a dialectical game; it is also an ascetic exercise, a means of purgation. Unlike the practices of the mystics, its end is not union with the divinity and the contemplation of the highest truth; it is a rendez-vous with nobody and its ultimate goal is non-contemplation.[11]

There appears to be an existential posture in Duchamp's activity as indicated by Paz. The goal of "noncontemplation" seems borne out of a rejection of the industrial world; for the artist to accept his role in this world, it becomes necessary to confront boredom as the underlying condition. Another critic, Rudi Blesh, characterized Duchamp's willingness towards indifference with this statement: "He made something positive of it in a very personal way; he arrived at complete detachment; he could participate in life without self-involvement."[12]

Although the artist's activities and actions may stem from a series of existential confrontations, the actual manifestation of the activity in the realm of art is connected to its language and how it functions within the syntax of language-structure. The anthropologist Claude Levi-Strauss believes,

> . . . it is not every object in itself which is a work of art, but certain arrangements, or patterns, or relationships between objects. It is exactly the same thing as with words of a language — in themselves they are almost devoid of significance and only acquire a sense from their context. . . . In the case of "ready-mades" . . . it is the "sentences" made with objects which have a meaning and not the single object in itself. . . . The "ready-made" is an object within a context of objects. . . .[13]

The meaning of the "readymades" is both syntactical and contextual; it resides within a semiotic construct. The problem of form may

be expressed in terms of language, but its content tends toward obscurity—to baffle the mind of the beholder. How does "noncontemplation," as expressed by the critic Octavio Paz fit into the decision-making process by which the artist Marcel Duchamp apparently suspends all judgment of aesthetic reference?

This problem might be considered from the standpoint of phenomenology, of which there are a number of possible applications to language and aesthetics. The revival of the Greek term *epoché* by the phenomenologist Edmund Husserl[14] is a "bracketing" procedure, whereby the receiver suspends any reference to causal beliefs or scientific reasoning in considering the true essence of worldly things. In the case of the "readymades," this approach might be used as a way of clarifying the experience of encountering one of these objects. The shift of context from that of utilitarian association to a functionless entity might begin to reveal some basis for consciousness through the reconstructing of language significations; this latter step, however, moves away from Husserl's *epoché* into the investigation of semiotics. The thinker who did much to bridge this reconstruction process was Husserl's student Martin Heidegger.[15] In Heidegger, a clue is provided to the interpretation of "noncontemplation." The issue is specifically addressed in his enactment of a conversation between a Scientist, a Teacher and a Scholar. It goes as follows:

> *Scientist:* As I see more clearly just now, all during our conversation I have been waiting for the arrival of the nature of thinking. But waiting itself has become clearer to me now and therewith this too, that presumably we all become more waitful along our path.
>
> *Teacher:* Can you tell us how this is so?
>
> *Scientist:* I'll be glad to try, providing I don't have to run the risk that you will at once pin me down to particular words.
>
> *Teacher:* In our conversations, we don't usually do that.
>
> *Scholar:* Rather, we see to it that we move freely in the realm of words.
>
> *Teacher:* Because a word does not and never can represent anything; but signifies something, that is, shows something as abiding into the range of its expressibility.
>
> *Scientist:* I am to say why I came to wait and the way I succeeded in clarifying the nature of thinking. I tried to release myself of all representing, because waiting moves into openness without re-presenting anything. And, released from re-presenting, I tried to release myself purely to that-which regions because that-which regions is the opening of openness.[16]

In considering Heidegger's term "that-which regions" as the cause or motivation for determining a selection of a more or less commonly manufactured object, the purpose of Duchamp's activity may become more apparent. Duchamp's "rendezvous" is undoubtedly based on some degree of chance operations. Although the intent may be specified, the result never is. The absence of aesthetic from the decision-making process does not preclude the unconscious allegiance to symbolic gesture. There is some evidence that the "readymades" were in fact literal devices in the sense that thoughts can be expressed in quite literal terms. While not "re-presenting" anything as formal art, there is a superficial congruence between the existential act and toward "that-which regions." This relationship may account for the paradoxical time of relationship between representation as language by way of the "readymades" and Heidegger's "openness without re-presenting anything."

This conjecture may equally apply to what Duchamp refers to as the "snapshot effect"—that moment of transition betwen the visual attributes and the verbal epithets that define an object. The result of this effect leaves nothing but the absence of the object, its snapshot or afterimage. It is an effect to contemplate, a gesture of the mind, a simultaneity of past and present tenses—the documentation of a rendezvous. In this analogy, Heidegger's representation evaporates into the mist of "that-which regions."

It is important to note that "Apropos of Readymades" was not written until 1961—nearly forty years after Duchamp's first "readymade," *Bicycle Wheel* (1913).[17] Duchamp's later reflections are perhaps mellowed in respect to the original act. The New York Dadaists, with whom Duchamp was associated, fomented a counterart spirit; hence, they were instrumental in bringing an audience to the "readymades." Another Dadaist, Hans Richter, explains:

> Art has been "thought through to a conclusion"; in other words, eliminated. Nothing, *nihil,* is all that is left. An illusion has been dispelled by the use of logic. In place of the illusion there is a vacuum with no moral or ethical attributes. This declaration of nothingness is free from cynicism and from regret. It is the factual revelation of a situation with which we have to come to terms!—a situation which Duchamp seems to have discovered rather than created.[18]

The existential overtones are implicit in Richter's commentary; and yet, the use of the object, whether created or discovered, gives the

activity a sense of ritual. From a phenomenological viewpoint, the object becomes a wedge between the artist's existence and a clue to his own essence. Duchamp's apparent "detachment" from the situation, in which the selection process epitomizes a rendezvous, implies some means toward an experience of transcendence. Therefore, the artist's decision to choose a common utensil as art symbolizes an "existential moment: the act of liberation which occurs within "the transcendence of the ego."[19] It is precisely this release from the ego as a foregrounded tendency in the creative process that Duchamp sought as a means toward avoiding overdetermination.[20] Critic Arturo Schwarz views Duchamp's actions in a similar way:

> To fulfill Duchamp's vision of the disappearance of the distinction between the artist and the layman implies, naturally, a degree of freedom that is not even imaginable today—a kind of freedom that is both a prerequisite for and a consequence of creating art, a kind of freedom that can only exist in a situation in which there is a future completely open to unlimited adventures....[21]

By relinquishing the traditional dependence on the art medium as a qualitative determinant of the creative act, a new freedom emerged in terms of how the object would be understood in relationship to the artist's work. The new freedom not only changed the role of what the artist could do and call "art," but it also changed the role of critical inquiry in relation to the work's aesthetic status. Judgments of "quality" were no longer dependent on the notion that the object served as a kind of relic-container for the presence of art. Duchamp changed the emphasis in terms of how one might interpret and evaluate the object by shifting the context of significance away from a purely "retinal" quality to one in which the idea of art was a predominant issue. This syntactical shift seemed to question the purpose of art at both the critical and the metacritical level.

In his essay "The Quality Problem," the artist Bruce Boice argues against notions of quality in painting which he believes are inconsistent with the issues of certain post–Minimal trends of the 1970s. Boice's argument is indebted to the "readymades" to the extent that the receiving of an artwork may be akin to that of confronting any object which evokes questions about its aesthetic purpose:

> If art has a purpose, that purpose is not contained within the art work itself, but within the experience of the art work, that is, within someone's

experience of the art work. When a stone is evaluated within the context of a purpose, that purpose is not somehow the stone's purpose; what is meant by the stone's having a purpose is that someone has a purpose for the stone. Similarly, an art work has a purpose only in the sense that someone has a purpose for it.[22]

While this statement seems to grasp the nature of aesthetic experience on some intuitive level, not unrelated to the philosophy of John Dewey, Boice departs from Duchamp by not dismissing retinal values in art altogether. Furthermore, Boice is incorrect in assuming that quality cannot be instigated by the art work in relation to the viewer's response. In the case of Duchamp, quality is something that exists outside of the retinal yet within the work's structural paradigm. This paradigm would necessarily have to include irony and a certain degree of skepticism as well.

In the "readymades," Duchamp displaces their original industrial and manufactured purpose in order to objectify them within the context of a nonutilitarian and nonaesthetic role. His appropriation of the French word *cervelle* (literally translated as "brain-fact") describes a fundamental aspect of Duchamp's work in relation to this new content or absence of content.[23] By transforming the context of the object — from purpose to purposelessness, from actual form to a "pictorial nominalism"[24] — it takes on the meaning of something conceptual; that is to say, it is transformed into a *cervelle*. It becomes an isolated fact in time/space, a thought suspended. A certain degree of immanence is implied here. The alien industrial object may be observed in its separateness as something released from representation, an object possessed by its own sign.

As part of his studio environment in New York, Duchamp made a point by suspending some of the "readymades" from the ceiling and walls in order to perceptually alter their normative functional appearance. They were not intended as works of sculpture, to be shown on pedestals, but rather to exist independently from either art or life: they hovered somewhere in between. According to Arturo Schwarz:

> Readymades can be approached from at least six nonconflicting viewpoints: one may discern their magic, fetish-like quality; their aesthetic importance; their symbolic value; their iconoclastic virtue; their relationship to the Large Glass; and finally, and more importantly, one may see them as a successful attempt to bridge the gap between art and life.[25]

Duchamp's displacement of the object became a catalyst toward language. It allowed the transformation of the object to move from a physical towards a conceptual frame of reference, thus establishing the *cervelle* within a mode of receivership. The fact that Duchamp could declare a common snow shovel a work of art was enough to make it so. The artist's declaration became synonymous with the choice. In linguistic terms, the signifier and the signified became a sign. The sign became an icon in relation to Duchamp's cynical machine aesthetics as epitomized in the *Large Glass*. The sign was tied—betrothed, as it were—to its iconic inscription, its referent. Once the sign was declared separate from its normative functional definition, another level of signification would appear. In other words, the "readymade" as *cervelle*—as a sign—was free from its former life, its predictable syntax, and given a new life within another system of language. It is impossible to deny that the sign retained certain resonances from its former usage. Duchamp was aware of the tension and found it paradoxically amusing.

Although the snow shovel was transformed into a "readymade" and given a title, *In Advance of a Broken Arm* (1915), the action did not entirely negate the apprehension of its previous function. By its transformation, the artist declared it functionless, but functionless within the terms of the game. There was always the possibility that it could be restored to its original use. Its suspension, therefore, was temporally based. Yet in its new temporary context, the work could exist conceptually as a *cervelle*.

The placement of the shovel, suspended from the ceiling of the artist's studio, gave it the appearance of a remnant. Its physical existence became secondary to its existence as a *cervelle*. By continuing to exist on the physical level, it persisted as an object of potential or past use—an object with a history and one with a certain technology. This display of the shovel might prolong the possibility of an aesthetic experience or recognition, or it might function as a catalyst, even though the artist's decision to declare it a "readymade" presumably held no aesthetic delectation.

There are essentially two actions in relation to the "readymades" which need to be accounted for. First, there is the activity of selection, the rendezvous with the object, the moment in which an artwork is declared—though not made—by way of negation; that is, by declaring the object, once defined according to function, functionless. Secondly, there is the actual physical displacement of the object which becomes

another manifestation of its separateness. The object's dislocation sets up an alienation effect, to use a Brechtian term, whereby it can be transformed from its physical state of being perceived to a *cervelle* — what Husserl might call "the intentional object — its conceptual reality. In doing so, the transformation — a mental alchemy — maintains a certain necessary tension between itself as a sign and the artist's systemic referent. Its potential use — as sign or object — may threaten its existence as art while its presence as a relic or document within the structure of art temporally suspends its function. To obtain its conceptual status, then, the "readymades" are both contextual and temporal. They are also purposeless and functionless.

Scores and Scripts

The resurgent interest in Duchamp during the 1950s in New York was heralded by the American avant-garde composer John Cage. It was Cage who picked up the idea of what he termed "chance operations" as previously determined by Duchamp in his selection of the "readymades." Coming from a musical background, Cage was fascinated by time as an abstract concept and the progression of events through time; he believed that this principle needed to be made explicit in music. He disliked the notion that a musical composition was necessarily separate from the intentions and motivations of the musical performer. Through "chance operations," Cage developed the principle of indeterminacy" which he describes as follows:

> An experimental action is one the outcome of which is not foreseen. Being unforeseen, this action is not concerned with its excuse. Like the land, like the air, it needs none. A performance of a composition which is indeterminate of its performance is necessarily unique. It cannot be repeated. When performed for a second time, the outcome is other than it was. Nothing therefore is accomplished by such a performance, since that performance cannot be grasped as an object in time. A recording of such a work has no more value than a postcard; it provides a knowledge of something that happened, whereas the action was a non-knowledge of something that had not yet happened.[26]

The fact that a performer could participate in the structure of a musical piece opened up the possibility of more varied interpretations. The focus of a Cage piece, such as *Music of Changes* (1961),[27] allows the performer considerable leeway in this respect. The score for *Music of Changes* is written on standard music pages. The notations, however, are noticeably sparse with a number of open measures. Cage

has often subscribed to the use of "silence" as being an integral component of music. The open measures or blank spaces in the score offer the performer the alternative of continuing a sound for a certain duration or of playing nothing at all.

An extreme example of Cage's emphasis on the open measure would be his 4'33" (1952) in which for the indicated duration there would be only silence; the silence, however, was scored in three parts and specified that a performer should sit behind a piano keyboard. Cage's intent was to incorporate the natural sounds which may occur in a concert hall as part of the performance. In phenomenological terms, the duration of the piece would "bracket" the performance through a reciprocal interaction of the perceiver with the event. Both audience and performer would contribute to the score through what Cage terms "aleatory" or indeterminate occurrence of sound. The receivership of the piece is therefore dependent upon each member's willingness to *listen*. The natural yet unplanned sounds that were heard during 4'33" became the composition. This musical event, perhaps more than any other formal composition, clearly established John Cage's point-of-view on the use of "chance operations" as a method of composition.

Cage has, in fact, openly expressed his gratitude to Duchamp for the method used in respect to the selection of "readymades." The artist-composer saw a connection between Duchamp's method and the teachings of the Zen master S.T. Suzuki, who further inspired Cage to seek less structure in music and more openness to coincidence. Cage's attraction to Zen Buddhism seemed to reinforce his interest in "chance operations." Suzuki based his teachings on those of Hui-neng,[28] the Sixth Patriarch of the southern sect, who wrote:

> There was never a bodhi tree
> Nor was the bright mirror on its stand
> There was never anything
> Whence then should the dust come?[29]

Hui-neng emphasized the concept of *wu-nien* or "without thought" from which the Zen student may suddenly discover *satori* or enlightenment.[30] Cage's writings in his first book, *Silence*, reflect this adherence to Zen in such passages as:

> Keeping one's mind
> on the emptiness,

on the space
one can see anything can be in it, is, as
a matter of fact, in it.[31]

Further experiments in composition included the use of the *I Ching, Book of Changes*, an ancient Chinese manual, in which a sequence of predetermined signs are associated in various combinations according to chance.

Cage's influence on the art of the sixties and seventies has been as significant in its own way as that of Duchamp. Through his lectures, John Cage made Duchamp's ideas more accessible to the American art audience. The alchemical mysticism often associated with Duchamp was somewhat unpalatable in the United States. On the other hand, the applications of Zen Buddhism espoused by Cage were readily absorbed and culturally appealing.[32]

Michael Kirby credits Cage with innovations not only in music but in theatre as well.[33] In pursuing his unique idea regarding the performance autonomy of musical composition, Cage became "the backbone of the new theatre." His teaching at the New School of Social Research in New York in the early fifties attracted various students, several of whom later established themselves as leaders in their respective areas. The common factor among this group of artists, however, was their allegiance to the idea of chance and to the overlapping of media by which the avant-garde was able to extend the boundaries of American art. Among those who studied with Cage were Jackson Mac Low, Dick Higgins, Nam June Paik, Yoko Ono, and Allan Kaprow.[34]

Allan Kaprow became the leading spokesperson and coinventor of the Happenings movement in the late fifties. In referring to the early Happenings, Kirby claims that events such as Kaprow's *18 Happenings in 6 Parts* (1959), first performed at the Reuben Gallery in New York City, had certain characteristics that distinguished them from those occurring in Europe and Japan.[35] For example, the Happenings outside of New York tended toward symbolism within a political or social context, whereas the Happenings in New York—such as those by Kaprow, Jim Dine, Claes Oldenburg, and Red Grooms—were more open in their interpretations. Kirby traces this latter tendency back to the Dada and Futurist artists who often performed in cabarets provoking a raucous, rebellious and joyful atmosphere.

Kaprow, who began as a painter, gradually shifted his concerns to collage in a way not unrelated to the *Merzbilder* of the Hannover

Dadaist Kurt Schwitters. With Kaprow, the concern did not rest in the realm of collage for very long. Soon the impetus to make collages expanded to the creation of large-scale assemblages, and from the making of assemblages, Kaprow moved into what he called Environments (early installation art). From the Environment, it was a short step into the Happenings.

It is most important to emphasize that Kaprow was not coming from a theatrical or performing background—that his ideas, at the outset, were an extension of Pollock's theory of "all-over composition" in painting. Kaprow became interested in bringing people back into art in a more direct participatory way. He wanted to see a live, autonomous element which would interact freely within a set of loosely prescribed "visual" actions. In his "Untitled Essay" (1958), Kaprow explains:

> I have always dreamed of a new art, a really new art. I am moved to roaring laughter by talk of consolidating forces, of learning from the past; by yearnings for the great tradition, the end of upheavals and the era of peace and seriousness. Such an essentially fear-ridden view cannot know what a positive joy revolting is. It has never realized that revolutions of the spirit are the spirit's very utterance of existence.[36]

It is also important to note that Kaprow did employ a written script, although it was never narrative or necessarily dramatic. It was more like a sequence of notations which could be shuffled and mixed and reenacted according to the discretion of the performer. The flexibility of these scripts varies according to the place and duration of the Happening. Unlike Conceptual Art, the presentation of the script with documentary photographs did little to enhance the meaning of the performance. These earlier events were not meant to be viewed systematically or even structurally; they were simply extensions of the visual dynamicism attributed to Action Painting. Furthermore, the New York Happenings were theatrical as opposed to hermetic; that is, they demanded an audience participation. Any documentary evidence of the performance was after the fact; it was not intrinsic to the understanding of the piece as later proved to be the case in conceptual performances.

The New York Happenings did much to bring various, isolated artistic interests into a common ground of energetic involvement and communication. Visual artists such as Claes Oldenburg, Jim Dine, Robert Whitman, and numerous others functioned side-by-side with

writers and poets. Some of these intermedia included Mac Low and Higgins, dancers such as Deborah Hay, Merce Cunningham, Steve Paxton and Yvonne Rainer, and musicians such as Phil Corner, Charlotte Moorman, James Tenney, Earl Brown, John Cage and La Monte Young. There were numerous others who deserve mention, but whose work is not the direct concern of this study.

Relics, Specimens and Essays

The "freedom" to which Arturo Schwarz addressed his statement on Duchamp in the retrospective of 1973 was a major issue in the work of such artists as Yves Klein, Piero Manzoni, Daniel Spoerri, John Cage, Robert Rauschenberg, Jasper Johns, Joseph Bueys, Allan Kaprow, Walter De Maria, Nam June Paik, and other avant-gardists who were involved or who had influenced New York art throughout the 1960s. Many of these artists served as antecedents and influences in the development of what Robert Pincus-Witten refers to as the "ontological" phase of conceptual art.[37] A number of them have made definitive written and verbal statements as to this new-found "freedom" to experiment within the context of events.

Walter De Maria, for example, who was later to become an important link between "earth art" and Conceptual Art, wrote a short essay in March, 1960, entitled "Meaningless Work" which states:

> Meaningless work can contain all of the best qualities of old art forms such as painting, writing, etc. It can make you feel and think about yourself, the outside world, morality, reality, unconsciousness, nature, history, time, philosophy, nothing at all, politics, etc., without the limitations of the old art forms.[38]

A year later, Henry Flynt, was to define "concept art" in an essay by that title.[39] The term "concept art" should not be confused with that of "conceptual art" as delineated by Sol LeWitt in his "Paragraphs on Conceptual Art" (1967).[40] Between the two statements is a period of six years; yet Flynt must be given credit for envisioning the connection between "nonmaterial" art and certain speculations in modern linguistic philosophy. He expressed it in the opening sentences:

> *Concept art* is first of all an art of which the material is *concepts*, as the material of e.g. music is sound. Since *concepts* are closely bound up with

language, concept art is a kind of art of which the material is language. That is unlike e.g. a work of music, in which the music proper (as opposed to notation, analysis, etc.) is just sound, concept art will involve language.[41]

Joseph Kosuth, who was later to regard Conceptual Art as a tautology in which art would be treated as any other proposition, found his impetus through the writings of A.J. Ayer and Ludwig Wittgenstein.[42] Flynt, on the other hand, points to the influence of Rudolf Carnap.[43] The question of language structure, and particularly its use and application to art, has been the determining link in what Pincus-Witten refers to as the "epistemological" phase of Conceptual Art.[44] The importance of Flynt's contribution, even in its somewhat isolated, raw state, provides a logical basis for tying elements of Fluxus art together with Kosuth's "Proto-investigations" of 1965[45]; from then on, and through the formal inquiries of Minimalism and Earth Art, the growth of Conceptual Art as a viable approach to the research and exploration of new content became known.

There were a number of European artists who might be cited for their contributions to Conceptual Art. The group known as *nouveaux réalistes*, in which Yves Klein was a member, based much of its thinking and actions on Duchamp's acceptance of the banal. Klein was a mutable figure in European art during the fifties up until his premature death in 1962. His monochrome paintings in "International Klein Blue," his sale of "immaterial pictorial sensitivity zones," and his adventures in the "theatre of the void" distinguish him as a leader of the avant-garde.[46] The emphasis on the idea of the work as well as the physical process in which the artist engages himself set the stage for exploring the boundaries of chance in relation to the art object. Klein's debt to Duchamp might be seen as ambivalent as expressed in the following statement:

> The artist who creates should no longer do so for the sake of signing his work, but as an honest citizen of the immeasurable space of sensitivity should create always from his awareness that he exists, in a state of profound illumination, as does all the universe, but which we neither see nor feel closed in the psychological world of our inherited optics.[47]

Klein's interest in expanding consciousness through the art event was evident in his exhibition of an empty gallery at Iris Clert in 1958. This might be considered the visual counterpart of Cage's 4'33" in

which silence determined the presence of space; in Klein's exhibition, the idea of the "void" is clearly in evidence.

Klein's dictum that "...the line prefers space. It is always in transit"[48] was picked up by the Italian artist Piero Manzoni and applied to a series of printed line drawings of various lengths which were displayed in encased cylinders, often on pedestals.[49] Manzoni's art is, in some ways, as enigmatic as Klein's. Both artists were highly energetic and moving constantly from one innovation to the next. Both were possessed by a sense of ritual in their art. Documents were used directly and internally in Klein's sale of zones; a receipt would be given to the buyer for the amount of gold purchased and then burned on location while Klein tossed the gold into the Seine River.[50]

Manzoni's documentation was even more direct; he would produce balloons full of the "Artist's Breath" to be sold at 200 lire per litre.[51] Manzoni believed that the biological traces left by the artist during the making of an artwork were as interesting as any visual traces. He maintained this rationale as he continued to produce "phials of Artist's Blood," fingerprints, and even editions of canned excrement. The extreme irony of this aspect of Manzoni's work is gratifying only from an intellectual standpoint. One might conclude that he pushed Duchamp's divorce from aesthetics into the realm of the absurd; art was beginning a new political involvement.[52]

As stated earlier, a major difference between the New York Happenings and those of Europe could be stated in terms of their political content. For the most part, New York Happenings did not appear political; their concerns were generally more in favor of the spectacle for its own sake.

The Fluxus group, for example, produced a number of events of varying lengths during the sixties throughout Europe and primarily in New York. Dick Higgins, a publisher, playwright and experimental poet, made several claims about Fluxus in which he stressed factors of "boredom and danger" as essential ingredients in these "miniature Happenings."[53] In stressing what Higgins terms the "educational" aspect of these works, he explains:

> The intention is more to enrich the experiential world of our spectators, our co-conspirators, by enlarging the repetoire of their over-all experience. These values cannot be achieved by emotional impact alone, and such impact has become, for the new artist, merely a language tool, a way of communicating which we can draw on when necessary.[54]

Fluxus contained many diverse artists who were not linked to the traditional gallery system and therefore depended upon other means to promulgate their ideas. Critics Lucy Lippard and Peter Frank have each referred to the Fluxus group—including Higgins, George Maciunas, Alison Knowles, Wolf Vostell, George Brecht, Geoff Hendricks, Jackson Mac Low, La Monte Young, Philip Corner, Joe Jones, Robert Watts and others—as the "proto-conceptualists."[55] Frank sees Maciunas as the major artistic force behind the group while Higgins provided the role of spokesman and organizer. It was Higgins who invented the term "intermedia,"[56] which proved instrumental in establishing an effective antiformalist posture in both New York art and criticism.

Geoff Hendricks, whose work has consistently been involved with problems of documentation, has performed a number of events secretly without audience feedback.[57] Even if an audience is allowed into the space where Hendricks works, he remains oblivious, objectified, and anonymous in his reactions to others. Hendricks is a true hermetic artist; each of his performed events incorporates a highly ritualized atmosphere in which some type of physical transference occurs.[58] However sporadic, his performances were presented throughout the sixties and into the seventies with single-minded perseverence and commitment to his artistic goals. One might say that Hendricks' performances are borne out of inner necessity as he abstracts circumstances of his diurnal feelings and existence into primitive rites of exchange between himself and (1) nature, (2) objects, and (3) people.

Hendricks is a diaristic artist; he records everything pertinent to his experience with the intention of using it as raw material in his work.[59] His notations are not always written, but sometimes drawn, mapped, diagrammed, or collected. Many of his early events involved the cutting of hair. The hair would be tied into small locks and catalogued with ritualized significance, recalling De Maria's "meaningless work" ethic. Often mailing tags are attached to various objects so that they become relics with corresponding narrative associations. The aspect of narration is central to Hendricks' concerns. The task of documentation has always been a conscious effort. The relics, fragments, photographs, typed statements, and all manner of natural and manufactured objects have been used as internal components within his art. It is as if he documents the feelings which are most central to his own being and presents them as a detached religion of the self, and yet without the slightest air of piety.

Still another type of Happening, concurrent with the Fluxus events in New York, was Carolee Schneemann's Kinetic Theatre.[60] The parallel between Kaprow's evolution from painting to collage to environment to performance and that of Schneemann's can be viewed as similar in appearance, but considerably different in thought and content. Within Kaprow's mixing of performed elements was a definite structure which guided the intent of the Happening from start to finish. In contrast to this approach, Carolee Schneemann's performances were closer to the theatre; her sensibility was to produce a particular image or set of images which would inhabit the space in such a way as to concentrate discrete energies on a single sphere of activity. Her *Meat Joy* (1964) was a highly charged, theatrical event which evoked a myriad of poetic images through the use of multimedia projections and live performance. Physical displays of energy have always played an integral role in Schneemann's works. Her film *Fuses* (1964–1967) focusses upon the issue of sexuality as a sustaining force expressive within human physical and biological actions.

Another important difference between the earlier Happenings of Kaprow, Whitman, Oldenburg et al. and those of the Kinetic Theatre was in how the actions were informed. Schneemann intended to express her actions from the point-of-view of a woman.[61] She believed that her art was

> ...about forms in the world that had been neglected, aesthetic forms that had a messianic or religious feeling. They had to be shared. They had to be clarified. And we were vehicles for which they could be realized. And it's not like that today. So when we used ourselves—when I used myself and my body—it was as an extensivity of principles that were already there visually, that were part of a painterly tradition.[62]

She chose to clarify the act of painting from the perception of a woman; that is, the experience of painting as opposed to that of being painted. In her book *Cezanne, She Was a Great Painter* (1975),[63] Schneemann envisions the act of painting in more openly expressive terms. She is committed to the *libido* in herself—that it must be free from the restrictions subtly placed upon a woman artist; in this sense, Schneemann is a pioneer in the woman's art movement of the seventies.

Props used in a Kinetic Theatre performance were often regarded as artworks that could function separately from the context of the piece. They did not function as documents, however, only as props or

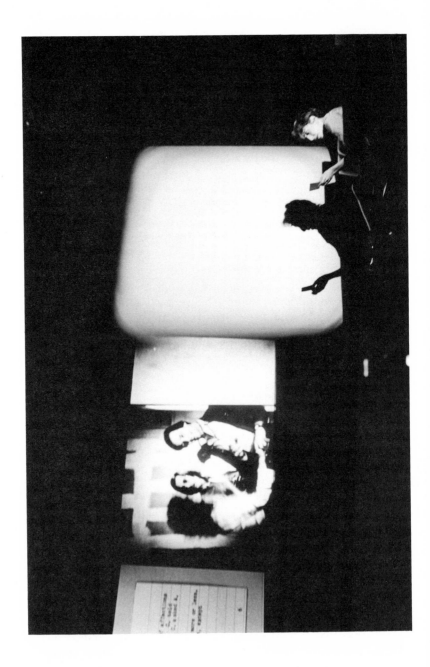

assemblages. The real documents were the diaries, notes, scripts, rehearsal agenda, exercise diagrams, slides, films, audiotapes and numerous drawings. Images were often produced directly from her thoughts as they existed in diary form; at some point, these thoughts would be interpreted as sketches. If her interest was sustained, a separate notebook would be constructed for the purpose of filing and organizing further sketches and notations until a script had been formalized. Photographs were usually taken during performances as records of the imagery. With the exception of the films, tapes and slides, the drawings and notes and so forth were not considered components of the actual performance; they existed outside of it as ephemeral elements.

In some ways, it would appear that Schneemann's Kinetic Theatre moved in a direction entirely opposite from that of Conceptual Art. For example, there was little attempt to define the language content of the diaries in any systematic way; the language existed almost as a ploy to beget the image. Also, the emphasis on theatricality became an opposite trend from that of Conceptual performance which, instead, followed in the hermetic tradition of Yves Klein. Thirdly, the documents were not used as tools for establishing a literal sense of time and space as much as they were projections of a stream-of-consciousness which tended toward visual effects.

On the other hand, Schneemann's art is anything but Formalistic. Her idea of painting is fantastic and emotive. She brings a refreshing concept of film into the theatre and thereby displaces the time of a performance into another level of consciousness. By detaching certain actions from the context of her natural environment, Schneemann brings the viewer face-to-face with the problem of behavior as a culturally applied signification. Finally, there is an appeal to the existentially absurd which makes no pretension about being narrative. In the seventies, Schneemann's art began to refine itself into another kind of psychological statement, such as in *Up To and Including Her Limits*.[64] The direction has maintained its theatricality, but the concerns persist about a woman's not merely producing images, but inciting them persuasively within the viewer's mind. The ideology that supported the image has always been Schneemann's central concern.

Opposite: Carolee Schneemann performing "ABC—We Print Anything in the Cards" at N.Y.U. Joel Center, May 14, 1977. Photo courtesy Carolee Schneemann.

Ad Reinhardt, Minimal Art and Earthworks

The transition from the expressionistic focus in American art since the forties to an idea-based art of the sixties may well be summed up in the work of Ad Reinhardt. Coming from a background in abstract painting, Reinhardt set out to achieve a "pure" statement in art. His earlier gestural paintings, which consisted of a field of openly spaced white brushstrokes, gradually evolved into more definitive geometric patterns.[65] These patterns were constructive in appearance; they depicted interlocking square and rectangular units with little evidence of the painter's hand in the brushwork. This series of paintings, such as *Abstract Painting* (1956–1960), appeared rectangular at first, alternating between a horizontal and vertical placement. Eventually the format changed to that of a square, 60″ × 60″ with only square interior units, usually nine. A further step was the elimination of color, which began in the early sixties. It was this series of *Untitled* (black) paintings, on which Reinhardt worked between 1952 and 1967, that caught the attention of a group of younger artists who were to influence a new type of "primary form" known as Minimal Art.[66]

Reinhardt wrote a considerable number of statements and essays in defense of his radical position. Many of his statements are directed toward the response of the viewer in order to clarify the nature of the art object. For example, in a magazine reproduction of one of his "black" paintings, he writes:

> This painting cannot be copied, reproduced, duplicated.
> This painting is not copyrighted, is not protected and may not be reproduced.
> . . .
> This painting is not a commodity, not a possession or a property, not a decoration or symbol, with few exceptions.
> This painting is unsalable, and it is not for sale except to someone who wants to buy it.
> This painting has no reason to be bought or sold or bartered.[67]

In the preceding statements, Reinhardt had indirectly laid the groundwork for art dealer Seth Siegelaub's theory on art exhibitions.[68] Siegelaub, who became the first important American representative of Conceptual Art, based his assumptions on the distribution of art "information." Reinhardt's irony in the first line above was to become a major point of contention for Siegelaub who felt:

When art does not any longer depend upon its physical presence, when it becomes an abstraction, it is not distorted and altered by its reproduction in books. It becomes "PRIMARY" information, while the reproduction of conventional art in books and catalogues is necessarily (distorted) "SECONDARY" information.[69]

Reinhardt's *Untitled* (black) paintings are a reductivist attempt at making art.[70] The entire series of these last paintings might be thought of as a single statement on art whereby the artist proceeds through a chosen medium to conduct a *phenomenological reduction.*

The Husserlian scholar Herbert Spiegelberg defines the function of this reduction as an attempt ". . . to free the phenomena from all trans-penomenal elements . . . thus leaving us with what is indubitably or 'absolutely' given."[71] Thus, in Reinhardt's attempt to come to grips with the *art* of painting, there seems to have been an aesthetic counterpart to Husserl's method. This may be further substantiated by Reinhardt in the essay "The New Revolution in Art." Although there is no direct reference to phenomenology, the painter states:

> Art-as-art is a concentration on Art's essential nature. The nature of art has not to do with the nature of perception or with the nature of light or with the nature of space or with the nature of time or with the nature of mankind or with the nature of society.[72]

Reinhardt's method is blatantly expressed in his "Art-as-Art Dogma, Part 5" in which he rhythmically equivocates between assertion and negation in a way not unlike the chanting of Hebraic scripture:

> The beginning of art is not the beginning.
> The finishing of art is not the finishing.
> The furnishing of art is not furnishing.
> The nothingness of art is not nothingness.
> Negation in art is not negation.
> The absolute in art is absolute.
>
> Art in art is art
> The end of art is art as art.
> The end of art is not the end.[73]

Reinhardt's barely discernible segmented grids were difficult to surpass in terms of reductivist painting — although it would be unfortunate to bypass the contributions of such painters as Barnett Newman,

Ellsworth Kelly, Agnes Martin, and others. Yet it was the work of
Reinhardt that led most directly to Minimal Art. The leaders in Mini-
mal Art can roughly be divided into two groups. First, there are the
"hard-core" minimalists such as Don Judd, Dan Flavin, Carl Andre,
Richard Serra, Sol LeWitt, and Robert Morris.[74] These sculptors were
possessed by a strong sense of anti-illusionism in art; the emphasis was
towards complete literalness. In specific works by Flavin, Morris, and
Bochner, one finds a certain epistemological interest. Their sculpture
is informed by such sources as Wittgenstein's *Philosophical Investiga-
tions*,[75] the numerology of William of Ockham,[76] and the physics of
Werner Heisenberg.[77]

Secondly, it is possible to speak of another group of sculptors as
representing the "romantic" phase of Minimalism.[78] These artists
would include Tony Smith, Ronald Bladen, Robert Smithson, and
Robert Grovesnor.[79] The emphasis in these sculptors' works was more
in the area of monumentality and subjective space. Tony Smith, who
was trained as an architect, acted as mentor for Minimalists on both
sides. Smith's important contribution to sculpture may be seen in
terms of relating a nonobjective scale to human physicality and move-
ment.

There are a number of reasons why the Minimalists proved signif-
icant to Conceptual Art and to the role of documentation as an inter-
nal property of the work. Most of their forms existed concurrently in
the New York galleries along with Conceptual Art; however, Tony
Smith's *Die* (1962), a manufactured steel cube, preceded Minimal Art
as a recognized tendency.[80] The position which Duchamp took in
regard to nonaesthetic judgment may be considered the assumption
by which the majority of Minimal Art was made. The relationship to
Reinhardt's paintings is even more direct in the sense that art was in-
deed being scrutinized at its purest, essential level. Morris, for exam-
ple, understood what he was doing more in terms of the fabrication of
objects rather than as a creator of works of art.[81] This concern held for
all of the "epistemological" group. The aura of detachment from the
work, almost as a research endeavor, challenged former criteria regard-
ing quality as a necessary focus for aesthetic inquiry. Information
about perception—specifically in Gestalt psychology—and modern
analytical philosophy gave Minimalism a new position in regard to
criticism.[82]

From Minimalism, it was a logical progression towards "process"
art which emphasized the implicitness of manufactured by-products,

often without any conscious attempt at organization. "Scatter pieces" by such artists as Barry Le Va and Carl Andre became apparent.[83] In these works, a direct antecedent could be traced to the Dada experiments of Hans Arp who dropped torn papers on a surface and randomly pasted them down. Duchamp's *Three Standard Stoppages* (1913-1914) involved a similar action, once again informed by "chance operations."

Morris and Serra arranged piles of residual scraps, steel, wood, and fabric remnants, on museum floors. De Maria filled a gallery with several tons of dirt in order to disorient the spatial horizon of the viewer.[84] Les Levine poured gallons of paint (with cans) as an ecology gesture in Los Angeles.[85] This exception to these deliberate "anti-form" statements was the work of Eva Hesse.[86] Hesse's forms were molded and cast with polyester resin and latex. In *Sequel* (1967-1968) there is a deliberate formal appearance to Hesse's sculpture which evokes a highly expressive content, particularly in relationship to the body. This unusual correlation of materials and biomorphic forms distinguishes her work from other artists who were working at the time with repetitive, modular elements in sculpture.[87]

Earth Art took the ideas of "process" outside of the gallery into the vast, open spaces of deserts, lakes and fields. Smithson, Michael Heizer, De Maria, and Dennis Oppenheim each worked systematically to produce forms that were inseparable from the landscape.[88] It was at this point that the problem of documentation in these newer art forms became apparent. In attempting to clarify this issue, the critic Diane Waldman explains:

> Documentation is fragmentary, incomplete, and an inadequate surrogate for the reality of the work, leaving the viewer totally unequipped to do more than just barely comprehend the actual experience. It is a common assumption, but a misleading one, that Earthworks only exist for the photographs....[89]

Another insightful comment was made by the critic Harold Rosenberg:

> Art communicated through documents is a development to the extreme of the Action-painting idea that a painting ought to be considered as a record of the artist's creative processes rather than as a physical object. It is the event of the doing, not the thing done, that is the "work." Logically, the work may therefore be invisible — told about but not seen.[90]

The shift of context from art gallery to out-of-doors in the form of Earthworks was both a concurrent and connecting link with the concerns of Conceptual Art. The role of documentation began to take on greater signification in that, for most viewers, the work had to be imagined. Smithson's solution to this problem was to create "nonsites" inside the gallery, using actual rocks and specimens from the "site" of the piece.[91] Maps, charts, legal documents, and notations made on location were gradually filtering back into the art world as marketable items.[92]

Where "process art" used fabricated products or by-products in a loose, destructed arrangement, the Italian counterpart, called *arte povera* ("impoverished art"), emphasized fragmentary materials and objects in a more poetic or romantic context. The Italian art critic Germano Celant organized the first show in Bologna where he invited artists such as Giovanni Anselmo, Alighieri Boetti, and Mario Merz, who would eventually become aligned with Conceptual Art.[93] Rosenberg believed that these indeterminate and informal approaches to art-making were based on a condition of what he called "de-aestheticization." To illustrate his point, Rosenberg alludes to a legal document, executed before a notary public in New York City, and exhibited by the artist Robert Morris:

> ### Statement of Aesthetic Withdrawal
>
> The undersigned, Robert Morris, being the maker of the metal construction entitled Litanies, described in the annexed Exhibit A, hereby withdraws from said construction all esthetic quality and content and declares that from the date hereof said construction has no such quality and content.
>
> Dated: November 15, 1963[94]

By declaring the negation of aesthetics within his work, and replacing it with a document, he declares the absence of any criterion based on traditional guidelines. The work is deprived of its mystique in a way that reverses the acculturated mystifying process given to Duchamp's "readymades." Whereas Duchamp's object had become mystified over time, Morris is putting a rhetorical halt to this possibility. The document also functions in physical space, along with the metal object, as a physical presence—again, like the "readymades." In this case, however, the document becomes an internalized aspect of the work. To come to terms with the work, one has to include the rhetoric in the documentation.

Perhaps, it was this dilemma in the art of the sixties that inspired this comment by the sculptor Donald Judd:

> "Non-art," "arti-art," "non-art art," and "anti-art art" are useless. If someone says his work is art, it's art.[95]

Morris' paradox in his "Statement of Esthetic Withdrawal" was that an opposing statement could do nothing to deny its context as art. Only when the object was removed entirely from the artwork did the role of the document become a questionable issue. It would appear that the status of this document had to remain present, yet subordinate to the initial object placed on the wall in order for the idea to emerge clearly.

Chapter II
Conceptual Art: The Internalization of the Document

The impetus for awarding recognition to Conceptual artists came about largely through the cultural and curatorial activities in New York during the late sixties. The duration of these activities, in respect to this study, begins around 1965 and extends through 1972.[1] It should be emphasized that a number of Europeans provided a fundamental cultural input and exchange with artists working with nonmaterial concerns in the United States and elsewhere. As Lucy Lippard has pointed out, Conceptual Art was not so much a movement as it was a phenomenon.[2] It was not isolated to any particular area in terms of origin or dissemination. Although most of the significant antecedents to Conceptual Art have been established, the significance of the various factions under this rubric have yet to be appraised. It' is through the examination of related documents that Conceptual artworks may begin to achieve a proper perspective.

In conducting research for this study, the author knew that the development of any artist's work does not always fit into an arbitrary niche — whether it be historical or contemporary. Those artists who considered themselves Conceptualists or those who were doing Conceptually related artworks during the 1960s have, with some exceptions, continued to pursue related concerns. In a few instances, there were artists who deliberately set aside a period of time in order to conduct an extensive set of investigations into the meaning of art.[3] These types of investigations are related to art theory and criticism in that they implied art-making to be a function of language and philosophy.[4] This position was contrary to the prevailing Formalism of the time. For the Conceptualists, art entered into life directly, borrowed from it, and

established a distant vantage-point whereby specific, if not systemic, cross-references became apparent. As Kynaston McShine stated in his catalogue essay to the *Information* exhibition in 1970:

> These artists are questioning our prejudices, asking us to renounce our inhibitions, and if they are re-evaluating the nature of art, they are also asking that we re-assess what we have always taken for granted as our accepted and culturally conditioned aesthetic response to art.[5]

An artist's work moves and develops according to a number of variables. While artistic growth or decline is not the subject of this study, it could be misleading to stop discussing an artist whose further evolution might be illuminating in retrospect. Therefore, some artists' work may be cited in this study which carries through into more current artistic trends.

Most artists involved in Conceptual Art before 1970 were not presenting "live" media documentation nearly to the extent that they were presenting static documents.[6] Notable exceptions to this were Bruce Nauman's work with video and film as early as 1966[7]; Dan Graham's film-loops as obverse performance structures[8]; and Vito Acconci's use of both film and video as self-documentation.[9] Electronic (video and audiotape) and film documents proved necessary, if not seminal, as a means toward clarifying issues — aesthetic, political, and social — that were moving into the art world. This study will concentrate primarily on static forms of documentation. This may include any one or combination of the following: (1) photographs, (2) maps, (3) printed text, (4) diagrams, (5) handwritten or drawn notations, (6) natural specimens, (7) found, manufactured or hand-built objects, and (8) legal certificates and papers.

Before venturing into the problem of documentation and its structural manifestations, it will be important to discuss the role of criticism and aesthetics in relation to Conceptual Art, and to further expand upon the earlier claim that both criticism and theory are essential modes of operation for the Conceptual artist.[10]

The crux of the Conceptual dilemma in the middle sixties was to instill content into art without imitating the aesthetics of formalism. As Jack Burnham observed:

> In a world of invisible values formalism has quickly beome a language with a gradually contracting spectrum of possibilities and variations. We observed that the precipitate collapse of classical formal values was suc-

ceeded by a less materially substantial "optical" formalism. Even this for-
malism of light plasticity and surface finish seemed to have exploitable
limitations. As a result, *invention*, the creative force which has propelled
formalism, has succeeded in pushing "sculpture" further and further out
of the scope of its original domain.[11]

The limitations of formalism worked well for the constructivists,
who followed in the tradition of Naum Gabo and Antoine Pevsner,
with mixed results; but, for the Minimal artists of the sixties, the
aesthetic formalism of the Bloomsbury circle became subverted
within a narrower concentration of literal space.[12] The earlier notion
of lyrical structure gave way to rising interests in geometric permuta-
tion and Gestalt theories of perception. Form was to be perceived at
its most reductive level. With the questioning of such basics as scale
and measurement in regard to objects came further questions as to the
necessity of producing objects for the sole purpose of manipulating
space and perceptual awareness.

One of the early spokespersons for Conceptual Art, Joseph
Kosuth, made the following charges against the eminence of For-
malism. He perceived that,

> Formalist art (painting and sculpture) is the vanguard of decoration, and,
> strictly speaking, one could reasonably assert that its art condition is so
> minimal that for all functional purposes it is not art at all but pure exercises
> in aesthetics. Above all things Clement Greenberg is the critic of taste.
> Behind every one of his decisions is an aesthetic judgment, with those
> judgments reflecting his taste. And what does his taste reflect? The period
> he grew up in as a critic, the period "real" for him: the fifties. . . .
> Formalist criticism is no more than an analysis of the physical attributes
> of particular objects that happen to exist in a morphological context. But
> this doesn't add any knowledge (or facts) to our understanding of the
> nature or function of art. And neither does it comment on whether or not
> the objects analyzed are even works of art, in that Formalist critics always
> bypass the conceptual element in works of art is precisely because For-
> malist art is only art by virtue of its resemblance to earlier works of art. It's
> a mindless art. . . .[13]

Kosuth's position against Formalist art and criticism did much to
alienate his more essential argument which favored art as something
"analogous to an analytic proposition" in which "art's existence as a
tautology . . . enables art to remain aloof from philosophical presump-
tions."[14] This view of art as something acknowledged for its content
of ideas gave the artist a different role. Instead of simply creating works
of art by which a critic—the impartial observer—would deem them

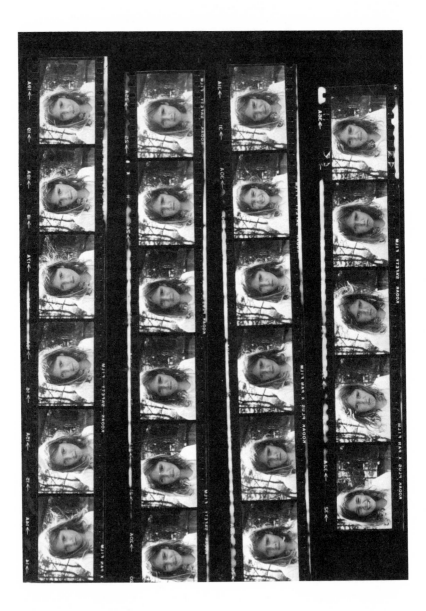

acceptable, the Conceptualist would set forth his or her own dictum as to the work's validity. In other words, it became the artist's responsibility to defend the work through a definitive statement of intent.[15]

Ursula Meyer has addressed the issue,

> The function of the critic and the function of the artist have been traditionally divided; the artist's concern was the production of the work and the critic's was its evaluation and interpretation. During the past several years a group of young artists evolved the idiom of Conceptual Art, which eliminated this division. Conceptual artists take over the role of the critic in terms of framing their own propositions, ideas, and concepts.[16]

Formalist art and criticism, represented by Greenberg and his followers, peaked around the early 1960s. By incorporating criticism into their art, the Conceptualists hoped to set their work outside the reach of Formalist aesthetics. In retrospect, this may have been a defensive position. Kosuth and company — including the Art-Language constituency in Britain — claimed nothing "formal" about what they were doing.[17] Through a deliberate abnegation of Formalist methodology, Kosuth raised the Conceptual banner by adopting a form of "metalanguage" largely conceived by way of A.J. Ayer's linguistic philosophy.[18] Kosuth may be regarded as a theoretician, though relying heavily on Duchamp as evidenced in this remark:

> What is the function of art, or the nature of art? If we continue our analogy of the forms art takes as being art's *language* one can realize then that a work of art is a kind of proposition presented within the context of art as a comment on art.[19]

One of the more cohesive arguments advocating Formalism came from Susan Sontag's polemical essay entitled "Against Interpretation":

> What is needed, first, is more attention to form in art. If excessive stress on content provokes the arrogance of interpretation, more extended and more descriptions of form would silence it. What is needed is a vocabulary — a descriptive, rather than prescriptive, vocabulary — for forms. The best criticism, and it is uncommon, is of this sort that dissolves considerations of content into those of form.[20]

Opposite: Douglas Huebler, *Variable Piece #28: Truro, Massachusetts* (1970). A ten-year-old child, Dana Huebler, was asked to pose for a series of photographs and instructed to keep a "straight face" — even though her brother and sister were allowed to try to make her laugh. Twenty-three photographs join with this statement to constitute the form of this piece. Photo courtesy of the artist.

Clement Greenberg's "Modernism" is, upon careful scrutiny, little more than applied Formalism—an Americanized version of earlier theories of "significant form" expounded by Clive Bell, Roger Fry and Herbert Read.[21] Greenberg was obliged to take on the role of rational arbitrator by interpreting those artworks which he felt represented the New York School. He was dogmatic in promoting his theories but exercised an ingenious subtlety combined with clarity and forthrightness. In 1975, he asserted:

> I repeat that Modernist art does not offer theoretical demonstrations. It could be said, rather, that it converts all theoretical possibilities into empirical ones, and in doing so tests, inadvertently, all theories about art for their relevance to the actual practice and experience of art. Modernism is subversive in this respect alone.[22]

In recognizing Greenberg's contribution to art theory and criticism, Michael Kirby countered his position with the following statement:

> The so-called forms of art are merely intellectual constructs that are helpful in describing experience. They do not limit it. We cannot reject things merely because they do not fit into a category. Nor do categories necessarily determine values, although Greenberg's criticism has influenced many artists and therefore is of great worth even though it is not fundamentally correct.[23]

It would seem that Formalist criticism is indeed a rationalist aesthetic. The polemics leveled against this particular strain of philosophy seemed to be the focus of a small publication in Great Britain called *Art-Language: The Journal of Conceptual Art.*[24] In the first issue, Sol LeWitt, an American Conceptualist, published his numbered "Sentences on Conceptual Art."[25] His argument against rationalism is clearly introduced in the first seven lines:

1. Conceptual Artists are mystics rather than rationalist. They leap to conclusions that logic cannot reach.
2. Rational judgements repeat rational judgements.
3. Illogical judgements lead to new experience.
4. Formal Art is essentially rational.
5. Irrational thoughts should be followed absolutely and logically.
6. If the artist changes his mind midway through the execution of the piece he compromises the results and repeats past results.
7. The artist's will is secondary to the process he initiates from idea to completion. His willfulness may only be ego.[26]

The usefulness of aesthetics — which Kosuth and others emphatically rejected[27] — is that it presents an external theory in relation to the art-work. Traditional aesthetics has too often limited itself by attempting to determine meaning within form. For example, an artist might present a form whereupon a philosopher would articulate its meaning: Conceptualists insisted on declaring their own meaning apart from philosophy. Kosuth, LeWitt, Huebler, and Weiner were all interested in stating their intentions prior to the execution of the work.

Is the alternative to revert to another form of idealism? Or is Conceptual Art merely another short-termed romanticism? It is not unlikely that certain works by conceptualists might fit either of these categories. There is, however, a third possibility — more comprehensive, perhaps — toward the evolution of a critical dialogue that accepts a more expanded set of criteria. The philosopher Ortega y Gasset envisioned that the problems of contemporary art would become the quandary of aesthetics as well; that is, the question of standards by which art ideas can be judged. Ortega expressed the following:

> Although the imaginary centaur does not really gallop, tail and mane in the wind, across real prairies, he has a peculiar independence with regard to the subject that imagines him. He is a virtual object, or, as the most recent philosophy expresses it, an ideal object. This is the type of phenomena which the thinker of our times considers most adequate as a basis for his universal system. Can we fail to be surprised at the coincidence between such a philosophy and its synchronous art?[28]

To understand the role of documentation in Conceptual Art, it will be necessary to examine a critical method which relates closely to the study of phenomenology. The challenge in adapting a philosophical method to aesthetic inquiry and finally to art criticism is to achieve an approach that offers access, breadth and consistency by which the critic can intuit meaning through the "ideal object."[29] It remains, however, that a revision of terms is needed in order to discuss the role of documentation in Conceptual Art on a phenomenological level. This may prove to be an effective way of bringing idea-oriented artworks into some kind of critical dialogue.

The Greek term *epoché*, as employed by the philosopher Edmund Husserl, refers to a method of investigation into the nature of objects as unique forms within consciousness.[30] According to Husserl, the *epoché* was a way of "bracketing" one's knowledge of a particular object or event, imaginary or otherwise, in order to come to terms with the

"object of cognition."[31] The method of bracketing any such phenomena allows for two types of perception in which time becomes an important factor. The first type of perception is referred to as "immanence." This deals with the problem of identifying the object as something perceivable within one's cognition; in doing so, it becomes part of the same "stream of experience" as the Ego.[32] He states:

> The perceiving here so conceals its objects in itself that it can be separated from it only through abstraction, and as something essentially incapable of subsisting alone.[33]

The other type of perception is called "transcendence."[34] This is the act of perceiving as it exists consciously independent of the object. Husserl asserts:

> The perception of a thing not only does not contain itself, in its real (reellen) constitution, the thing itself, it is also without *any essential unity with it,* its existence naturally presupposed.[35]

In a photograph, for example, one experiences the image in relation to cognition; that is, one discovers a set of givens about the image which in turn identifies it as a reference to some other place and time. The process of cognition, in this case, is dependent upon understanding the reality of the image apart from its representation. In light of the fact that a photographic document operates as *a posteriori* information, insofar as it represents an object or event other than itself, the viewer must then come to terms with its relationship to the present. At this point the photograph ceases to be symbolic; instead it becomes a literal thing; in Conceptual Art, it becomes data or documentation or simply information.

Husserl refers to this problem of cognition, but without any direct acknowledgment to the photograph. The following passage is descriptive of the eye-brain mechanism in which "consciousness" has just been called "an empty box"[36]:

> Isn't it true that in every representation or judgment we get a datum in a certain sense? Isn't each object a datum, and an evident datum, just insofar as it is intuited, represented, or thought in such and such a way?[37]

It may be possible, then, to interpret Husserl's "datum" as something which can be manifested or recorded through the use of a

camera. For in order to make sense out of Husserl's phenomenology in aesthetic inquiry, certain terms need explication as metaphor. Subsequent phenomenologists, such as Heidegger and Merleau-Ponty, were able to see this problem and thereby developed means for directing the use of language to accommodate other issues in art and society.[38] For Husserl, such an accommodation became at times unwieldy. Perhaps, this is due to the philosopher's continued recourse to intuition in order to justify the consciousness from which all cognition is made apparent.

It may be said that one's perception of any type of document, presented within the context of an artwork, works photographically in the sense that it is always once removed from the originating idea. However, it is important not to confuse documentation with manifestation — the two are entirely different results emerging from the artist's intent. Sol LeWitt, who has clearly defined each of these in the course of his "structures" and "wall drawings," made this opening statement in his "Paragraphs on Conceptual Art":

> I will refer to the kind of art in which I am involved as conceptual art. In conceptual art the idea or concept is the most important aspect of the work. When an artist uses a conceptual form of art, it means that all of the planning and decisions are made beforehand and the execution is a perfunctory affair. The idea becomes a machine that makes the art. This kind of art is not theoretical or illustrative of theories; it is intuitive, it is involved with all types of mental processes and it is purposeless.[39]

In LeWitt's work, the manifestation of the idea — his idea or system or instructional notation — becomes the work; the documentation simply records the process. This approach to documentation varies from artist to artist. Douglas Huebler, for example, may execute a piece by taking photographs; the photographs act not only as documents of his activity but as structural components as well.[40] These distinctions will be explored throughout the course of this study; they are essential to understanding the problems of form to which Conceptualists addressed their most significant work.

In Husserl's phenomenological reduction, there are the two essential levels of perception, immanence and transcendence, which are directed at very specific aspects of human consciousness. In translating these terms into a viable apparatus for aesthetic inquiry, another phenomenologist, Eugene Kaelin, may refer to certain paintings as possessing "surface counters" and "depth counters."[41] In other words,

a work of art may be understood through a series of perceptions which reconstruct the meaning of the image in entirely different ways. How, then, might these terms apply to the viewing of documents in a work of Conceptual Art? In order to provide the proper context for critical dialogue, the "counters" must be capable of retrieving the artist's intent from the data which is given. Instead of subtle brushstrokes operating on the level of "surface counters," a photographic document might show an overexposed subject of a brick wall.[42]

First there is the content of the image. What do the various tones in the photograph represent? How does one proceed to identify what is being seen? Second, there is the photograph as a literal object. The latter becomes more abstract in the sense that its meaning depends largely on the context in which it is understood. The content here may begin to emerge as pure structure. An appropriate question might be, How has the photograph been manipulated? How does it contribute to the syntactical structure of the piece?

In the first case the image is perceived in terms of what it represents. In the second case the image is presented only as a literal fact; its meaning becomes something other than pictorial representation. By making use of the phenomenological *epoché*, the view must be able to accommodate both levels of perception, or both "surface" and "depth counters" in order to derive substantial meaning of how the document functions in respect to the piece.

By framing an image in the camera, the artist makes a decision to select specific information. Extraneous matter is deleted in order to focus on the chosen subject from a particular angle and at a particular time. The camera will capture an instant, or series of instants, as in strobe-action photography, but there can never be a complete record of an object or event. Photography has its acceptable limits as does human cognition, and the mind must fill in the missing data to create what Husserl calls the "object of cognition" or the *cognitatio*.[43] In conceptual artworks, it is the *cognitatio* that becomes necessary for the viewer to complete the work. The Conceptualist Douglas Huebler refers to this activity as "content-filling."[44]

This study includes the formulation of a theoretical commentary, derived predominantly from studies in phenomenology, as well as critical discussions which deal with specific works by Conceptualists and other artists who touch upon these concerns in some direct way. The common factor to which all of these artists and artworks adhere is their dependence upon the viewer's *cognitatio* which beckons the

engagement of activity for completing the work. It is significant —
especially for Conceptual Art — that Duchamp explained the viewer's
role as essential to the very existence of the artworks.

> The creative act takes another aspect when the spectator experiences
> the phenomenon of transmutation; through the change from inert matter
> into a work of art, an actual transubstantiation has taken place, and the
> role of the spectator is to determine the weight of the work on the esthetic
> scale.[45]

This act of completion through what Duchamp aptly acknowl-
edges as "the phenomenon of transmutation" is usually perceived as
part of the general schema in works of Conceptual Art. The openness
of structure, purported by Conceptual artists, allows for a greater
degree of individual interpretation; in this sense, the work may be said
to engage the viewer directly. There is no object that stands between
the art and the viewer; Duchamp's "transubstantiation" is a process of
fusion. The perceiver and the perceived become a single and vital
entity.

The following untitled work by Conceptualist Robert Barry has
the ability to focus an extremely intimate experience into a gen-
eralized statement on human cognition:

> All the things I know
> but of which I am not
> at the moment thinking—
> 1:36 PM; June 15, 1969.[46]

The piece is evidenced by a small typographical placement of the
preceding four lines centered on a white page. There are no sup-
plementary documents. It has the form of a diaristic notation. On
another level, it is a statement of faith. It lends a diurnal context to the
irreducible cognition once formulated by Descartes. The method is in-
ductive aesthetically in that the viewer is asked to identify with Barry's
work through an extended context of meaning; the scale of the work
is vast. It is beyond Formalism.

Lawrence Weiner's words and phrases are less intimate but
equally as generalized. For example, his work "Transferred"[47] from the
same year as the above, presents itself as a title in the traditional sense.
The fact is that "Transferred" is a language component for an activity
or event, possibly very intimate, and presumably in the past tense. The
obverse structure in "Transferred" is its material or sculptural significa-

tion. This piece is presented on a blank page in a book called *Traces*.[48] The meaning of the word is specialized only to the extent that it is acted upon and reflected upon. The existence of the word without action or reflection merely means an absence of qualifications; the structure remains open for the viewer/spectator to explore its syntactical possibilities of interpretation.

The phenomenological method of *epoché* or "bracketing" as revived from the Greeks by Husserl and applied heuristically to art criticism and theory may prove useful in order to bring works of Conceptual Art into critical dialogue on several different levels. Any theoretical approach that exists outside of the art itself is dependent on a semantic interpretation of the artist's intent.

Kosuth's early position as a Conceptual Art theorist was that artistic intentions should be self-articulated rather than voiced by intermediaries as was the case with Formalism. No one should dictate philosophically or any other way how an artist should produce or "think" art. This stance appears inherently correct, but it tends to underestimate the role of aesthetics in art-making as a necessary and vital source of critical dialogue. The author's point is that without critical dialogue no amount of documentation can sustain the existence of artworks purely on the level of language signification.[49]

Absence of outside criticism may have certain advantages in allowing artists to dissuade critics from a false interpretation of newer work, but this has generally not proved true. Conceptual Art has passed too easily out of the artists' hands, through reproduction, and into the prescribed anthologies of contemporary art "history." There is nothing basically unfavorable about these compendiums, which are fairly numerous, other than the fact that they do not substitute for a critical response with specific works, as those by On Kawara, Bruce Nauman, and Robert Barry, which carry considerable interest on the level of criticism emanating from purely philosophical concerns.

Problems with Documentation

The question of what is a document and what is not a document in artworks related to Conceptual Art has been one of the major theoretical points of contention in the thinking of both artists and critics. In 1970, an editor from *Arts Magazine* gave each of four artists a single page to submit any kind of typographic document for publica-

tion therein.[50] The artists—Lawrence Weiner, Daniel Buren, Mel Bochner and Sol LeWitt—presented vastly different contributions which, according to the editor, were "to serve as examples of several types of art documentation frequently utilized by Idea artists." The editor goes on to say that "the texts . . . are apparently intended to be evaluated as art rather than criticism, aesthetics, or reportage. . . ." This uncritical appraisal of these "documents" more or less epitomizes the ambiguity that has attended conceptual artworks.

Weiner's contribution included his three-part statement of intentionality—his frequently printed *raison d'être*—in which he asserts the following:

> 1. The artist may construct the piece.
> 2. The piece may be fabricated.
> 3. The piece need not be built.
> Each being equal and consistent with the intent of the artist the decision as to condition rests with the receiver upon the occasion of receivership.[51]

This is a document, not an artwork; it exists as an adjunct to the artist's books, films, records, walls, objects, and videotapes. Weiner's artwork is the language of the "piece" to which he refers by way of general and specific syntax. Weiner maintains that there is always a "process" counterpart to his work which may be interpreted as either physical or biological structure.[52] It is interesting to compare Weiner's statement of intention with a much earlier (1925) statement written by the Hungarian-born Bauhaus artist Laszlo Moholy-Nagy: "In comparison with the inventive *mental* process of the genesis of the work, the manner—whether personal or by assignment of labor, whether manual or mechanized—is irrelevant."[53]

Daniel Buren's essay entitled "It Rains, It Snows, It Paints" is a written statement. It is also a document. It is *not* an artwork and should not be evaluated as such. (Buren was one of the first Conceptualists to clearly acknowledge the difference between *in situ* installations and the secondary status of his writings and "photo-souvenirs." Although important as theoretical supports, the documentation only alludes to the artist's activist role in deconstructing the social and political parameters of art.) His essay exists as an adjunct to Buren's recurrent stripe installations and related projects. The essay incisively comments on the social context of art from the perspective of the social anonymity or disappearance of the artist.

> Creating, producing, is henceforth of only relative interest, and the creator, the producer, no longer has any reason to glorify "his" product. We

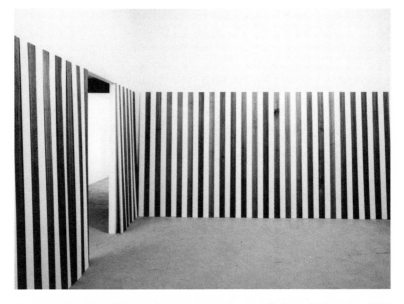

An example of Daniel Buren's recurrent stripe installations: *Palapi ciré*, 1991.
Photo courtesy capcMusée d'art contemporain de Bordeaux.

> might even say that the producer-"creator" is only himself, a man alone
> before his product; his self is no longer revealed through his product.

Mel Bochner's page of "documentation" has a single typed line at
the top which reads: "No Thought Exists Without a Sustaining Sup-
port." Below it, Bochner has ruled in a design for an installation involv-
ing four squares at equal intervals. Within each square are scrawled
sets of word variables — single prepositions written above or below a
fraction line — which signify the visual placement of a solid tone in
relation to the square. There are additional scrawled notations on the
page which presumably are meant to explain a "Theory of Boundaries"
illustrated by the four squares which, in turn, are intended to be
viewed as a gallery or room installation.

Bochner's contribution differs from those of Weiner and Buren in
that it is a reproduction of a drawing in contrast to primary informa-
tion. The fact that it is a drawing "loads" its meaning as an artwork.
Any drawing might in fact be considered a record or study of an artist's
projected ideas; in most cases this would serve as a sketch, a prepara-
tion study, but not an artwork. On the other hand, a drawing which

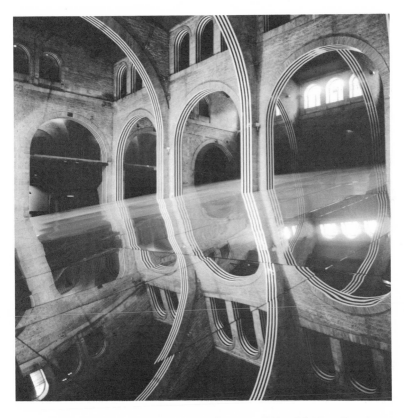

Another Daniel Buren installation from the same 1991 exhibition: *Dominant-Dominé*. Photo courtesy capcMusée d'art contemporain de Bordeaux.

is intentionally made to exist independently of an artwork, such as some of Don Judd's isometric configurations, functions as an artwork. It is more than a study or notation although it might serve that purpose as well.

Although Bochner's work consists of axiomatic paradigms based on the language and mathematics of rationalism, he assiduously ferrets out a multitude of visual and material ambiguities through a reductivist means.[54] The rules of the game are invariably fixed in their reasoning towards solutions. The application of words and numbers to spatial constructs may have the appearance of Conceptual Art, but the task is intrinsically decorative and ultraformalistic. The guard of expressed axioms and systemic references must rely on Formalist pro-

cedures to avoid the obvious. Bochner's relentless grip on traditional, Euclidean space as a measurable container limits the feeling for ideas and the convergence of receivership which makes ideas plausible.

The final "document" in the magazine was by Sol LeWitt. This page consisted of an unnumbered sequence of twenty sentences with each sentence spaced separately in qualified margins. The content of these sentences was a discussion of how LeWitt came to do "wall drawings." As with Weiner and Buren, the sentences are adjunctive to the art. They are not internalized components or references to a specific artwork. It is clearly a statement by the artist—an attempt to communicate information about procedures. As LeWitt expressed it a year earlier in *Art-Language:* "These sentences comment on art, but are not art."[55]

In view of the foregoing analysis of these pages, presented under the title of "Documentation in Conceptual Art," it would appear that the editor's claims are not only misleading but erroneous and intellectually irresponsible. A further remark lends an additional, unqualified claim:

> The texts themselves have become the art. . . . After all, in this instance, the artworks are not reproductions; the pages that follow are the works of art. There are no more reproductions. There is no more criticism. No more aesthetics. Only art.[56]

The fact is that none of the four pages qualifies as an artwork if one applies the method of aesthetic inquiry proposed for this study; yet it has been this kind of art journalism which has had the widest influence in publicizing the work of Conceptual artists. Because of its proximity to the printed media, Conceptual Art could be fed almost instantly to the art public as "primary information."[57] These journals proved indispensable for this reason. The work was described and the artists became known; antecedents were rapidly traced and ways of selling were soon devised. The problem of documentation was left virtually untouched by critics who seemed more interested in politics as the next logical step for discerning the future of art in the existing art world.[58]

Undoubtedly, one of the most important revelations given to the definition and dissemination of Conceptual Art came by way of a young art dealer in New York during the late 1960s. Seth Siegelaub became a pivotal figure in determining the role of exhibiting art, and consequently, in establishing the function of documentation as part of

it. In an interview conducted by the English Conceptualist Charles Harrison, Siegelaub made the following assertion:

> Until 1967, the problems of exhibition of art were quite clear, because at that time the "art" of art and the "presentation" of art were coincident. When a painting was hung, all the necessary intrinsic art information was there. But gradually there developed an "art" which didn't need to be hung.... Because the work was not visual in nature, it did not require the traditional means of exhibition but a means that would present the intrinsic ideas of the art.
>
> For many years it has been well known that more people are aware of an artist's work through (1) the printed media or (2) conversation than by direct confrontation with the art itself. For painting and sculpture, where the visual presence—color, scale, size, location—is important to the work, the photograph or verbalization of that work is a bastardization of the art. But when art concerns itself with things not germane to physical presence, its intrinsic (communicative) value is not altered by its presentation in printed media. The use of catalogues and books to communicate (and disseminate) art is the most neutral means to present the new art. The catalogue can now act as primary information for the exhibition, as opposed to secondary information *about* art in magazines, catalogues, etc., and in some cases the "exhibition" can be the "catalogue."[59]

The terms primary and secondary information are intrinsic to Siegelaub's theory of exhibitions. The fact that illustrations and reproductions of art objects proliferated throughout the sixties made the experience of viewing art as "secondary information" a common occurrence. The "real" objects might have been exhibited once or sporadically in various shows, but their images persisted in the form of magazines and art journals. As the British critic and art theorist John Berger has pointed out, the photographic image acts as a kind of mnemonic device which incites the viewer to perceive the work as an arbitrary experience and to "feel" its mystique through the sheer power of recognition.[60] Glossy art periodicals were doing more to disseminate the images created by artists than any traditionally conceived traveling exhibition could ever hope to accomplish. Artworks could be transmitted through photographic and electronic media with greater speed and to a wider audience. An artist could literally become an "overnight success" in a way similar to the film or television personality. Although these images of artworks were generally not intended to substitute for the "aesthetic experience" in terms of experiencing the art object or event directly, they quickly became a major force in bringing the visual icons of the sixties to a mass audience.

On the basis of these observations, Siegelaub saw the contradiction that was developing between the actual art object and the public's knowledge of it through the various art publications. One problem was that traditional media, used in the production of art objects, did not coincide with the information level of photographic illustrations. Another coincidental problem was that several artists had begun questioning the importance of art objects. For these artists, who largely followed in the tradition of Duchamp, the use of illustrations was sorely deficient, if not irrelevant. Conceptual Art, which claimed a non-object orientation, was more interested in the communication of ideas. Ideas could be presented as primary information. Whereas a painting or sculpture had limitations in terms of singular placement, Conceptual Art had none. Ideas were being stated in the form of art propositions and a new method of presentation was needed to accommodate them.

One of the most significant shows of Conceptual Art to predate Kynaston McShine's Information exhibition at the Museum of Modern Art was Siegelaub's *January 5-31, 1969*. For this exhibition, Siegelaub rented an office space at 44 East 52nd Street, New York City in which he installed a couch, chairs and table with catalogues.[61] A statement from the publication read: "The exhibition consists of [the ideas communicated in] the catalog; the physical presence [of the work] is supplementary to the catalog." Four artists' work was included in the exhibition: Kosuth, Weiner, Barry and Huebler. The receptionist, Adrian Piper, was an artist-philosopher, then an undergraduate student at Hunter College.

In *January 5-31, 1969*, and other subsequent catalogue shows which Siegelaub sponsored that year, there was a reversal of the traditional idea of exhibiting artwork. Instead of the objects' assuming primary importance, the catalogue of documents is ironically raised to the pedestal. The catalogue, consisting of printed statements, photographs, maps and borrowed text, became primary information.

Through this presentation, the viewer/reader was permitted to focus directly on the artists' ideas. As Kosuth once stated: "I want to remove the experience from the work of art."[62] This statement could be interpreted as meaning that art and aesthetics are indeed separate, and only through this separation can an artwork based on ideas exist for its own sake.

The problems of documentation in Conceptual Art cannot be solved simply by understanding how they exist as primary informa-

tion. Often a document will stand as a reference to something other than itself. A photograph, for example, may exist solely on a referential level without any aesthetic value of its own. The referent becomes the idea, core or nexus of the piece—not encapsulated by any regard for material "permanence."

Another type of document may exist not solely for its referential value but for its component value as well. In this case, the document exists within the context of a particular semiotic system. It takes on a syntactical meaning. Donald Burgy's rock specimens,[63] Hans Haacke's meteorological charts,[64] and Agnes Denes' diagrams of "dialectic triangulations"[65] are all syntactical elements within a particular context of language. Each of these elements necessitates the function of receivership to complete the existence of the piece.

These references and or components, as discussed thus far, operate internally; that is, they exist as evidence of structure and are intrinsic to the receivership by which the artwork is determined. The existence of an artist's idea without a reference is superfluous. A reductive statement, such as one by Robert Barry or Lawrence Weiner, is still a reference to an idea. Its typography is visual, but its signification is conceptual. The reference is internal to the piece; it documents an idea or proposal.

Lawrence Weiner, who claims not to use documentation in his work, has clearly presented his language in terms of a sign value.[66] The reference is internal and not outside the structure of the piece. While not specifically indicative of a piece having actually been "built" or "fabricated," Weiner's use of language does contain specific references as presented in his book *Statements* (1968).[67] According to his dictum, a piece can exist within the mind and without material manifestation; this is possible by way of its language counterpart which operates as a signifier within the context of art. The late French semiologist Roland Barthes has stated,

> That which is a sign (namely the associative total of a concept and an image) in the first system, becomes a mere signifier in the second. We must here recall the materials of mythical speech (the language itself, photography, painting, posters, rituals, objects, etc.), however different at the start, are reduced to a pure signifying function. . . .[68]

Weiner asserts, in reference to his own work, that "the piece need not be built." Nonetheless, its existence within the mind, that is, on a purely conceptual level, still brings to cognition the possibility of its

existence or construction. One wonders, as in the case of the "readymades," whether the process of construction would negate the piece as an artwork or the activity would suffice in terms of its "signifying function."[69] The physical existence of his piece "One sheet of plywood secured to the floor or wall" would seem to be dependent upon some previous knowledge of its context in this regard.

The use of primary information in the presentation of Conceptual artworks is one type of documentation. It may be understood as either a referent or as a component internally operative within the structure of the piece. It might also be read as "adjunctive" to the artist's work—a term suggested by McShine in describing the function of the *Information* catalogue.[70] Although an adjunctive document may function as primary information, it may not always function internally to a specific piece. This term applies more accurately to catalogues, books, or magazine articles about art. In other words, the adjunctive document is usually of a critical nature. Most documentation in art, prior to Conceptualism in the mid–1960s, operated externally to art objects; that is, it was not intrinsic to the existence of the work. On the other hand, documents which function internally are intrinsic to the existence of the work. So where does this leave the use of secondary information in art?

Traditional documentation of art objects provided information about art without being a part of it. The information was illustrative, descriptive or critical in relation to the artwork. Secondary information, as defined by Siegelaub, simply means information that has been extracted from its originating source. The fact that it is "secondary" implies that it is twice removed; the art object itself would be "primary," meaning that it is once removed from the *idea* of art which might then be stated as a proposition. The critic's words can only be "secondary" at best; this point has been explored by the editors of *Art-Language*:

> The content of the artist's idea is expressed through the semantic qualities of the written language. As such, many people would judge that this tendency is better described by the category-name "art-theory" or "art criticism": there can be little doubt that works of "conceptual art" can be seen to include both the periphery of art criticism and of art theory, and this tendency may well be amplified.[71]

Nonetheless, an explanatory position about how an artist goes about making art does not function on a documentary level in the

same way as an artwork involving language as both typography and signification. For example, Donald Burgy's contribution to the *Information* catalogue contained the following printed material and included a photograph of a pregnant woman (profile view):

> Documentation of the
> pregnancy of Mrs. Geoffrey Moran
> on 3/1/69 and the
> birth of Sean Moran
> on 3/11/69.
>
> Contents
>
> Birth photographs
> Body measurements
> Body photographs
> Delivery room records
> Labor room records.
>
> March, 1969

These documents are the components of the piece; their notation in the catalogue is referential and still internally operative as a structure. The catalogue is an adjunct to the exhibition and internally operative within the context of an exhibition.

The problem of documentation in art is fundamentally a problem of retrieving the form of the piece through the information presented. This chapter has suggested that Conceptual artists have generally used documents either as internal references or components within the structure of their work. Prior to the advent of Conceptual Art, documentation was primarily considered a secondary source which was removed from the art object. This was because the art object "housed" the form of the piece; and to perceive the form of the piece, one must observe the art object. In Conceptual Art, the secondary or external function of documentation changed. Instead of having to perceive the form of the piece through the art object, one could now "see" the structure of the piece directly through the observation of documents. The documents, however, were only representative of the artist's ideas; therefore, to understand a work of Conceptual Art, one must reconstruct the piece through a proper context of receivership. It has been further suggested that certain phenomenological methods, such as Husserl's *epoché*, might prove beneficial in establishing the proper context in which to determine the value of Conceptual Art on a number of significant levels.

Chapter III

The Photograph
as Information
Within the Context
of Art

In general, the history of photography in the fine arts has been concerned with representing subject matter as a formal arrangement of light and dark shapes by using various contrasts of tonal gradation. The content of a conventional photographic print has involved the translation of an object, a vista, a portrait, or an event on a two-dimensional, light-sensitive surface. The issue of the rarefied print, based on a limited edition, has been a fundamental concern for collectors of fine art photography for over a century.

Much of the controversy that has evolved over the use of photographs in Conceptual artworks has been the result of a misunderstanding concerning the intent of the artist; that is, how an artist *uses* photography. It should be apparent, but often is not, that an accurate interpretation of a photograph is dependent upon an understanding of the context in which images are presented. An advertising image within the context of advertising is consistent. An advertising image in Pop Art is not.[1]

For purposes of this study, it will be necessary to clarify the differences between the photographic print, on the one hand, and the implementation of reproduced images and documents in works of Conceptual Art. Furthermore, it should be stated that the criteria used in viewing photographic prints are considerably different from the issues which confront the view of Conceptual works which employ photographs. This latter point will be explored in the second part of this chapter.

Photographic Prints, Images, and Documents

The communication of an image, photographic or otherwise, has much to do with how it is perceived and where it is presented. How the viewer responds to an image does not always correspond to what the artist intended. One need look no further than commercial advertising to see how this occurs. Manipulation of the imagery and reproduction on a large-scale basis has expanded the possibilities of both photography and art. As the poet Blaise Cendrars once exclaimed: "Yes, truly, advertising is the finest expression of our time, the greatest novelty of the day, an Art."[2]

On the other hand, the eminence of reproduction through photographic technology has changed human relationships—not only in terms of personal and mass psychology but also in terms of object-relationships. Walter Benjamin has given some insight into this problem:

> Mechanical reproduction emancipates the work of art from its parasitical dependence on ritual. To an ever greater degree the work of art reproduced becomes the work of art designed for reproducibility. From a photographic negative, for example, one can make any number of prints; to ask for the "authentic" print makes no sense.[3]

The fact that photographs have become so rampant in contemporary life has, according to Benjamin, degraded the "authority of the object" to which artistic excellence has subscribed for so long.[4] The aura once given to objects has disappeared in Western culture with the development of a photographic mystique. Formerly, it was this aura which kept the artwork within the context of ritual. For Benjamin, the ritual was the initial cause, the *raison d'être*, for the production of the art object; without ritual, the art object has become open to reproduction, exhibition, and politics.

Andreas Feininger once wrote that photography as an art form should possess a theoretical framework as carefully and intuitively considered as painting. He then proceeded to define a successful photograph as "the subjective interpretation of a manifestation of reality through the mechanical means." Feininger asserted the necessity for a subjective control in photography in order to affirm the selection process which he understood as the primary consideration in a work of art.

More recently, contemporary photographers have argued that

traditional materials and processes no longer provide the full vocabulary which is necessary to the evolution of newer forms. This position does not regard the extremes of craft or carelessness to be the crucial aspect in photographing a subject; rather, there are elements of formal composition balanced with uniqueness and technique which occur in the process. Ben Clements and David Rosenfield, for example, advocate an ability to think abstractly in relation to the subject.[5] It is this ability which ultimately determines whether a photograph has reached the level that earns it the designation of art.

A good amount of theory and practice in photography has been done from the point of view of the photographic print; that is, the photograph as a picture of something, a subject which has been exploited to some greater or lesser degree. In her book *On Photography*, Susan Sontag attempts to break through this notion of mystique:

> A new sense of the notion of information has been constructed around the photographic image. The photograph is a thin slice of space as well as time. In a world ruled by photographic images, all borders ("framing") seem arbitrary. Anything can be separated, can be made discontinuous, from anything else: all that is necessary is to frame the subject differently.[6]

Traditional fine art photography, as defined by Alfred Stieglitz and Edward Steichen in the early part of the century, deals with the containment of a subject in much the same way as traditional painting. The camera's viewfinder becomes the given, the "readymade," as it might be interpreted by Duchamp. The image is cropped and thereby contained within the periphery of the frame. Simply stated, the subject is transformed into a picture. It is visible, and yet its visibility is limited. This problem of pictorial space as a container for the subject of the artist-photographer paralleled many of the concerns which led to Cubism.

For the Cubists, the problem was posed in terms of how the most essential visual structure of any subject could be rendered, given the limitations of two-dimensional space. The solution came in the form of geometric planes which were attributed to the theories of Cézanne.[7] The Cubist process involved a transformation of the subject—the art dealer Kahnweiler for example—into a series of linear, flat shapes representative of the position of the subject posed in real space. The view of the subject would then be simultaneous; that is, each angle would be revealed through abstraction.

To perceive a subject in its entirety, one must compress the

experience of circumscribing appearances from several positions in space. This kind of representation could not resort to realism; instead, the canvas became, in one sense, a documentary analysis of the subject in time and space. This exercise, for the Cubist, might be comparable to the cartographer's attempt to flatten the volume of a globe.

In order to construct a flat image from three-dimensional reality, the Cubists turned to abstraction and thereby declared their autonomy as painters distinct from photography. Perhaps it was the limitations of the perceived image that brought these painters to such a conclusion. The camera had reinforced the limits of visibility. The Cubists, in turn, expected that painting could refine itself in a more specialized fashion. This turn in painting was eventually to become known as Formalism, in which a work of art defined itself through adherence to a specific medium.[8]

Many of the Photo-Secessionists, following the example of Stieglitz and Steichen, were impressed by what the Cubists did and tried consciously to imitate their subject-matter.[9] This relationship between painting and photography was to continue for the first quarter of the twentieth century. Henry Holmes Smith cites Stieglitz, and rightly so, for his insight into this relationship:

> Stieglitz took camera work a giant step toward the world of art. His pictures exploited confrontation of the subject, found rhythms of nature that best support lyricism, and in his studies of the city buildings also provided a direct response to certain aspects of the geometry related to cubists and other artists involved with urban and industrial motifs.[10]

Stieglitz, who gave considerable attention to the quality of photographic prints, allowed rarity to become an essential issue. Just as with lithography and etching, the limiting of editions made photography something more than a facile means for obtaining a representation. Each print from an edition would achieve the status of an art object. The size of these editions, of course, varied, the implication being that the smaller the number of original prints, the greater the value. The fact that the "authentic" print has been eulogized instead of disclaimed, as suggested by Benjamin, was possibly related to Stieglitz's proselytizing through his publication, *Camera Work*, and his Gallery 291 in New York.[11]

The determination of Stieglitz to make photography into a respected art medium may be summarized in the following:

Stieglitz desired — noblesse oblige — to lead a crusade; his was for the acceptance of photography as High (Salon) Art. At the time he embarked on his quest, the most rampant forms of High Art were recognizable via adherence to conventions of subject matter and style, among them livestock in rural setting, sturdy peasants, fuzziness, and Orientalia.[12]

A practical consideration in determining the "value" of photographic prints, prior to Stieglitz, was the problem of durability related to the negative. The glass plates, on which the early negatives were processed, were far less durable than the lithographer's stone or the etcher's zinc or copper. Consequently, the consistency of the tones from one print to another would become somewhat difficult to control throughout the printing of an edition. This eventually led to the realization that the processing and printing of a photograph was a specialization apart from the purely optical concerns of the photographer. The development of celluloid did much to mitigate frequent problems of breaking and fading in negatives.

Insofar as subject matter and composition go, it would not be unreasonable to assert that "Art Photography," as tagged by Stieglitz, dealt with pictorial concepts similar to those of painting.[13] Edward Steichen, co-founder of the Photo-Secessionists and formerly a painter, relied heavily on painting effects in making photographs. In his portraits of such notables as J. Pierpont Morgan and Auguste Rodin, Steichen would employ the most subtle and imaginative techniques of lighting known to his craft. The formal and technical considerations which interested Steichen were, in fact, not very far distant from those which occupied the great chiaroscurists in Belgium and Holland over two centuries before. This is not to discredit the vision or virtuosity of Steichen, but rather to emphasize the kind of formal thinking to which traditional painting and photography have been aligned.

The formal qualities in the work of Stieglitz and Steichen are easily accessible and brilliantly executed. Their immediate successors, however, did not always produce results of equal competence, vision or insight. There were notable exceptions, but the immediate trend, prior to the middle twenties, was towards conservatism. The dramatic effects of the worst narrative painting were exploited in the most obvious ways. The importance given to placing interior components within a designated area became the crux of the formal statement as it had always been in pictorial art since Byzantium.

The pioneers in the experimental revival of photography during the 1920s were the American Dadaist Man Ray and the Bauhaus artist-

teacher Laszlo Moholy-Nagy. Both were originally painters with keen insights and some brilliance in understanding the relationship between technology and art, as became particularly apparent in the area of photographic experimentation.

In the following statement, Moholy-Nagy establishes a unique position in photography, whereby he emphasizes the inherent capabilities of the lens, thus indirectly setting photography apart from painting. He asserts:

> We have hitherto used the capacities of the camera in a secondary sense only. This is apparent too in the so-called "faulty" photographs: the view from above, from below, the oblique view, which today often disconcert people who take them to be accidental shots. The secret of their effect is that the photographic camera reproduces the purely optical image and therefore shows the optically true distortions, deformations, foreshortenings, etc., whereas the eye together without intellectual experience, supplements perceived optical phenomena by means of association and formally and spatially creates a conceptual image. Thus in the photographic camera we have the most reliable aid to a beginning of objective vision. Everyone will be compelled to see that which is optically true, is explicable in its own terms, is objective, before he can arrive at any possible subjective position.[14]

Moholy's "objective vision" demystified the camera and let it be a mechanism for recording objects and events. The importance which Stieglitz gave to the quality print was no longer an issue. For Moholy, photography would begin to emphasize the inherent autonomy of the camera as well as the intrinsic optical mechanism of the lens; photography would advance beyond the traditional concerns of composition and subject matter and rarity of issue. This is not to imply that photography was to replace painting. As another artist-photographer, Man Ray, once expressed it, "I photograph what I do not wish to paint and I paint what I cannot photograph."[15]

This attitude towards the camera has been utilized in many ways by a number of photographers. One application of the "objective vision" can be seen in a photographic work by the Canadian artist Michael Snow entitled 8 × 10 (1969). The piece is described in the catalogue presented by the Center for Inter-American Relations:

> To make 8 × 10, Michael Snow photographed, in his studio in New York, a stainless-steel plaque on which he had put black adhesive tape forming the outline of a rectangle which was proportionate in size to each of the

resulting photographic prints—eight by ten inches. These prints are affixed to the gallery's wall by means of white, double-sided adhesive tape; together they form a grid of two hundred and eighty-five rectangles whose outside dimensions are eight by ten inches.[16]

Taking a standard print size, Snow photographed the appearance of its dimensions as represented by the black tape. Each of the eighty prints within the grid sequence shows a different angle at which these dimensions appear to the lens of the camera. There, the apparent shape of the dimensions in each print varies considerably. Often the rectangular shape appears trapezoidal or triangular if a side is missing. There is only one print where the image of the 8×10 rectangle corresponds to the actual size. This piece is a clear critique of the print mystique. Although they may be viewed separately, their strongest appeal is when they are seen within the context of the grid as units constructing a whole.

The use of photographs in Conceptual artworks and those works related to Conceptual schemas, such as the piece by Michael Snow, has challenged a number of old notions about the status and meaning of photography in the fine arts. Instead of regarding all photographs shown in museums and galleries as either succeeding or failing in terms of their composition, scale, tone, subject or color, the viewer may be asked to confront a set of images or documents to be "read" as objective information. The challenge for photography criticism becomes one of distinguishing the context in which a photograph is shown. Before any aesthetic judgment can be made, it would seem appropriate for the viewer or critic to consider the intent of the photograph—in terms not only of what it means but of how it functions. For example, in Conceptual artworks, the use of photographs is generally away from expressive content and more towards a factual presentation.[17]

By suspending the aesthetics of Formalism, its composition and tonality and so forth, more attention may be directed towards the temporal dimension of the work. The original experience of something observed is thereby reduced to a commonplace visual idiom. For example, in the photographs of Hilla and Bernhard Becher, two German artists, one observes a grid of houses, refineries and water coolers—documents of industrialization reduced to a standardized visual scale, a photographic scale. Each photograph operates as a rhythmical unit within a modular series. Within the context of the grid the Bechers'

photographs might be interpreted as a way of viewing syntactical changes within a grammatical construct.

Another example would be Michael Kirby's photographic sculpture which he calls "embedded sculpture."[18] Kirby's work deals more directly with ideas about location but still within the context of structure. He sees the photograph, in the pure sense, as a constructive element. Each photograph becomes an element in a physical structure, often cubistic, involving tangential planes measured and placed at odd angles. The photographs, then, are used to represent a notation of surrounding space as if each sculptural plane were peering through, or mirroring back, another image. Consequently, a compression of temporal moments is adhered into one photographic configuration. The entire structure may be thought of as a contemplative unit.

Kirby has provided the following explanation:

> A photograph as they say, "captures" an instant of the continuum. As soon as it has been taken, it is "out-of-date." In some situations and relationships, this fact can be exploited. A picture can refer not only to another point in space but to another time.[19]

There is a constant reference back to an original location, an original time, and an original activity—that of perceiving something uniquely for the first time. As with the dialectical "site/non-site" sculpture of Robert Smithson (1967–69), the role of the photographic document in relation to the environment is always shifting.[20] The sculpture itself becomes a document. The viewer's role, then, becomes essential to the sculpture in that perception follows from the environment inward and vice versa; human perception metaphorically retrieves information about itself through the environment. Kirby's "embedded sculpture" unites human perception with its field of vision. This kind of observation was perhaps best described by the phenomenologist Maurice Merleau-Ponty:

> I do not think the world in the act of perception: it organizes itself in front of me. When I perceive a cube, it is not because my reason sets the perspectival appearances straight and thinks the geometrical definition of a cube with respect to them. I do not even notice the distortions of perspective, much less correct them; I am at the cube itself in its manifestness through what I see.[21]

The central problem posed by Kirby's sculptural achievement is this: Where does the form of the piece reside? If the piece is physically

structured as a system of components that are themselves external, then it must refer to something other than its appearance. Should the form of the piece be discoverable only through the archaeological exercise of restoring it to the location from which the artist experienced its optical temporality? Or should the form be sought in terms of its "conceptual" meaning—its language structure within time? Can it subsequently be viewed as a process in which documentation has been internalized—"embedded," as it were—into the appearance of its structure?

These questions are, in fact, points of theory which will be discussed in reference to a number of Conceptual and related artworks in the remainder of this chapter. Whereas the print in traditional fine arts photography borrowed heavily from painting as a model for composition and expressive content, the photographs used in Conceptual Art seem to reflect the concerns of sculpture. The use of the camera by sculptors often projects a greater interest in real physical space as evidenced in the work of the artists discussed thus far. It is the sculptor's task to objectify the relationship between camera (perceiver) and subject (perceived) and thereby to avoid creating pictorial fiction as if being seduced by the camera's viewfinder. In lieu of the essential pictorial meaning found in the prints of Stieglitz and Steichen, Conceptual artists have substituted a structural interaction between image and idea. This structural interaction stems from theories concurrent among Minimal and Earth sculptors of the sixties.

Conceptual artists have used the limitations of the camera's viewfinder to their advantage; in the work of Douglas Huebler, Bruce Nauman, Hamish Fulton, Hans Haacke, and Allan Kaprow, among others, the restrictions offered by both camera and photographic image have been one of the fundamental precepts in carrying out the artist's documentary procedures. As with the Minimalists, the photographic vision became a rationale for understanding certain realities about human and mechanical perception. Dan Graham's "minimal photographs" certainly attest to this awareness.[22] The task of refocusing attention on "seeing" became an essential drive in Conceptual artworks.[23] The camera often played the role of arbitrator between the structure of a piece and the viewer's responsiveness. Also, in certain incidents, the camera allowed the viewer's imagination an occasion to reconstruct a sense of time and place. In some cases, the viewer was even asked to complete the piece given only a selection of fragmentary information.[24]

The photographic image in Conceptual Art may appear in reproductive form with the same authority that it might appear as an "authentic" print. An image is not necessarily a document, although it may be. In Conceptual and related artworks, the photographic document is usually functional within the workings of the piece. Examples of how this occurs will be discussed in further detail.

Conceptual Art and Related Artworks Involving Photographs

Given the temporal condition of visual form in Conceptual artworks, the photograph has been used in various structures as an accompaniment to the narrative presentation of ideas, activities and perceptions in time and space. These presentations often consist of written information which refers in some way to one or more photographic images. This means that the photograph supports the coherence of the form as an index to a physical event outside of any pictorial limitations. Without this reference, the photograph might appear vague, uncommunicative, or incapable of providing necessary visual information. Its effectiveness largely depends upon the context of the image and the strength of its conceptual basis as evidenced in the supporting documents which accompany it.

The photograph in Conceptual Art often becomes a clue to the unraveling of a system of ideas. It is a visual element, but does not necessarily connote a visual idea. As a document, internally operative within the form, it substantiates a nonvisible and nonmaterial apparatus. The emphasis is more in terms of the image-content than its rarity as a fine art print. The craft of the medium is often, in fact, suppressed in order to allow the photograph to function as factual information. It becomes a signifier, an image-referent or visual datum.

In most Conceptual work, the formal sense of an image is not exclusive of its content; this is not to imply that aesthetic considerations are absent from the work. Rather, the function of most photographs used by Conceptualists is to provide a record of a piece through its existence in time. Consequently, those critical standards which might apply in determining whether or not a photograph is a "good" photograph are really of a different league entirely.[25] In Conceptual Art, the photograph either works or does not work within the context of the piece; in this sense, the photograph becomes a structural component

which is capable of supporting a system of ideas. The photograph supports the non-visual structure of the piece as a catalyst to its organization within the mind of the receiver.

For example, in Robert Barry's piece *Inert Gas Series* (1969), the photographic image is a view of the Mojave Desert landscape.[26] Unless the viewer acknowledges the image as a document — in this case, a record of an *event* in which the escaped gas (a material substance) is virtually invisible — it is meaningless, merely an uninteresting picture of a desert landscape. The photograph is used to record the time and location of Barry's event; the material is in a nonsolid state. The photograph becomes a single component along with other information which reconstructs the artist's idea for the viewer.

As stated elsewhere, the problem of documentation in Conceptual Art is perhaps more closely linked to sculpture than it is to painting. Whereas painting developed as an inward-directed system of organizing shapes and gestures, sculpture became an outward extension of human form and action. Much of the performance work done in Conceptual Art grew out of concerns related to sculpture. Assuming that sculpture requires an interaction of elements occurring in physical space, a photograph is limited in the amount of space which it can present for interpretation. Conceptual Art and Conceptual performance present a similar problem in that various references to time will often exist within an artwork, thereby limiting the usefulness of photography.[27]

Douglas Huebler was one of the first artists to regard the camera as an "objective" recording instrument in the tradition of Moholy-Nagy. Huebler took the camera one step further than Moholy by refusing to compose an image on the basis of some visual interest or attraction. Rather, Huebler saw the photograph essentially in terms of data or information; a photograph transcribed a pattern or activity as a manifestation of an idea.[28]

A composite grouping of photographs, not necessarily arranged in their sequential order, could describe an object or event through a multitude of perspectives in time. Time, in fact, became a central concern for Huebler in restructuring his former views of static sculpture into a series of Conceptual works which could be viewed simultaneously the world over by means of photographs and other documentary materials.[29] The internal role of documentation, especially through photographs, is characteristic of Huebler's method of perceiving form.

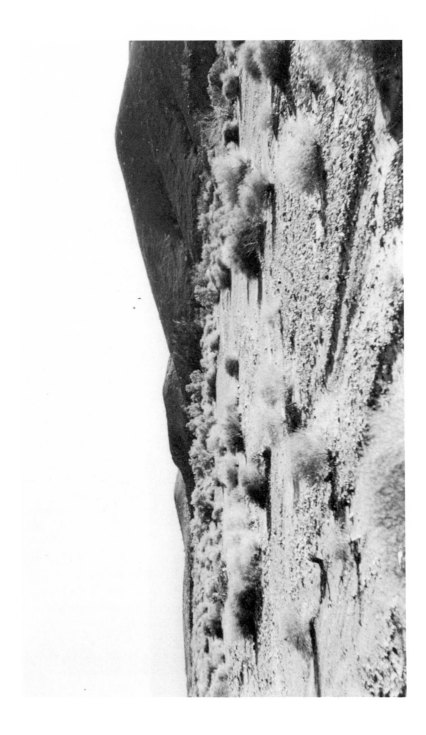

In *Variable Piece No. 28* (see page 30), Huebler presents two documents which include a typewritten statement with his signature and a single contact sheet of sequential black and white images. The statement describes the idea and or process, given in the form of instructions to his daughter. To paraphrase, she is directed to keep a straight face while her brother and sister try to make her laugh. The time of the event is expressed through the sequence of repeated frames. The viewer sees the daughter's face, not once, but several times, moving from left to right and down the page as if a portrait were, in fact, being read. The proximity of the time sequence can be understood through the use of a fixed frame and a continuity of outdoor light. The movement in the 23 photographic images is not directional (moving from one point to another) but gestural. What develops the mood of the piece is the shifting features on the daughter's face — the stern eyebrows, the pursed lips, finally giving way to laughter.

Through Huebler's typewritten statement, the viewer learns that others are involved — though not photographed — within the construct of the piece. The viewer sees only the varying responses of one daughter whereas the brother, the sister and Huebler himself are playing definite roles in an attempt to evoke laughter from the subject. This sets up a goal which may or may not be obtained during the time it takes the celluloid to stop advancing in the camera; this prospect lends the activity a certain intensity of mounting excitement which can only be imagined in retrospect. The contact sheet is presented as primary information. The documentation has been internalized to the extent that it becomes necessary to the effectiveness of the piece.

The fact that some images might be missing or substituted in written form indicates that some process of selection has occurred in Huebler's presentation of information. In recognition of this apparent contradiction, Huebler set out in November 1971 to "photographically document . . . the existence of everyone alive in order to produce the most authentic and inclusive representation of the human species that may be assembled in that manner.[30] During an interview in August 1976, Huebler remarked:

Opposite: **Robert Barry, *Inert Gas Series, Helium,* 1969. From measured volume to indefinite expansion on the morning of March 5, 1969, somewhere in the Mojave Desert in California, two cubic feet of helium was returned to the atmosphere. Photo courtesy Robert Barry.**

Whether or not I make the photograph, you see, is not so important. As a matter of fact, this is why I have deliberately allowed others to do it ... because the photograph simply represents again nature or appearance. And it is that appearance against the construct that is really important.[31]

Although not considered a Conceptualist, either by himself or by most critics,[32] the late American sculptor Robert Smithson created a series of dialectical sculptures which involved the use of photographic documentation. He referred to these works as "sites" and "non-sites." These terms were used to designate areas, such as the Cayuga Salt mine, where Smithson manipulated the actual site through the placement of mirrors and photographs.[33] The non-site would be the reverse of this activity. Sample specimens would be removed from the site and then taken to another indoor location (a gallery or museum) where another displacement would be enacted.

According to Smithson, the difference between his work and the work of most Conceptual artists was in the priority given to ideas over materials. To this effect, he once remarked, "Somehow to have something physical that generates ideas is more interesting to me than just an idea that might generate something physical."

In the work of Smithson, this distinction tends to become somewhat blurred. It often becomes a futile task trying to separate the physical, structural concerns in his work from those concerns which are entirely conceptual. Nonetheless, Smithson has used photographs in ways which seem to approach the early "photo-paths" of the late sixties by the British Conceptualist Victor Burgin.[34]

The use of photographs in Smithson's "site" sculpture is indeed a curiosity. As in other Earth works and Conceptual works, Smithson relied upon the camera as a means of recording; but, in contrast to these works, he often employed the photographs as physical properties in the construction of his "non-sites."[35] This gave his images a unique purpose; for in addition to being documents of the site they became structural elements. This should be considered an important issue in Smithson's contribution to sculpture. The idea of the mirror reflecting a portion of the site became the photograph. His interest in photography is expressed in the following comment taken from an interview on his earth works:

One day the photograph is going to become even more important than it is now — there'll be a heightened respect for photographers. Let's assume that art has moved away from its manual phase and that now it's more

concerned with the location of material and with speculation. So the work of art has to be visited or abstracted from a photograph, rather than made. I don't think the photograph could have had the same richness of meaning in the past as it has now. But I'm not particularly an advocate of the photograph.[36]

The difference between Smithson's work and the Formalist sculptors of the late sixties was not so much in his negation of the object, which is what the Conceptualists advocated, as in his faith in the ability of materials to convey the meaning of his art. Perhaps there is a link with Neoclassicism in Smithson's desire to alter natural appearances into ideal situations. This relationship might be considered as a phenomenological reduction from what Husserl referred to as "natural thinking" to that of the "new dimension."[37] Smithson once stated that "the world is a museum. Photography makes nature obsolete."[38] Perhaps it was the photograph that became a determining factor in expressing the "new dimension" of his sculpture as existing absolutely within time.

In an interview with Lucy Lippard, Robert Morris once discussed the role which photographs have played in respect to his sculpture:

> Photographs function as a peculiar kind of sign. There is a strange relation between their reality and artificiality, the signifier-signified relation they set up is not at all clear or transparent. One of the things they do is to give too much information and not enough at the same time.[39]

The use of a photograph as a memory device has been a central issue in documenting artworks of the late sixties. Morris continues:

> You see a thing day after day for several days and you think you know it pretty well. Then you see the photograph and it's so completely different. Your memory fails you right at that point where the photograph replaces your memory. Five minutes before you have seen the photograph you remember a situation in such and such a way. The very second you are shown the photograph, that becomes the memory, and everything else, reality, bites the dust. People end up living through their photographic memories instead of through reality.[40]

Morris seems to be saying that the role of photography as an illustrative representation of art has diminished the more essential role of seeing. For a sculptor, seeing is a paramount activity, not something delegated through a secondary source. For many Conceptualists the physical object is so fundamentally joined to dematerialized

concerns that the existence of a document becomes the primary source.

This is true for artists as diverse as Douglas Huebler and Michael Kirby—both of whom present ideas related to sculpture, but interpret the photographs in terms of having distinct variations within a multidimensional space. The temporal existence of their works is evident but in entirely different ways. For Kirby a physical structure remains intransient—fixed in perception—as if to contradict any banal references to temporality, not unlike the mystic Ouspensky's reference to the Great Sphinx.[41] In Huebler's work, the authority of temporal involvement seems to linger; the routines are set. The participants merely act out their roles, but nothing is proven; life goes on and myths are created. Huebler observes and records; his photographs attempt to humanize situations, often with rather explicitly existential overtones. The remaining structure for Huebler is time—not metaphysical time as in Kirby's "embedded sculpture," but temporality as a condition of human life.

The logical extension of Minimal sculpture in the mid–1960s seemed to be the analytic phase of Conceptual Art. Such Minimalists as Robert Morris, Donald Judd, and Sol LeWitt have made statements as to the problems inherent in this transition. Although none of these artists ever left the physical presence of materials out of his work, they each considered the content of their work to rest heavily within the realm of ideas.[42]

Many of LeWitt's "sentences" and "paragraphs" have already been reviewed in Chapter II. His fundamental evolution from extreme reductivism in sculptural objects to Conceptual Art was also discussed in both chapters I and II. His regard for documentation is essentially a practical matter; that is, he records the time and place of his wall drawings and lists the names of the artists as well as the scale of the piece.[43] These documents, as mentioned earlier, are to be considered *external* to the piece. The photographs taken of the various drawings are then illustrative of the physical completion of a specific set of instructions. They do not work as internal components of the piece; they are, in fact, adjunctive to it.

There have been exceptions to LeWitt's external use of photographs. Perhaps his best-known photographic works are the structural peep boxes which he built in 1964.[44] These works consisted of a row of sequential photos of a nude woman; each image was mounted inside an elongated rectangular box. The viewer must "peep" through a

series of holes in the horizontal box which are aligned with the individual photographs. Moving from left to right, each view presents an image of a woman which is closer to the lens of the camera. The view at the far left, for example, is quite distant while the view at the far right is directly in front of her navel. This group of works is intentionally derived from the more scientific concerns of the late nineteenth century photographer Eadweard Muybridge; in fact, LeWitt has described it as a homage.[45]

The preceding work is not a documentary use of photographs; it is structural and sequential—two terms which aptly characterize LeWitt's three-dimensional concerns. On the other hand, the Muybridge piece is not exactly pictorial either; that is, it does not reflect the concerns of Stieglitz or those of Art Photography. It is not compositional. Nonetheless, the photographs do succeed as elements of sculpture in much the same way as Michael Kirby's photographs. They are, both figuratively and literally, internalized.

A 1968 piece entitled *The Buried Cube* was one of LeWitt's first Conceptual works which incorporated photographic documentation to carry its meaning.[46] An object-size cube was placed in the ground at Bergeyck, Holland. The entire process, step by step, was recorded in a series of images which were then placed in a 12-page booklet.

In 1974, LeWitt presented his *Incomplete Open Cubes* at the John Weber Gallery in New York. Accompanying this exhibition was a book in which the cubes were presented as a series in all their permutations as photographs and isometric drawings. LeWitt believed that the most essential part of the exhibition was the three-dimensional manifestation of the systemic concept—that being the skeletal structures of the cubic variations, beginning with three sides and permutating through 11 sides. The second most essential part of the exhibition was the isometric renderings which were two-dimensional manifestations of the concept. The least essential part of the exhibition was the photographs in that the documentary process was twice removed from the originating idea.

In book form, however, the absence of the actual structures and the conscious layout of placing a photograph with a line drawing creates a different role for these components. Because of the lack of physical reference to the cubic object being presented, the photographs assume the role of Siegelaub's "primary information." They have shifted emphasis from gallery to book, and within the book they

function internally. Photographs and drawings in this context may be seen semistically in reference to one another.

Formerly, most photographs taken of LeWitt's work, including both wall drawings and structural pieces, were external to the work; that is to say, the photograph had no internal function in the existence of a piece. Nonetheless, as early as 1967, Lucy Lippard suggested that

> A photograph ... is orderly in that it is static and not subject to constant perceptual change, but it is absolutely disorderly in that it provides none of the flashes of information about the structure that are offered by direct confrontation of the object. Thousands of photographs might not suffice to provide the full picture of the piece that can be achieved in a few minutes of actual viewing time.[47]

The book format of *Incomplete Open Cubes*,[48] published concurrently with the exhibition, succeeds in giving the viewer a connection between the idea and the document of its manifestation. The missing element is, of course, the physical realization of the segmented cubes in their individual, logically preconceived variations. The drawings represented LeWitt's systemic idea of the segmented cube whereas the photographs represent a perception in space. The book declares its own sense of structure in that all images, whether photographic or drawn, become sequential elements. Also, the book is "contained" in the sense that the photographs need not refer to the actual existence of the object—the cubic variation—but only to its isometric counterpart.

This kind of "bracketing" information of what is there may relate to the *epoché* in the phenomenology of Husserl. The following excerpt from his Gottingen lectures of 1907 seems appropriate as a guide to viewing LeWitt's bookworks:

> And the whole trick consists in this—to give free rein to the seeing eye and to bracket the references which go beyond the "seeing" and are entangled with the seeing, along with the entities which are supposedly given and thought along with the "seeing," and, finally, to bracket what is read into them through the accompanying reflections.[49]

In the mid–1970s LeWitt began working with color instamatics. One of the first exhibited versions of these was shown at the Rosa Esman Gallery in *Photonotations* (1976),[50] an exemplary display of unusual photographic work by a group of various, unrelated artists. LeWitt's piece, *Grid of Grids*, consisted of 64 random snapshots of

grid-like structures, taken mostly in New York, and arranged into a
square grid format. Subsequently he published a book entitled *Photo-
Grids*[51] which basically deals with the same idea. Like Moholy-Nagy,
it is a play between graphic structure and syntactical meaning. Like
the Bechers, LeWitt's photographs in these pieces are both documen-
tary and semiotic in that each image records a grid variation in the con-
text of city life; yet, with the grid layout of the page, they function as
a language structure.

This relationship of parts to the whole takes precedence over the
exclusive representation of a pictorial subject. On one level, the photo-
graphs simply convey information about the material formation of
grids. In printing a book of photographs, the context of the image
changes. It becomes a reproduction twice removed. The photograph
is screened for book printing before it is actually printed. In color print-
ing, the process is more complex as a result of breaking each color
down into primaries in order to reprint the image on a page. In this
sense, each removal after the original printing process from the
original negative is, in fact, a photo-image of a photograph. It was this
emphasis on technique that gave Stieglitz a certain popular credibility
as an Art Photographer. That is to say, the rarity of the print became
an issue in photography as much as in any other traditional print-
making technique.[52]

Although the quality and rarity of prints has been emphasized less
by Conceptual artists in recent years, the earlier notion that a
photograph was merely a useful image to be used within the construct
of one's ideas—the attitude employed in the books of Ruscha and
Baldessari and the "Duration pieces" of Huebler—implied that con-
ventional aesthetic criteria were somehow outside the discourse of
how these images were meant to function in relation to everyday
culture.

Another book by Sol LeWitt called *Cock Fight Dance* (1980)[53] con-
sists of a sequence of three groups of color instamatics—one to a
page—all contained in a small-format book measuring just over four
inches square. In flipping the pages, an animation of the two fowl
begins to occur, suggesting that the sequential time relationship of
this random action is important. The fact that this sequence can be
reproduced in an edition of several hundred or a thousand does not
diminish the structural concept represented in and by the medium of
the book.

By the late sixties in New York, one could not help but acknowl-

edge that with electronic means for reproduction of line copy or photo-imagery, as used in *The Xerox Book* (1968), new aesthetic possibilities were revealed to Conceptualists. Rather than rarity of print as a criterion for evaluation, the issue was becoming one of content recognition through the phenomenology of structure.[54]

Therefore, the context in which the image appears, as well as its relative scale and format, may prove significant in terms of how the structure of a piece is understood. This care of presentation is highly emphasized in the performance texts of Allan Kaprow and the "worksets" of Franz Erhard Walther.[55] Both of these artists work with the photograph as a means toward describing a set of specific yet simple instructions to be performed. In other words, the photograph takes on a diagrammatic meaning; it documents a piece and at the same time offers a visual aid to anyone who wishes to perform the event in another context at a later date.[56]

The format of the photographs in the booklets of Kaprow, such as *Routine*[57] or *Echo-Logy*,[58] is clear and precise. He understands the effect of visual imagery as a tool for interpreting sequential and non-sequential activities in the most economical manner. The sources to which he turns are not aesthetic but commercial, such as repair manuals and advertising billboards. Trained in the area of typography, Kaprow is knowledgeable in laying out an effective format in which the photograph assumes more than the common role of illustration. Kaprow's photographs invent a language of their own — a semiotics of social ritual — that seems to correspond rhythmically to the physical space of the page as well as the metaphysical or psychological space to which their content is directed.[59]

The displacement or suspension of aesthetic concerns is also present in the photo-imagery of Ed Ruscha. Considered the forerunner of the trend towards artists' books in the 1970s, Ruscha is adamant about his lack of interest in traditional photography.[60] In an interview conducted on July 23, 1976, the author asked Ruscha to respond to the role of the photograph in his work:

> I was not interested in the photograph *per se* as an art form — never was — just as a recording device. It was more the idea of making a book, rather than the photographs. The photographs were secondary to the book — a product of the book. That's what really intrigues me with the whole thing is the finished product of a book. And the photographs are simply, like I say, a device to complete the idea. So the art of photography doesn't even play a part in my books.[61]

The artist explained that most of the photographs, with the exception of some of the images in *Various Small Fires and Milk*,[62] were taken by him; nonetheless, he refuses to consider the photographs anything more than a means towards the printed publication. Ruscha continues:

> I have never exhibited a photographed print, never really made one. People ask me — galleries will call and say: "Well, we'd like to show some of your photographs from your books." And I say: "That's not the art, it's the book that's the art, not the photographs."
> In the beginning I never embraced that idea of photography as an art, the photographic print as an art. It has always been in the form of a reproduction.[63]

For Ruscha, the printed book of reproductions becomes the goal of his work. If there was ever a cogent argument against Stieglitz's approach to photography it would certainly be the work of Ed Ruscha. For Ruscha it is not the photographic print that controls the decision-making of the work, but rather the standardized format of the book. Elsewhere in the interview Ruscha explained how there are standard sizes of books which are determined by signatures of 16 pages; generally, the minimum size is 48 pages. Sometimes Ruscha will select a 64-page book; but this choice has little to do with the number of photo-images which go into the book. In *Colored People*,[64] for example, one flips through several pages of cut-out palm trees facing blank pages, then the images disappear altogether, leaving the remaining half of the book blank.

The earliest publication by Ed Ruscha was *Twenty-Six Gasoline Stations* (1962), which set the stage — that is to say, the system of the idea — for all of the 15 publications that followed up through 1976.[65] The photographs have a certain neutrality, as Ruscha explains, due to the straightforwardness of the subject's unembellished presentation. The photographs are simply facts — data which will later be applied to a system, only without a conclusion. One may observe that the inconsistencies of Ruscha's publications are often more startling than the seemingly predictable format. For example, in *Nine Swimming Pools and a Broken Glass* (1968),[66] there appear at sporadic intervals nine color photo-images of pools. A pleasant and serene atmosphere is created only to be punctuated by the jagged refuse of a broken water-glass.

Ruscha does not deny that people will see his books in different

ways. His intention, however, is to factually present an arrangement of photographic reproductions, each dealing with a theme or concept. He is not trying to interpret a situation, but only to document and present it as a phenomenon. The document again becomes internal to the presentation of the form. But is it the book itself or the concept that touches upon human experience through cognition?

Although Ruscha claims to have little interest in the photographic quality of his images, the framing and cropping of the images in the books is clearly the work of someone other than an amateur. Rather than make an issue out of these factors, he points them out as common sense. He states:

> If I completely ignored what a camera was about, I wouldn't have the same kind of pictures as I usually do. So I have to consider the elements of a camera and how to use them to get the right picture. In other words, when I point a camera at something I focus it rather than not focus it. And so I am bound by the laws of what cameras are made up of . . . and how you use them.[67]

Donald Karshan, the curator of *Conceptual Art and Conceptual Aspects* (1970) at the New York Cultural Center, remarks:

> In the area I refer to as "conceptual aspects" many of the artists use the camera as an opinionless copying device. The use of photography allows a "conceptual" kind of presentation — such as a photographic documentation of subject matter which is "frozen" into use by a system, and subsequently only exists as photographs; the subexperiential presentation of outdoor works, that exists no longer — or never did exist; and for various informational kinds of structure.[68]

In most Conceptual artworks completed between 1965 and 1971, the photo-image is bound to satisfy few if any aesthetic requirements. It is generally not concerned with the intrinsic meaning of pictorial representation. However, it may have a specific reference as in the black and white photographic series *Perspective Correction* by the Dutch Conceptualist Jan Dibbets.[69]

This piece by Dibbets, completed in 1969, presents an interesting visual tension between perception and the visual reality of the flat image.[70] One piece from the series consists of a single photograph without text. It appears to be a "straight" photograph, but upon closer inspection, one realizes the visual impossibility of its subject. In the foreground of a sizable grassy area, a square section of turf has been

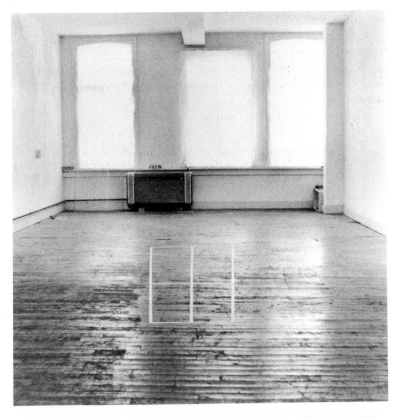

Jan Dibbets, *Perspective Correction—My Studio II, 3: Square with Cross on Floor,*
1969. Black and white photograph on photographic canvas, 43 5/16 × 43 5/16
inches. Photo courtesy Solomon R. Guggenheim Museum, private collection.

removed. But then a contradiction occurs in viewing the buildings in
the distance. They are seen in normal perspective above the horizon
line at the top of the photograph; however, the square of empty turf
towards the bottom of the same photograph appears ambiguous. In
other words, the perspective of the subject has been altered. The
square piece of turf, removed from its location in the picture, was not
really square. If it were square, its shape would appear to recede with
the perspective of the buildings in the distance. Through the lens of
a camera one is conditioned to accept the tenet that all parallel lines
recede. But the square remains in the shape of a square; how is this
possible? It soon becomes evident that what appears to be a square

removal of turf is in fact a trapezoidal configuration. The photograph, then, becomes a document of two things: the law of optical perspective, and the artist's perspective. Once again, phenomenological terms could be easily applied here, related specifically to what Husserl calls the "phenomenal being of the transcent, the absolute being of the immanent."[71]

To this effect, Husserl states:

> The presentings of things are set out through presentations whereby the perspective variations themselves, the apprehensions, and thus the phenomena in their entirety and through and through, are modified in reproduction.[72]

An interior version of *Perspective Correction* was made on Dibbets' studio wall that same year. The form of its ambiguity is similar in that a tension is set up for the viewer between the wall and the position of the camera. Upon first glance, it might appear as though the square shape was drawn on the actual surface of the photograph as opposed to being "in the picture." This very notion becomes intriguing: Is the delineation truly within the time of the photograph or is it after the fact?

Ian Wilson inscribed a six-foot chalk circle on the floor of Bykert Gallery a year earlier, though the result was not considered a "correction" piece. The photographic document shows the circle not as a circle but as an ellipse. A true picture of the circle as a circle would have to be an aerial shot from directly above the circle at its midpoint. If the ceiling were not of sufficient height, any photograph of the circle would register it as an ellipse; the "concept" was that a circle could not be revealed, that only a perspective view of it could be documented. The difference between Wilson's document and Dibbets' *Perspective Correction*(s) may be considered one of intention. Whereas Dibbets' image maintains a twist, implying a knack for irony, Wilson's piece is much less direct in its responsiveness to any comment upon *trompe l'oeil* affectations. Whereas Dibbets exploits the objectivity of the camera as a recording device, Wilson questions the language of that objectivity.[73]

The British artist Victor Burgin has done considerable work—as both an artist and theorist—in expanding the perceptual, psychological, and political possibilities inherent in photography. Burgin considers the semiotic construct to be more important than the pictorial

aspects of the work. His "photo paths" from 1967–69 involved taking sequential shots of a designated floor space, then enlarging the detailed areas to make prints which would then be replaced at the site represented, thus raising questions about the nature of representation and the perception of illusion.

Burgin's photographs operate as linguistic components within a specific syntax.[74] The aesthetic function of the image becomes entirely secondary or subservient to its linguistic function. After 1972, Burgin moved away from his affiliation with Art and Language and questions concerning the tautology of art, and began to direct his attention towards the deconstruction of advertising images. He became specifically involved with commenting on how advertising impacts perceptions of race, gender, and class.

As with the "photo paths," Burgin's most recent photographic projects, such as those image and text works presented in his book *Between* (1986), document an actual site — usually a billboard or a poster in an urban setting — which is then fed back to the viewer as a recontextualized narrative.[75] Internalizing the photographic document allows Burgin to focus on the subtextual comment that the external document (advertising) tries to mask. This deconstructive strategy is evident in an early comment by Burgin:

> Accepting the shifting and ephemeral nature of perceptual experience, and if we accept that both real and conceptual objects are appreciated in an analogous manner, then it becomes reasonable to posit aesthetic objects which are located partly in real space and partly in psychological space.[76]

The systemization and documentation of activities proclaimed by Iain and Ingrid Baxter and their "N.E. Thing Co."[77] involved a similar approach to Burgin's concern for "a revised attitude towards materials and a reversal of function between these materials and their context."[78] For example, in the Baxters' piece entitled *Right 90° Parallel Turn. 100' turn in 6" powdered snow. Mt. Seymour, B.C. Canada* (1968), two photographs present both an action shot of a skier and the skier's trail as marked in the snow. This might be perceived as a common activity for that type of climate in which people engage regularly in winter sports. But by designating the activity as "aesthetic" the piece becomes significant from another point of view. The idea is present in this work through the application of an ecological analysis to a single human gesture. The viewer of the photographs may then ponder the

implications of the activity from the context of an art event with definite social and political overtones.

Photographic documentation is clearly evidenced in a series of sequential images entitled *Four 36-38 Exposures,* photographed by Alice Aycock.[79] The title refers to four separate contact sheets, each dealing with the passing, formation and dissipation of clouds. The piece was done in 1971; the first two contact sheets were photographed in Pennsylvania and the last two in New York City. All but #3 of the four sheets present a view of clouds against a neutral sky. In #3, Aycock has included in the frame of each image a section of rooftops. According to the artist, "The buildings provided a fixed point of reference for the movement of the clouds." Each of the four documents deals with an event-structure based on the appearance of form as it develops through time and space. In each case, the camera lens remains fixed so that all motion occurs in relation to the subject. The time period described in each sheet is 10–15 minutes.

The photographs are documents which indicate the feeling of transition from one image-pattern of clouds to the next, yet because of the limitation of the still image, the feeling of transition is perhaps greater than observing the clouds in actual progress. With Aycock's photographic work from this period, a significant point is established in respect to the camera's role as a neutral organizer of nature. Here nature is represented in the cloud formations. The camera is the necessary structural element that gives the event (nature) meaning as art.

One aspect of these studies that distinguishes them from other progressive sequences, with the exception of works by Dibbets, Baldessari, and Ger Van Elk, is their strong adherence to pictorial representation. It is not that Aycock is imitating the subject matter of painting but that the reference of the pictorial frame, through which the clouds move, establishes a specific context for viewing. Consequently, what might appear to be a "painterly" subject, involving indeterminate composition, is in fact the beckoning of a pure figure-to-ground arbitrariness from the camera pointed skyward. Aycock decided that the frame should remain a constant.

She points out that in contact sheet #2 "an accidental camera movement in frame 34 gives the mistaken impression that the cloud backs up." The rigor involved in this kind of photography is reminiscent of the scientific method, the objective recording device to which Huebler and Ruscha have both referred.

This kind of objectivity in relation to subject matter may be traced to the turn-of-the-century zoopraxologist Eadweard Muybridge. Muybridge applied a rigorous standard to his photographic experiments involving various mammals (including humans) as motion-studies. Originally a landscape photographer, he left behind his formal concerns for aestheticism and devoted himself entirely to photography as a scientific endeavor.[80] It is interesting that several Conceptual artists, Sol LeWitt among them, have acknowledged their debt to his experiments. With Muybridge begins the rebirth of imagery as a language system to be "read."

There is a kind of visual poetry evident in the sequential photographs of John Baldessari. In *Cigar Smoke to Match Clouds that are Different*,[81] one may observe six images: three separate photographs are placed side-by-side with three smaller photographs within each of the larger frames. In each of these three combinations, one observes a full front view of the artist's face, blowing cigar smoke out of his mouth, while against his forehead is pasted the smaller photograph of a cloud. The viewer is asked to relate this combination of imagery both as a sequence and as a visual (or metaphysical) composite.

These photographs differ from other works that have been discussed thus far. The question of where the process of documentation fits into the photographic image is somewhat elusive. There appears to be a confluence of time factors mixing, crisscrossing and overlapping. The viewer observes three photographs not only in sequence, but in subsequence as well. The fact that Baldessari is blowing smoke may or may not correspond to the shape of the clouds. He has created an event, through combinations of photographs, which probably never happened; rather, it was conceived, thought or imagined. *Cigar Smoke* as a work of Conceptual Art may allude too easily to subjective metaphor verging on cynical narration. This recontextualizing of similar yet disparate images, as in Eisenstein's theory of ideographic montage, is an important element in Baldessari's so-called "story art."[82] Certainly the facial expression is as deadpan as that achieved by the best of poker players. The relationship of the clouds to the simple gesture of blowing cigar smoke may then be accepted as coincidental. For Baldessari, the event is created in front of the photographs rather than through reconstruction. Two or more objective elements may produce a subjective response.

There is, in fact, very little connection between the shape of the clouds and the shape of his smoke. This may indicate that the form

of the piece is not so much a tangible viewing experience as a metaphorical one. As in Huebler's work. Baldessari sets the stage for "content-filling." The structure is not entirely a semiotic connection of images, but a numerical system as well. There is a persistent poetic notion that surfaces between clouds and smoke. The event-structure occurs through the juxtaposition of the two photographic images in sequence. The meaning emerges through the placement of the images.

William Wegman's photographs require a certain amount of conceptual activity on the part of the viewer in order to sense their meaning. Often he has presented two photographs of a subject in which the content of one image is dependent upon the other. For example, in his piece entitled *Differences* (1970), two photographs show a wooden desk with a hand-saw propped on its side so that the tool is in full view. Each image shows the exact same information, including the cropped frame, except for the position of the saw-teeth. In the left photograph, the saw sits on its teeth; in the right photograph, it sits on its back with the teeth pointed up. There is a certain dynamic push-and-pull interaction that occurs between the juxtaposition of the two images through a simple, hardly noticeable adjustment of the saw's position in the frame. But the formality seems merely a ploy to set up a verbal punning on the perception of the tool—i.e., to see the saw, or see-saw. Here the manipulation of information has occurred within the photographic images before they were set in relation to one another. There is a consistent regard for humor in Wegman's work which relies, for the most part, on banal circumstances and absurdly personal confrontations with objects and technology.[83]

As pointed out in some of Baldessari's work, the evidence of documentation is not inherently applicable to Wegman's photographs. The fact that they are photographs about ideas that challenge human perception appears to be the crux of their meaning. There is something instinctive about the best of Wegman's work, such as *Family Combination*. In this photographic piece, the artist super-imposed portraits representing three generations in his family. The manipulation of the facial portraits not only conveys personal information about Wegman's physiognomy but also enhances the mystery of social ties and family evolution. The "closeness" of Wegman's work implies that it is clearly derived from subjective input, but in a strangely detached way. Perhaps Wegman's photographic work is best described as manipulative rather than documentary. A photograph does not

always function as a document within the context of a Conceptual work. Often it will function as a component within a specific viewing structure or as a semiotic puzzle. In this case, the photograph guides the viewer to complete the artist's statement. There are, of course, other considerations as well, but in terms of the photograph, there is the expectation that the image will function directly as a sign, that it will indirectly refer to a language or numeric system in spite of itself. Therefore, in Wegman's photographs, the detachment of the imagery, regardless of its content, becomes the deciding factor in the work's success. The family portraits are free for manipulation as is any other "objective" information. How does the system work? Which face is super-imposed in the middle position? What does the order of faces represent in terms of genealogy? This is not to deny the emotional responsiveness of the viewer, but the criterion for determining the success of the piece often rests in the satisfaction of unraveling the content from its structure and putting it back again.

Chapter IV

Conceptual Performance and Language Notations

Another vital aspect of Conceptual Art is performance or "body art." Here the artist performs or exhibits a condition of behavior in relation to language, culture, or numerical constructs. This kind of performance, as in the earlier hermetic works of Yves Klein and Piero Manzoni, does not always require an audience to be present. Many of these events are photographed, filmed, and/or recorded on tape (audio and video). The artist often performs in isolation, as for example at home or in the studio, and presents the work for audience viewing at some later date. Other events are performed theatrically with a certain psychological distance from the audience, but rarely are they performed on a stage or in a theatrical setting. Still others involve the use of installations or spatial displacements of various kinds where people are informally admitted into the performance area as a matter of choice.

As distinct from the Fluxus artists, most Conceptualists derived their influences not from the performing arts — music, dance, theatre — but from the visual arts — usually hybrids of painting and sculpture. However, there were some interesting exceptions. Both Vito Acconci and Dan Graham emerged as performance artists after working in experimental writing and poetry.[1] Yvonne Rainer and Robert Morris were initially involved in dance and choreography. Rainer became increasingly more conscious of "mind" coordination in relation to the structure of movement. In the early 1970s, Rainer turned to filmmaking, from which she developed an important feminist position.[2] Morris evolved his concerns from performance to Minimal sculpture, installations, process art, and video.[3] By the 1980s, he had turned to a hybrid form of painting, highly charged with political and social meaning.

79

In New York, the dominant influences toward Conceptual perfor-
mance were coming from several sources. The 1960s was the era of a
growing attention to civil rights, feminism, ecology, and the tragic
Vietnam War. It was also the era of the media explosion, largely
espoused by the Canadian theorist Marshall McLuhan, and the bur-
geoning youth culture, turned on to music, poetry, and psychedelic
drugs. It was a period of transition in which one set of values was being
evaluated and re-evaluated in relation to another. The 1960s also
witnessed the assassinations of President John Kennedy, Senator
Robert Kennedy, Martin Luther King, Jr., and Malcolm X. The at-
mosphere was spirited, marked by social revolution and a renewed
quest for individual freedom.

In addition to these momentous social, cultural, and political
upheavals, artists were steadily intrigued by Duchamp's intellectual
divorce from "retinal" art-making. Fluxus and Minimal Art seemed to
provide another direction, a new terrain to explore. Another major in-
fluence was the strong reaction against Formalism and a resurgent
interest in defining the meaning of content in art through a demysti-
fication and recontextualization of behavior.

The notion of a Conceptual performance relies to a large extent
on the presentation of documents as a substitute concern for the non-
theatricality of the performance. One of the first American artists to
implement this concern was Allan Kaprow.[4] For him, performance
was not detached from the kinds of activities which "non-artistic"
individuals might perform routinely on a daily basis. The fact that
they are not up on a stage "performing" does not lessen the meaning
of their activity. In an article written in 1966, Kaprow proclaimed that:
"THE LINE BETWEEN THE HAPPENING AND DAILY LIFE SHOULD BE KEPT AS
FLUID AND PERHAPS INDISTINCT AS POSSIBLE."[5] This is to say that a perfor-
mance may be viewed conceptually. In another article written in 1961,
Kaprow argued, "To the extent that a Happening is not a commodity
but a brief event, from the standpoint of any publicity it may re-
ceive, *it may become a state of mind.* Who will have been there at any
event?[6]

Performance may exist outside the confines of a theater and be
commensurate to a Conceptual artwork. In Paris, a year before Kap-
row's "state of mind" delivery, Yves Klein decided that he would desig-
nate one day, November 27, 1960, as his day.[7] It would become for him
a celebration of what Klein termed "the theatre of the void." Klein's
concept actually grew out of an event held some two years earlier at

the Galerie Iris Clert in Paris. He painted the facade in monochrome IKB blue but left the walls inside a stark white. The guests invited to the black tie opening were served blue champagne. In his plea for "immateriality" Klein had accidently stumbled upon a performance. The "void" became a working concept for Klein, and, in designating one day for himself, he would enact any theatrical role he wished in real life. As one critic observed:

> He described this theatre of the void in a project for a theatre which would function normally (but with no audience) at the usual theatre hours and perhaps also at dawn. The audience and the actors, during these moments of intensity, would be invited to think about the theatre, which would light up as much in their imagination as in reality.[8]

The day of November 27, 1960, was a collective effort in spite of Klein's stern allegiance to the "void." He spent considerable time and money publicizing his event, printing enormous spreads of explanatory prose in the Parisian dailies. At this point he decided that the public contact would not be as significant as the making of private pacts with individuals; in other words, Klein decided to create an artwork for a single individual who, coincidentally, would become the collector of the work as well as its sole witness.

Klein established a series of what he called "zones of immaterial pictorial sensibility" which were to be represented in the form of receipts.[9] These receipts would be given to the purchaser in exchange for allowing Klein to toss an exact weight of gold leaf into the River Seine. In the process of relinquishing the gold back to nature, the purchaser would simultaneously burn the receipt representing his ownership of the gold, thus transforming himself into a mystical presence. This event epitomizes Klein's allegiance to alchemy in contemporary life. In addition, it further extended Duchamp's earlier prototype of entering into private agreements with individuals in order to establish a sense of ritual in the production of art.[10]

The necessity of ritual as a context for aesthetic experience became an important issue for the late critic Walter Benjamin. In his essay "The Work of Art in the Age of Mechanical Reproduction," he states:

> We know that the earliest works originated in the service of a ritual—first the magical, then the religious kind. It is significant that the existence of the work of art with reference to its aura is never entirely separated from its ritual function.[11]

In Klein's "zones," the work of art has to be performed for it to have any meaning at all. The fact is that no object remains to attest to its occurrence; the materials are discarded and, in doing so, the ritual is enacted. The act of discarding something as valuable as gold, the primary basis for material exchange in the Western world, only reinforces the conceptual basis of art as "immaterial" substance. If the purchaser wishes to "own" the artwork, he must give Klein an amount of money equal to the value of the gold; he then receives a notarized statement to this effect signed before two witnesses. This further action will ensure that "the immaterial pictorial sensitivity zone belongs to the buyer absolutely and intrinsically."[12] The collector's evidence of ownership as well as participation in the event then becomes this notarized document of receivership.

One of the problems Seth Siegelaub foresaw in the sale of Conceptual artworks a few years later was in how to establish ownership rights to artists' proposals and ideas which disavowed any containment in object form. As an alternative to the object structure, Conceptualists resorted to the use of language in one form or another. The statement could be written, typed, printed or spoken. Sometimes photo-documentation would accompany this information, but not always. Other documentary materials might include books, maps, specimens, charts, diagrams, videotape, audiotape, film, xerox pages, etc.

Lawrence Weiner's *Statements* (1968)[13] is a book of notations which indicate the manner of a material process or event in terms of its language structure. The statement, "An Object Tossed from One Country to Another,"[14] implies a way of doing something—a simple task without explanation or specific reference to a place, person or time. The phrase may also indicate some element of secrecy, a hermetic quality, in which only one individual performs. The phrase exists in the past tense indicating that the event has already occurred. There is no evidence that the action was performed by the artist himself; it may have been observed, found, discovered, intuited, imagined. Whether the event was performed at all is not the point. The phrase can be accepted as a notation, whether imaginary or factual, but it cannot be accepted as proof. The documentary value of the phrase becomes obscured. Does the piece have to exist in order to be noted? Can a document exist for an event that is thought but not enacted? Or is the language simply the counterpart of the object or event?

A document generally functions as supportive evidence; it gives

"information" about something that has occurred. Weiner's language pieces — at least, the earlier works from the late sixties — are equivocal. They tend to read as notations in reference to anthropomorphic phenomena. These words and phrases seem to operate as a sign system as if they were meant to recall tribal meanings. Recall Ernest Cassirer's comment on the use of a "purely theoretical" or conceptual language:

> We can show that all the intellectual labor whereby the mind forms general concepts out of specific impressions is directed toward breaking the isolation of the datum, wresting it from the "here and now" of its actual occurence, relating it to other things and gathering it and them into some inclusive order, into the unity of a "system."[15]

The difficulty with these fragmented syntactical structures, applied to cards, books, posters and walls devoted to Lawrence Weiner, is that the idea is limited by the overriding intention that somehow the artwork is equivalent to the receiver's "object of cognition."[16] Nonetheless, the implication remains; the mental construct is provided; the language continues to mean something despite the gaps. The key to performance may reside here.

Language events are one type of Conceptual performance; second, there is the photographic or sculptural event in which physical perspective is an essential factor; third, body works compose the major corpus of works usually associated with Conceptual performance in which the artist's body becomes the "ground" for psychological penetration; finally, there are the dance and movement pieces which are to some degree extensions of earlier multi-media experimentations.

The first of these categories, language events, is usually not regarded as performance for the simple reason that its duration is not an integral part of the experience. However, it is in the most rigorous sense the basis for all other forms of Conceptual performance. One of the conditions by which these events are delivered is the assumption that the receivership will reconstruct the idea of the piece in terms of the language structure provided. The previously cited work by Lawrence Weiner certainly begs for this type of response. This might also be true of works by Robert Barry such as *A Work Submitted to David Askevold's Projects Class, Nova Scotia College of Art and Design, Halifax, Fall 1969*. Barry provided the following data for this event:

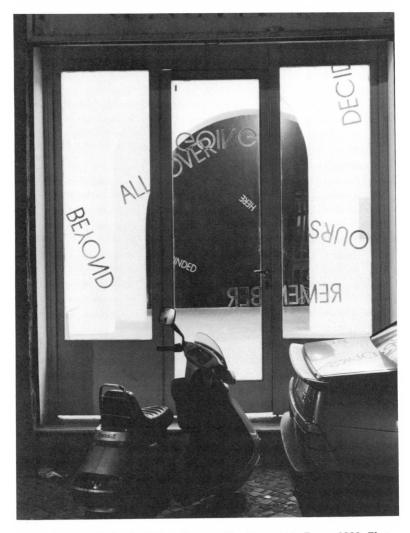

View of an installation by Robert Barry at Ugo Ferranti in Rome, 1989. Photo
courtesy Robert Barry.

The students will gather together in a group and decide on a single com-
mon idea. The idea can be of any nature, simple or complex. The idea will
be known only to members of the group. You or I will not know it. The
piece will remain in existence as long as the idea remains in the confines
of the group. If just one student unknown to anyone else and at any time,
informs someone outside the group the piece will cease to exist. It may

exist for a few seconds or it may go on indefinitely, depending on the human nature of the participating students. We may never know when or if the piece comes to an end.[17]

A piece with a similar intent was executed at Bradford, Massachusetts, by Douglas Huebler, earlier that year. Huebler's *Location Piece No. 8* was the first actual manifestation of an idea in which members of a group—in this case, a studio art class—participated.[18] The artist began by sending out a memorandum to "400 girls [sic] who form the student body of Bradford Junior College." Huebler instructed the students to write down a secret on a piece of paper, then burn the paper, and seal the ashes in an envelope to be deposited in his faculty mailbox.[19] In a typed statement, Huebler states: "On May 25, 1969, the ashes of 63 secrets were all mixed together and that mixture scattered in a random manner throughout the campus."[20]

Both the Huebler and Barry events were involved primarily with language not only as an instructional device but also as a means to appropriate a generalized structure for encompassing social and psychological premonitions towards behavior.

Allan Kaprow's activities since the late sixties are strongly inclined towards pointing out the dialectic between language and behavior as a primary mode of performance.[21] Kaprow's "non-theatrical performance" relies a great deal on banal circumstances.[22] Within these circumstances one is bound to notice the surfacing of certain ritualized gestures which might otherwise go unnoticed. Often a Happening will allow these gestures to emerge at the forefront of an activity while assuming larger-than-life proportions. Such was the case with a 1968 Happening, entitled *Travelog,* in which a number of student-participants drove their cars to various gasoline stations in the town of Madison, New Jersey.[23] At each station, the participants would ask for a tire change and then record the activity with a tape-recorder and a Polaroid camera. Kaprow writes:

> Few of us had ever paid attention to gas stations. It turned out that there were two types of station. One, the older kind, was a gas-and-repairs shop, and looked like a garage with signs attached. The other was a modern, brushed-aluminum and plastic affair which mainly pumped gas.
> The first kind was a social center on a small scale: lots of cars parked around, tools, old tires, grease stains. The owner was in charge, a man usually in his late forties; his younger assistants were hot rodders or bikers and tended to come from lower middle class backgrounds. Besides those who worked there, there were hangers-on, truckers and others similarly

belonging to the automotive life. A few girlfriends also hung around drink-
ing soda pop from the vending machines.

The second type of station was impersonal, was served not only by an
owner but by one or two employees who, though they would do minimal
work such as changing a tire, were there to operate the pumps and process
the bills and credit cards. There was next to no social life, few parked cars,
and the places were very, very clean with well-lighted toilets. They were
decorated shells, large facades for advertising the gas. The station was a
three-dimensional billboard, a theatre setting.[24]

The "script" for *Travelog* consisted of a few simple word-phrases
with accompanying photographs. They served as captions for the Hap-
pening and were both descriptive and instructional. The language was
reduced and without embellishment. It was structural in the con-
notative sense. It documented the activity to the extent that it pro-
vided a necessary reference point for viewing the activity in
retrospect. The phrases operated as instructional units or components
within an information system. It provided some guidance for the man-
ner in which the activity was to occur. The language was functional
on at least three levels: (1) it provided the piece with a conceptual
schema; (2) it facilitated the dispensing of information to the par-
ticipants; and (3) it described the activity. The process of documenta-
tion was successfully internalized. It was built into the structure of the
piece.

Kaprow's contribution to the idea of documentation as an inter-
nal structure, as opposed to an adjunctive reference, places him at the
heart of Conceptual performance. Kaprow further states that,

> cameras and tape recorders transformed hazy occurrences into documen-
> tary clarity—different and better than if the machines hadn't been used.
> They were *aide-memoires* that literally framed moments out of real time
> and that could be recalled indefinitely.[25]

Kaprow's role in the realm of Conceptual performance spans
several areas of concern. The language event, for Kaprow's more re-
cent endeavors, is a critical aspect of his work—assuming that the
experience of a "performance" is more or less delegated to the partici-
pant. The extreme closeness of art and life in any of Kaprow's works
makes the superficial aspect of the work seem absurd. Understanding
what is truly "happening," then, requires acceptance of certain ground
rules about art to which Kaprow presently adheres.

The ground rules do not necessarily refer to any "aesthetic" prin-

ciple; indeed Kaprow comes close to detesting the word and all its ramifications and pretentions.[26] It is really the behavior structure of individuals that he is determined to explore in relation to the cultural standardization which in turn examines structures of intimacy. This becomes most apparent beginning around 1973 with an activity he calls *Time Pieces.*[27]

Performed in West Germany and the United States, *Time Pieces* consists of a group of dyads (two-person pairs) who measure, listen and record each other's pulses after engaging in various types of encounters. The interest in documentation continues to play a role so carefully mixed into the performance that it might be read as natural time commenting on clock-time; hence, the title works as a metaphor.

A good argument could be made aligning Kaprow with the second category of Conceptual performance in this study. This category involves the use of photographic documentation within the structure of the piece. The performance may also be called a "sculptural event" because of the emphasis placed upon the artist's direct interaction with physical space. Several of Kaprow's works from the late sixties call for the intervention of some type of camera activity, bringing the photographer into the work as his earlier works involved the audience.

During the *Pier 18* exhibition in 1969, a group of artists were invited to perform, under the auspices of Willoughby Sharp, a series of events on location which would be documented and later presented as photographs at the Museum of Modern Art.[28] A professional team of photographers was to be present for the duration of each artist's performance. Dan Graham and John Baldessari, two of the artists who participated, were not interested in separating the camera work of the professional photographers from their own work; in other words, they each wanted their own photographs to be taken as part of what they performed. The importance of the *Pier 18* show centered on the use of the camera as a functionary element in the artist's performance. The "look" of the photographic document would therefore begin to have some conscious consideration. Color photographs were starting to become standard artwork information, thus counteracting the assumption that a document had to consist of black and white tones exclusively.[29]

Graham performed an event in which a single reflex camera recorded images from points in a pattern corresponding directly to the physical shape of his body. In placing the camera at various locations

on his body, he established points that would become references to exterior positions of time and space through the lens. He selected a random location on the pier in which to photograph the surrounding space according to the contours of his body.

He began by holding the camera at the top of his forehead, without looking through the viewfinder, and photographing a random image. He gradually moved the camera in a spiral position from the head around to the side and behind and front again, gradually working the camera down to his neck, shoulders, torso, back, stomach, lower back, groin, legs, and feet. At irregular intervals, Graham snapped a picture from whatever position the lens occupied at the moment. The visual problem was one of physical placement, encompassing his own sense of being where the camera was, and in relation to the surrounding space; Graham was engaging himself in a centering process, a gestalt action. As shown by M.C. Richards, the location of a center is not entirely a visual or even a conscious process; it is a conceptual process as well.[30]

The photo-documents resulting from Graham's performance were in many ways as interesting as the activity. A series of color slides, describing the points of rotation, captured a unique attitude of perceptual distance as told by the camera when not held perpendicular to the ground plane at eye-level. Graham's piece was a choreography designed for himself and a mechanical third eye which penetrated and held the land, water, sky, buildings, and motion around him. The documentation determined the significance of the activity which, in turn, revealed its structure.

Another *Pier 18* event was John Baldessari's piece. Baldessari decided that he too would document his own performance. The structure would involve throwing a colored ball straight up into the air 36 times—a number equal to that of the exposures on a roll of Ektachrome film.[31] With each toss of the ball, he would center the viewfinder on the position of the object at its highest position. Whereas Graham used his body as a centering device, Baldessari chose an object outside himself in order to determine the image. The sense of structure had to do with establishing the time factor whereby the image would be shot at a controlled yet random instant. Baldessari's method was perhaps more painterly, drawing more on subject-eye coordination. Graham's piece, in contrast, was more poetic in its intent, more open to juxtaposition of imagery and time variables. For Baldessari, the picture was more dependent on precision timing, as time was

the controlling variable in shaping how the space would be perceived. The pictures varied, of course, depending on where the zenith of the ball fell in relation to sky and horizon. What happened in the photo-image was, within certain limits, arbitrated by a moving reference point emanating from the force—the thrust upward from ground level—of the artist's hand.

In 1973, Baldessari was to do a similar photographic performance entitled *Throwing Three Balls in the Air to Get a Straight Line.*[32] In this piece he used three balls instead of one, thereby complicating the method by which he connected with the image. The time factor became more relative and less controllable; consequently, in the book which came as a result of the action, only the "best attempts" were printed. This decision implies a selection process based on structural rather than aesthetic concerns, but there is no reason to assume that a contradiction necessarily exists between the two. Conceivably, it could have been the other way around; that is, the best *photographs* might have been selected. A twist of irony is often present in Baldessari's work. In *Throwing Three Balls,* the visual information becomes more random and the structure more apparent.

Another element in Baldessari's photographic performances is music.[33] The visual counterpart of music exists for Baldessari perhaps in the way that language structure exists for Lawrence Weiner. In a later work entitled *Throwing a Ball Once to Get Three Melodies and Fifteen Chords* (1975),[34] each still-frame image of a film clip describes the artist (full-view) in various stages of throwing. The separate images are presented one to a page on the right side of the book with an empty page facing. The 15 photographs show a series of gestural movements from the inception of throwing a ball to the follow-through of the arm motion. Superimposed on each photograph are three horizontal lines in three primary colors. The lines begin in relation to the position of the left throwing hand (red line), the right hand (yellow line), and the left foot (blue line) which rises from the floor. These overprinted lines serve to redefine the space in each image. For example, as the left foot rises to the height of the right hand, the blue and yellow lines merge. As the ball is released from the left hand to become airborne, the red line follows the direction of the ball. The sequential change begins with Baldessari's movement and is notated through the placement of the lines. Consequently, with each shift of the lines, a sense of transition emerges through relative progression within the pictorial space.

The concentration on points within a strictly defined field of

vision marks Baldessari's musical structures. These sequences of progression seem to visually represent the way music is heard. The phenomenologist Edmund Husserl explains:

> In the "perception of a melody," we distinguish the tone *given now*, which we term the "perceived," from those which *have gone by*, which we say are "not perceived." On the other hand, we call the *whole melody* one that is *perceived*, although the now-point actually is.[35]

Many of Vito Acconci's early Conceptual works set up a dialogue between himself and some type of cause and effect situation; the camera would be used directly as a tool if not a ploy for the situation to occur. For example, in *Twelve Pictures* (1969),[36] the artist attempted to surprise or shock his audience through a series of intermittent flashes of light while traversing one step at a time the proscenium of a stage. This piece may be perceived in two essential ways. First there is the performance itself in which the house-lights are turned off and Acconci's action is "measured" to cross the stage in 12 steps. For the audience, the first clue as to a structure in the piece at this time is the fact that the steps seem to occur in a linear progression as determined by the "points" of light occurring within a specific duration; the activity becomes a spectacle. Secondly, there are the 12 photographs, taken with an instant camera, which are later presented in conjunction with a printed statement. These photographs serve as documents which in fact define the artist's intent and therefore reveal the structure of the piece. Without the eventual presentation of these 12 documents, the performance would be incomplete. The audience becomes the subject as much as the artist. The piece is relational in two directions — towards the perceiver and towards the perceived.

It was the "body art" of Vito Acconci that brought the legacy of Conceptual Art to the media forefront — not only in terms of the art community, but in terms of the general public as well. In an infamous *Time* article, the critic Robert Hughes blasted Conceptual Art as representing "not simply a recession of interest (and talent) but a general weariness." He went on to say, "There is something indubitably menacing about the work of people like Vito Acconci, one of whose recent pieces was to build a ramp and crawl around below it, masturbating invisibly. . . ." Finally Hughes proclaimed: "If Conceptual Art represents a pedagogy and a stale metaphysics at the end of their tether, Body Art is the last rictus of Expressionism."[37]

Written in December 1972, Hughes' criticism was direct in its attempt to incite a polemic against the avant-garde.

The most interesting counter-attack came from the artist Les Levine:

> Conceptual Art, art that exists as ideas rather than as objects, was not only important, but totally necessary, to reexamine an art world that had lost its way in the boom of the mid-sixties. . . .
> The public loves to be told that art is a sham, that, after all, art is no better than the worst of them. Trying to frighten the public back to painting and sculpture, that no longer have any meaning, will only scare them further away from art.[38]

Levine's comments are reflective, not vengeful; he bounces off Hughes' polemical verbiage so as to clarify some important issues in Conceptual Art as well as the political substrata which Levine feels are endemic to those reactionary affectations leveled against it.

One of the early supporters of Acconci's work was Willoughby Sharp, cofounder of *Avalanche* magazine. Recognizing the need to publish a vehicle for Conceptual performance in America, Sharp and Liza Bear began using a glossy magazine format to "exhibit" documents by various artists who might otherwise be ignored by the existing bastions of Formalism. In 1972, an entire issue of *Avalanche* was devoted to Vito Acconci in the form of a published retrospective of his work over a four-year period.[39] This issue was important in clarifying the work of Acconci, which, because of its shocking appeal, had been susceptible to critical distortions and misinterpretations.

Despite the deliberately hermetic character of Acconci's body works, the significance of the documents should not be underestimated.[40] Acconci's frame of reference, so to speak, was in literature and creative writing. The transition from writing, poetry especially, to sculpture in the form of his own body came about in a somewhat existential way. In confronting the literalness of an empty page, almost as if it were a mirror, Vito felt there was no need to create signs for what he could express directly through performance. He then asked the question, "What is my ground?" The answer came in the form of his own body—as literal a device as the page which he confronted.[41]

The development of Acconci's work from his earlier pieces of 1969, in which he intuited various phases of Conceptual Art through the use of tape and Instamatic and Super-8 film, to his more theatrical performances such as *Learning Piece* (1970) may be understood as a

series of phenomenal and psychological vignettes. His regard for the performance "space" gradually became more concentrated—more valuable to Acconci as an extension of self. The "space" to which he refers is the body as expressed in the following statement:

> Body as starting point: rather, notion of body as starting point: the agent's starting notion heads for his body: body as end-point: a place where notions are stored: since it is a place, it doesn't need a place: the body needs no room to stand in: it can be used to stand on: from there, walk off (body as starting-point—go out of my body).[42]

Notations such as this are used by the artist as ways of reflecting on a performance as well as instructions for a process of behavior during the performance; they also serve in a way similar to Lawrence Weiner's syntactical structures in that they define the form of the piece in terms of language. Acconci sees his work as sculpture within the framework of his body.

Beginning in 1971 with such performances as *Claim* and *Seedbed*[43] Acconci sets his body in juxtaposition to that of gallery—acting within the context of an exhibition space while attempting to remain detached from it. In *Seedbed*, for example, the physical space of the gallery is distorted by a constructed ramp that changes the spectator's orientation to the room. The artist is beneath the ramp, where he remains unseen for the duration of the gallery's hours each day during the installation. There are speakers installed in the room so that Acconci may "imagine" his audience walking above him on the ramp. The artist addresses them within the exhibition space, while he remains embedded, as it were, in the space, yet without being visible. Acconci has noted the following:

> I'm turned to myself: turned onto myself: constant contact with my body (rub my body in order to rub it away, rub something away from it, leave that and move on): masturbating: I have to continue all day—cover the floor with sperm, seed the floor.[44]

Understanding the intent of the piece—this being, in Conceptual Art, its language structure—becomes the necessary criterion by which its receivership can be characterized as, for a better word, art criticism. The statement against Formalism in Acconci's work is difficult to fathom, but is undeniable through his notations.

An artist closely associated with Acconci in terms of the psycho-

logical recall affected through his body works is Dennis Oppenheim. Whereas Acconci was initially involved in language structure as derived from experimental poetics, Oppenheim's performances evolved from his sculpture. The link between their works has always been a projection of psychological and visceral energies, often appealing to an absurd state of irresolution and pathetic humor.

The photograph and its presentation are essential to Oppenheim's concerns. Although Acconci used photographs through 1972 as documentary references to his work, he was rarely involved in how they were presented; in other words, there was a consistent lack of formality in this aspect of Acconci's earlier Conceptual/body works. Oppenheim's early use of photographs is similar to that of Wegmen to the extent that often two photo-images are presented in juxtaposition. Perhaps his most famous piece in this regard is *Reading Position* (1970), in which the frame of the camera is crucial to the subject.[45] Two photographs are shown in color, one on top of the other. The top photograph has Oppenheim's torso in a supine position with a large red book over his chest. The title of the book, *Tactics*, is clearly visible; the content is about cavalry artillery in military strategy. The lower image shows the same torso view of the artist, but without the book. Replacing the book is a sunburned impression on his chest; both images reveal that he has been sunning himself on the beach for a certain duration of time; the political commentary is not accidental.

One of the distinguishing characteristics of Oppenheim's works, besides their psychological content, is their strong adherence to metaphor; particularly in his figurative installations like *Attempt to Raise Hell* (1974). In this piece, a seated figure—smaller than actual size—has a built-in mechanized device so that every few seconds the head moves forward and strikes a large bell that resounds loudly throughout the space. In his more reductive, large-scale Earth works, such as *Branded Mountain* (1969), the metaphor is more indirect but maintains its social, psychological, and environmental impact. An important contribution is Oppenheim's ability to identify and extend his own mind and body into the landscape almost as if it were a ritualized communion and exchange with nature, not unlike the technique practiced by Pollock.

Duchamp's insight into the artist as a "mediumistic being"—as he phrased it in his address to the American Federation of Arts in Houston (1957)—testifies to the strength of conviction that underlies much of his approach to art-making.[46] The most profound realization

of bodily transformation was Duchamp's imagined female persona of Rrose Selavy, photographed by Man Ray in 1921. Another, more contemporary, artist, Piero Manzoni, who set the stage for the body art of the sixties and seventies went even further—from the purely psychological to physiological data—by attempting to document various secretions from his body and then present them as evidence of "living sculpture." What some critics saw as cynical in Duchamp or nihilistic in Manzoni, others saw as entirely noble, even humanistic. For example, Germano Celant describes Manzoni's art as "an exaltation and realization of existence."[47]

This "exaltation" could be no more in evidence than in the Polaroid photographs taken of Rosemarie Castoro tumbling in front of her painted "walls." Castoro, who is basically and foremost a sculptor of materials, constructed and painted a series of large standing panels in 1969.[48] The content of these works was involved with filamentary lines in a highly charged, gestural maneuvering of the paint. Observing that the overall field presented an oddly subdued turbulence, reminiscent of hair, wheat, or ocean waves, Castoro felt the desire to enter the turbulence in some way, to swim in it, so to speak. Alone in her studio, she set up a tripod and set the time exposure of her camera; once in place, she would tumble and swing by a rope unclothed in front of her painted walls. The photographs then served as documents, or a subseries of elements, in relation to the physical structure. The panels evoked a theatrical expression; for Castoro it was a matter of self-renewal, of giving oneself back to oneself after relinquishing it to the act of making an art object—a ritual in the pure sense.

Bruce Nauman's interaction with materiality and sculpture eventually led him to the recording of gestures and spaces relative to his body. His first pieces from the mid-sixties were heavily endowed with process; polyester resins and fiberglass molded into linear wall and floor displacements. In 1966, Nauman made a group of body works in which materials were still used as objects but as negative recesses left from his body. One of these is called *Neon Templates of the Left Half of My Body Taken at Ten Inch Intervals*.[49] This piece is important for Nauman in that it focuses on two important interests which were to prevail for the next few years: one was his concern for human gesture (his own) and movement; the other was the medium of light—in the form of photographs, holograms, film and videotape. Nauman has used each of these media successfully and uniquely in recording everything from walking around his studio for an hour with his hands on top

of his head with the camera upside down to contortions of his face, legs, thighs and torso.[50] These earlier documents really fall within the realm of experimentation; they are deliberately boring and contain an aura of cockiness. Nonetheless, Nauman's forceful penetration into the self through body-oriented intuitions and recognitions of human physical perception make his Conceptual performances both sensually and intellectually gratifying.

Two English sculptors, Gilbert and George, began making duets in a piece called *Singing Sculpture* (1970).[51] In the tradition of Klein, Manzoni, Ferrer, and Ben Vautier, to name a few, Gilbert and George considered themselves "living sculpture." The phrase seems to have been first applied by Manzoni to his signing of actual subjects. Gilbert and George also follow in the romantic tradition of British art along with contemporaries such as Richard Long and Hamish Fulton, appreciating the landscape as a source of ideal fulfillment. Photographs have naturally played an overwhelming part in their work. Rather than seeing the photographs as documents of performance, they view them as components in the sense that the "event" is submitted to an audience for interpretation. This function of photographs, however, did not become evident until after *Singing Sculpture* was performed live for a number of audiences in Europe and America.

Joan Jonas has contributed an important element to the Conceptual performance in her application of live video playback within a contained theatrical experience. Unlike Acconci and Nauman who initially viewed videotape as a recording medium, Jonas sought to incorporate the instant information aspect of television as something apart from its normal storage-retrieval programming. Credit for rediscovery of television as an art form must go to Nam June Paik. He is both the pioneer and leading applicator of video sculpture.[52] It was Joan Jonas, however, who advanced the idea of a video performance in a highly poetic manner. Her piece titled *Organic Honey's Vertical Roll* (1973)[53] brought together a myriad of subtle images which stem from earlier concerns with sculptural space. For Jonas, physical space has always been an arena for three-dimensional activity; the possibility of being alienated from space outside that arena is very much implied. The synthesis of material and software media through creative manipulation plus a recognition of theatrical performance, which emerges as banal and deadpan, makes her work a daring outgrowth of Conceptualism in which the idea of a private space occupies every gesture.

There is little internal use of documentation in the performances

of Joan Jonas. Her photographs are, for the most part, adjunctive; her real recording medium is video, which is internalized but not always retained. A similarly temporary form of documentation is found in the blank films and tape-loops of Christine Kozlov on which information is recorded momentarily only to be erased for the emergence of a new reference[54]; emptiness becomes reality and the performance is the thing.

Joseph Beuys, the German Conceptualist, made a considerable impact upon artists working in the United States even before he had exhibited or performed a single work in this country.[55] Although Beuys may be labeled a body artist, the term does not exactly apply. His work has involved "actions" in which the artist performs for lengthy durations, usually in a public space. Politics has occupied much of Beuys' thinking, as was expressed metaphorically through the sixties in such pieces as *Twenty-four Hours* (1965).[56] The artist fasted for several days before the action and then proceeded to stand on a box with his arms upraised and, clinging to a Y-shaped apparatus for support, remained in a stationary position for a full day; the political meaning of such actions is concerned chiefly with problems of individual freedom and release of creative energies which Beuys believes are suppressed by governments.

The presence of organic matter in Beuys' work has taken various forms — including animal fat, *Fetteke,* stuffed into the corners of rooms in which an air pump may be inserted. Another apparent symbol in Beuys' past actions has been the presence of a dead hare. Beuys has spent a number of hours "talking" to dead hares, trying to explain his aesthetic intentions. Drawings have been made from the blood of hares, which become remnants more than documents of the piece.[57]

The documentation in Beuys' action-sculptures has played a significant part in getting his work known to artists in New York. Small art publications, such as *Avalanche* and *Art-Rite,* became increasingly responsible for giving Beuys American coverage.[58] It was not until 1972 that Beuys agreed to exhibit his works in the United States and not until 1974 that Beuys performed his first action at the René Bloch Gallery in Soho. By then his reputation had been firmly and legendarily established in New York through videotaped interviews, photographs and transcripts of Beuys' public dialogue with students in Düsseldorf and elsewhere in Europe. In an interview for *Avalanche,* Beuys was asked if his political views constituted a new aesthetic. He replied:

> I think art is the only political power, the only revolutionary power, the
> only evolutionary power, the only power to free humankind from all
> repression, I say not that art has already realized this, on the contrary; and
> because it has not, it has to be developed as a weapon—at first there are
> radical levels, then you can speak about special details.[59]

During his public dialogues, Beuys does considerable diagramming on chalk boards; these notations are aids to the communication of ideas. They are considered temporal effects, but curator Bernice Rose has expressed an interest in them as drawings or language equivalents.[60] Documentation for Beuys has occurred on several levels. His transcripts and tapes of recorded dialogues are internal to the extent that they provide valuable spoken information; without these media, Beuys' ideas and his transmission of feeling would not have been known to American artists during the period in which the United States was involved politically, economically and militarily in Vietnam. The documents were essential tools for Beuys in that they made his views obtainable.

The animal remnants from the actions functioned in much the same way as Manzoni's remnants of breath and feces. There are associations with Fluxus art in much of Beuys' work. Photographic information was often integrated with printed transcripts of interviews and various statements. In this sense, the photographs operated internally in connection with these transcriptions; apart from them, however, they would probably be considered adjunctive. *Art-Rite* critic Walter Robinson expresses a significant view in this regard:

> The media appearance is a manifestation of a personal iconography, but
> it's not exactly social. The magazine presentation removes the sociologics
> from mediation (the "audience problem" is opaqued) and delivers the con-
> tact more obviously to the individual imagination, though still insisting
> that the critical values are personal. The freeze on time and space is more
> convenient, accessible and concentrated than in live performance, which
> is sensibly transient and akoluthic. Live public addresses seem to have a
> momentary realness that photographs do not carry, but this "added"
> realness is a function of social extroversion, not a measure of experience.
> Publishing, especially in regard to performance, appeals to the mis-
> anthropic—the literary bookworm with a marginal public existence.[61]

It may be true that the image-appearance, delivered through photographs, has had much influence on body art methodology. A classic example would be another German Conceptualist, Klaus Rinke, for whom the expressive power of his body gestures evokes an inherent camera dialogue.

The most brutal exponents of body works are perhaps best known as the Vienna group. These artists are conscientiously bent on discovering mind-sensations through the most gruesome mutilations and juxtapositions of animal (and human) organs. These performances range from the spectacular stagings of Hermann Nitsch to the hermetic suicide of Rudolf Schwarzkogler.[62] Their common heritage is the use of human bodies as extreme metaphors of aesthetic affectation, contrivance and madness. Upon closer examination of the various artists involved in this Austrian contingent of body theater, one sees that the content of their ideas and their approach to language are not always in agreement. Photographs are, needless to say, a major tool for communication; they are untrustworthy, however, as references to anything beyond their sensational appeal. Schwarzkogler, for example, in his final catharsis ended his life by amputating various organs and appendages while photographs described each phase of the process.[63] In this case, the documentary process seems even more unbelievable than the action itself. An aesthetic inquiry into the action, based on the evidence provided, reveals the limitations of any language structure in confrontation with the absurd.

The choreography of movement in Conceptual performance is often related to dance and comes closest to theater. Performances directed by Robert Wilson and Richard Foreman are unquestionably involved with theater. The context of their ideas is theatrical.[64] But these artists' work may fall only superficially within the domain of Conceptual performance. Whereas they implement and inspire intellectual thought processes, their focus is of a different order from that of most Conceptual Art. Wilson and Foreman deal with language not as a material concern but through repetition and incident in order to extend premises of non-narrative drama. Their methods for doing so are unique and stylistically distinguishable.

Avant-garde dance during the sixties was carried forward by a group of artists who were keenly in touch with the constant shifting and developmental changes occurring in the visual arts; among them were Ann Halprin, Robert Morris, Simone Forti and Yvonne Rainer.[65] By the early seventies, each of these artists had become established in a particular style, method or approach. Morris, of course, turned his attention almost exclusively to sculpture. Rainer picked up the idea of Minimalism and began applying this concern to her dances. In 1968, she performed *The Mind Is a Muscle* in New York which demonstrated a range of movement interpretations related to film and sculpture.

This performance was also important in that it expressed a concern for situation—not in the dramatic sense, but through an introduction of thought sequence expressed as movement and broken by static bits of recorded dialogue.

One of the most original and fascinating developments in Rainer's choreography was the use of text as projected on screens at intervals during the dance. The text would help establish a situation in which movement connected some specific psychological intent. She elaborated on this point in an interview from 1972:

> The texts provided an emotional and dramatic cohesiveness that I had denied or rejected in the making of the dance, a filling in of crevices or projection of a content that the dance itself did not totally satisfy. There was always a total exploration of a given content—like inventories, filling out a body of information in as complete a way as I could think of, which is not the way I went at dancing at all, at making movement. For me, the physical aspect of my work was always what interested me.[66]

Text, film, objects, audio-recordings and projected slides are structural elements by which Rainer punctuates the situation in which her movements occur. Her significant contribution to Conceptual performances is in her detachment of narrative from temporal action. The text, therefore, operates as a detached element much like Sol LeWitt's premises for wall drawings. Her documents are functional properties of the dance; a performance may be repeated, but the situation of the text may receive numerous interpretations.

Although not a dancer, the San Francisco artist Howard Fried has produced a number of performances in which choreography, photography and text are primary issues. Fried's integration of objective psychology into his 1970–1972 performances involved a series of givens often related to number systems. His work really transcends any single category of Conceptual performance.

The psychological roots of his work deal with an "approach-avoidance" construct in which film-loops and photographs are taken of some type of human, physical struggle, then later formulated into an installation along with an accompanying text. Fried maintains that his art consists of "structures of irrationality with a qualitative degree of some rationale attributes incompletely arranged."[67] His accompanying narratives are usually numbered and separated one line at a time by horizontal divisions. They may be characterized as free-form ruminations in search of some type of behavior apparently unknown to Fried at the outset of the performed activity.

In 1971, he produced *Inside the Harlequin*[68] and *Chronometric Depth Perception*.[69] Both events were performed, documented and restructured for gallery viewing. They involved physical struggle — some type of conflict-resolution situation — which might be interpreted as elements within the artist's psyche being projected outward into sculptural space. In the best of Fried's performances there is an indelible yearning for kinetic behavior through expanding chaos and self-recognition. This is accompanied by a further insistence on the possibilities of what his "archetypal sculptures" might evoke within the viewer as psychological content.

Chapter V

Documentation, Criticism and Art as Social Context

When Joseph Kosuth declaimed Formalist aesthetics as the basis by which a critic should determine the value of a work of art, he opened up the possibility that art could become a metacritical investigation; that is, the function of the artist would be one of intermediary between information and culture.[1] In order for this basic Duchampian image to become a reality, the artist must pursue an understanding of the social context in which various objects or events are presented. In doing so, the artist may determine the validity of an artwork—either his own or others—based upon the presumption that it carries social and political meaning, whether by formal intent or not.

In reflecting upon the development of Conceptual Art during the late sixties, Kosuth remarks:

> The myth of modernism, which includes painting and sculpture, collapsing at our heels, left only its shock waves—the sense of a more direct relationship with the cultural bias of western civilization, left for us to try and express in some historical way. It is impossible to understand this without understanding the sixties, and appreciate CA [Conceptual Art] for what it was: the art of the Vietnam war era. Perhaps there is some interwoven nature to the myth of America and the myth of modernism, and when both have been sufficiently unwoven the autonomy of art may be seen for what it is: one colored strand and part of a larger fabric.[2]

Beginning in 1965 with his *Art as Idea as Idea* series,[3] an apparent takeoff on Reinhardt's statements, Kosuth rejected Formalism as antithetical to his proposition that art falls distinctly within the realm of social context. In order to reinforce his thinking about art in relation to society, Kosuth began a series of *Investigations* in which information of various types, usually physical or linguistic, would be listed in

columns as part of a "readymade" collage of news media.[4] The "chance operations" approach to this earlier work was determined by the anonymous paste-up "artist" who would, in turn, refer it to the printer. The printed page became the format in *The Second Investigations* (1968) with a taxonomy, taken from Roget's *Thesaurus,* such as:

III. Communication of Ideas

D. Indication

566. Indication
567. Insignia
568. Record
569. Recorder[5]

The section of the newspaper in which the information appeared had much to do with the signification of the words. For example, with the preceding selection, an article appeared in the column above it which read: "Sir Henry Loses His Voice."[6] Beside this headline, there appeared a photographic image of none other than Sir Henry dressed in a tophat. There is an immediate sense of relationship between Kosuth's insert and the news that surrounds it. The opportunity for this sort of encounter in art was, for Kosuth, severely limited by Formalism. He addresses the problem as follows:

> "Formalism" was at issue in Conceptual Art (CA) in more ways than the apparent ones. With Greenbergian formalism what is at issue is a belief that artistic activity consists of superstructural analysis (prominent traditional modes of art are taken as "givens" and the issue is to attempt to understand the nature of art qua technical praxis of those traditional modes). CA, which might be described as a formalism of another sort, has as its basis infrastructural analysis, and it is in this context that one understands the endeavor to "question the nature of art."[7]

In discussing the role of documentation in the preceding chapters, this study has attempted to delineate the methods by which artists have *internalized* information about structure into the works themselves. The problem for the viewer in confronting a set of documents has been in terms of retrieving the form of the piece as the artist may have conceived it. Kosuth argues (1975) that the basis of Conceptual Art is its "infrastructural analysis." The fact that the work posits a tautology regarding its aesthetic basis gives it an added substance. Its content becomes dialectical in relation to its public (social) context. The British Conceptualist Victor Burgin writes:

> Conceptualism administered a rebuff to the Modernist demand for
> aesthetic confections and for formal novelty for its own sake. It disre-
> garded the arbitrary and fetishistic restrictions which "Art" placed on
> technology—the anachronistic daubing of woven fabrics with coloured
> mud, the chipping apart of rocks and the sticking together of pipes—all
> in the name of timeless aesthetic values.[8]

There is no question that Burgin disdains "Art" as an anti-social-
istic endeavor which persists in upholding those values akin to the
middle class. Burgin feels that only through a semiotic evaluation of
culture can art begin to "unmask the mystifications of bourgeois
culture by laying bare its codes, by exposing the devices through
which it constructs its self-image."[9] It is curious that in Burgin's
rhetoric, the term Art has taken on such a degree of social om-
nipotence, surpassing even the role credited to it by Reinhardt.
Whereas in Reinhardt's statements, "Art in art is art,"[10] Burgin seems
to glorify the fact that Art in art is culture, more specifically "bourgeois
culture."[11]

Clement Greenberg, a would-be opponent of Burgin's thesis, has
maintained a more plausible separation in titling his collection of
critical essays, *Art and Culture;*[12] the reader is prepared to accept the
dialectical encounters which Greenberg posits. The problem of art as
a medium of social awareness is expressed in the following passage:

> It is a platitude that art becomes caviar to the general when the reality it
> imitates no longer corresponds even roughly to the reality recognized by
> the general. Even then, however, the resentment the common man may
> feel is silenced by the awe in which he stands of the patrons of this art.
> Only when he becomes dissatisfied with the social order they administer
> does he begin to criticize their culture.[13]

The relationship of art to culture has become an outstanding
issue among Conceptualists and other artists whose work denies
adherence to the conventional modes of presentation and distribu-
tion. One of the most vehement protests of art as an embodiment of
American cultural values was made by the Guerrilla Art Action Group
in New York.[14] On January 10, 1970, the group issued a statement on
the misuse of art of which the following is an excerpt:

> Art is guilty of the worst sort of crime against human beings: silence. Art
> is satisfied with being an aesthetic/machinery, satisfied with being a con-
> tinuum of itself and its so-called history, while in fact, it has become the

> supreme instrument through which our repressive society idealizes its im-
> age. Art is used today to distract people from the urgency of their crises.
> Art is used today to force people to accept more easily the repression of
> big business. Museums and cultural institutions are the sacred temples
> where the artists who collaborate in such manipulations and cultivate such
> idealization are sanctified.[15]

This polemical utterance by artists Jon Hendricks, Poppy
Johnson, and Jean Toche reflects Kosuth's explanation five years later
that Conceptual Art was "the art of the Vietnam war era." It was also
the era of civil rights demonstrations, urban uprisings, student pro-
tests, assassinations, ecological awareness, counter-culture lifestyles,
and feminism. Marshall McLuhan observed that cultural contact was
beginning to reach the American public in heavy doses; in short, the
era of Conceptual Art was a period of media explosion.[16] The presen-
tation of new ideas accelerated the transformation of value systems to
a very high rate of speed. Because of this acceleration, one could
almost speak of the decade of the seventies as a period of recovery and
re-evaluation of changes which were so rapidly acculturated into
American thought during the sixties.

Lucy Lippard wrote an article called "The Dilemma" which at-
tempted to deal with the social and political implications of avant-
garde art. She argues,

> One of the most common complaints heard nowadays from artists who
> feel threatened by political action in or out of the art world is that they are
> being used. One can only wonder why or how a successful artist allows
> himself or his work to be "used" by a critic or institution or system he
> claims to despise. Why can't he simply refuse to be used?[17]

A more generalized overview of the issue which focuses less on
the artist's dilemma and more on the existential situation with which
the artist must cope is Harold Rosenberg's statement:

> The concept of art as thinking fused with doing offers a point of
> resistance to the present trend toward incorporating the arts into the mass
> media, on the one hand, and subjecting them to ideological manipulation
> by an avant-garde academy, on the other. The hand, that primitive instru-
> ment on which each of us still depends, wishes to conserve its limited
> powers against the overwhelming forces let loose upon the imagination by
> the deluge of technological innovations, from synthetics to transistors.[18]

Rosenberg's observation touches upon the invisible synapse be-
tween aesthetics and politics which certain Conceptualists were able
to grasp successfully.

It has been established in this study that Conceptual Art, in its initial stages, attempted to suspend aesthetic judgment in order to emphasize the existence of ideas, as supported by some method of documentation, within a proposed language structure. The use of systems by such artists as Douglas Huebler, Hans Haacke, Hanne Darboven, Dan Graham, Yvonne Rainer, Daniel Buren, and Sol LeWitt helped to establish a viable alternative to Formalism as an art-making procedure. Although the social context of the work may appear blatant, and often does, the intent of the artist must persist as a clear extension of the idea of art. To understand the application of systems in an artist's work, it becomes necessary to know how that artist defines the proposition Art. Jack Burnham describes Conceptual Art as an activity which occurs in "real time," which is again contrary to the notion of Formalism. He has taken the following position:

> A major illusion of art systems is that art resides in specific objects. Such artifacts are the material basis for the concept of the "work of art." But in essence, all institutions which process art data, thus making information, are components of the work of art. Without the support system, the object ceases to have definition; but without the object, the support system can still sustain the notion of art. So we can see why the art experience attaches itself less and less to canonical or given forms but embraces every conceivable experiential mode, including living in everyday environments.[19]

Burnham wishes to distinguish between "hardware" and "software" as two conditions in making works of art. The traditional approach to fabrication is through a medium, such as stone, steel, wood, canvas, etc., in which the artwork is identified with its container, the object. Another approach, according to Burnham, stresses "software," which became the primary medium or media in Conceptual artworks. He points to a general definition of software as "procedures or programs for processing data." This definition, however, says nothing about the relationship of art to software. Burnham explains that criticism must

> extend the meaning of software to cover the entire art information processing cycle, then art books, catalogues, interviews, reviews, advertisements, sales, and contracts are all software extensions of art, and as such legitimately embody the work of art.[20]

The Conceptual artist Douglas Huebler has advocated the use of "real time" in carrying out various procedures or events which are then

documented through the use of photographs, maps, written
statements, postal receipts, newspaper articles, legal papers, sketches,
and other paraphernalia. Huebler's attitude is one of detachment; he
proposes an idea which he, in turn, sets into operation. The natural
circumstances that follow are simply the manifestations of his con-
struct as they unfold in "real time." The presentation of Huebler's
documents emphasizes his powers of observation over the work itself.
This way of perceiving events is akin to that of Duchamp as well as
the practices of the Zen masters to whom the artist feels a certain in-
debtedness.[21] In a catalogue statement for his exhibition at the
Museum of Fine Arts in Boston (1972), he states:

> A system existing in the world, disinterested in the purposes of art, may
> be "plugged into" in such a way as to produce a work that possesses a
> separate existence and that neither changes nor comments on the system
> so used.[22]

What Huebler presents to the viewer in such works as *Location
Piece No. 6,* for which the artist solicited articles of local interest in
various newspapers throughout the United States, is an "information
processing cycle"—a software manifestation in the form of letters and
photographs received from those editors who agreed to participate in
the artist's construct. This form of art-making recalls Sol LeWitt's dic-
tum that "the idea becomes a machine that makes the art."[23]

Perhaps the most classic example of a Conceptual artist involved
in systems and systems theory is the work of Hans Haacke. Haacke
began working with natural occurrences of various phenomena in
kinetic sculpture as early as 1962 in a piece called *Rain Tower.*[24] The
appearance of *Rain Tower* is somewhat Minimalistic, comparable to
Don Judd's *Untitled* "stacks." Ten acrylic plastic boxes are piled one on
top of another in a vertical column, standing free from the wall. Inside
the boxes, which are transparent, the viewer may perceive water
descending from the highest box through the lower ones; the water
level in each is proportionate to the amount of interior space within
the box.

From this piece, Haacke moved into the field of aerodynamics in
which he projected air currents toward a single, spherical shape hover-
ing in space, not resting on a support as is traditionally used for
sculpture. Haacke has emphasized the fact that he is not involved in
working out formal solutions to art problems; rather, his efforts are

directed toward revealing the system of a phenomenon while observing its activity or transformation through "natural time and natural laws."[25] Sources of Haacke's interests may be traced to his earlier involvement with the Zero Group in Düsseldorf as well as his association with the *Groupe de Recherche d'Art Visuel* between 1960 and 1963. The experience of time has always been a central concern in Haacke's work, rendering irrelevant a number of traditional concerns which relate specifically to the static art object.

As the critic Betite Vinklers has adequately shown, Haacke's systems are of two types: the first involves the production of a system, as in his works using principles of hydrodynamics and aerodynamics in relation to basic cubes, mounds, obelisks, spheres, and other shapes, whereas the second presents a system which already exists, but to which the artist responds by tapping into it, thereby documenting the existence of his idea in operation with the system. It is the latter approach which should be explored in further detail, largely because of Haacke's more direct social, political and economic statements by which he extends the meaning of documentation in Conceptual Art.[26]

Haacke has spoken of his interest in Duchamp with respect to the "readymades."[27] Whereas Cage interpreted Duchamp's idea in terms of "chance operations" which could be applied directly to aleatory forms of musical composition, Haacke chose to interpret Duchamp's selection process as "the principle and conscious acceptance of natural laws."[28] In Haacke's systems, Jack Burnham sees a succinct alternative to the aesthetics of Formalism:

> From 1965 to the present, Haacke has identified his art with ideas implicit to General Systems Theory. In part, he has employed systems thinking to dissociate himself from the intentions of formalist art. Rather than the manipulation of color, gestalts and textural surfaces, he has chosen to define art in terms of open and closed systems, self-regulating, as opposed to run-a-way systems, and hierarchical organization of physical relationships.[29]

Around 1969, Haacke's work began to be focused toward the spectators of his art rather than toward the observation and concomitant transformation of detached physical and biological data. Instead of presenting documents as he had done a year earlier with *Live Airborne System*, a piece concerning the ecological food-chain cycle offshore at Coney Island, Haacke chose to incorporate the process of documentation into the actual viewing space; rather than removing the work from

the spectator's sense of "real time," Haacke made the recording of information about the viewer an integral part of the space. In *Gallery Goers' Residence Profile, Part 1* (1969), and *Part 2* (1970), visitors were asked to provide information about their socio-economic background and political views. This idea was presented at the *Information* exhibition in the form of a question and answer proposal attached to the wall with two large transparent boxes beside it. The statement read as follows:

> Question:
>
> Would the fact that Governor Rockefeller has not denounced President Nixon's Indochina policy be a reason for you not to vote for him in November?
>
> Answer:
>
> If "yes" please cast your ballot into the left box; if "no" into the right box.[30]

In this piece, the viewer's space is literal in the sense that he or she occupies the space in which the work is being made. It may be seen as a process involving the materiality of documentation in the form of ballots piling up in each of the two boxes. The presumption is that the viewer's space occurs in real time, of which current events are a very real part; therefore the artwork becomes a means of extending human consciousness through documentation. At this point, Haacke's art may be characterized as self-transforming; while maintaining its presence within the gallery and museum space, it transforms not only its appearance but its function — from that of aesthetics to one of social context. This paradox of art and culture may be summed up in the words of the sculptor Carl Andre: "Art is what we [artists] do to culture. Culture is that which is done to us."[31]

Perhaps the most controversial work by Haacke to date was a piece concerning real estate holdings in New York in which the artist investigated the ownership of various tenements and other lower-income housing and stores. Haacke was to present the information in the form of a nine-page booklet of documents, including photographs, in a showing of his work at the Guggenheim Museum in April 1971.[32] The director, Thomas Messer, ordered the show to be canceled unless Haacke agreed to certain modifications. Haacke, who had cautiously avoided any commentary upon the information which he had gathered, refused to comply with Messer's demand, and the show was dropped. In protest, Haacke accused the museum of art censorship;

the curator, Edward Fry, resigned in defense of the artist's right to free expression. Haacke's response was to denounce Messer as symbolizing a threat to artistic freedom.

> Mr. Messer is wrong on two counts: First in his confusion of the political stand which an artist's work may assert with a political stand taken by the museum that shows this work; secondly, in his assumption that my pieces advocate any political cause. They do not. Mr. Messer has taken a stand which puts him completely at variance with the professed attitudes of all the world's major museums, except for those located in countries under totalitarian domination, a stand which must put him in potential conflict with every artist who accepts an invitation to show his work at the Guggenheim Museum.[33]

The use of systems in art as "self-sustaining functioning entities" allows a certain freedom on the part of the artist to operate within a chosen realm of inquiry. The artist may remain totally committed to his actions and at the same time proceed with an air of complete detachment. Although it had been alluded to in Duchamp's anonymous selectivity of objects, the Conceptualists were confronting the issue of freedom in a less metaphorical, more political manner. Kosuth, for example, believed that Western art history had followed a certain linearity of which Formalism was the final, archaic result. The political implications of Formalism became as much of an issue as its statement on aesthetics, if not more. Kosuth recounts:

> My reading of art history tells me that I now find myself capable of seeing for art (out of art) a tradition independent of and unmolested by a social coloration . . . which describes and reenforces the presently unacceptable social status-quo. In this sense the Marxists are correct when they claim that art cannot be apolitical. When I realize this I must ask myself: if art is necessarily political (though not necessarily *about* politics) is it not necessary to make one's politics explicit? If art is *context* dependent (as I've always maintained) then it cannot escape a socio-political context of meaning (ignoring this issue only means that one's art drifts into one).[34]

In a talk given to students in Oswego, New York, in 1973, Dan Graham expressed a much more psychological view of his role as an artist within a social context which seemed foreign to him. He stated,

> I wished to open myself and a system to less psychologically deceptive motives and to the entire social-economic system of which art and the artist's "self" had been considered closed-off sectors. An aim was to collect "motives" from non-art viewpoints which regulated other self-enclosed

categories of self-definition. This issue encompasses a situation where a socially defined idea of "self" or individual is used against oneself by society to coerce or control him.[35]

Graham's position indicates that some degree of artistic freedom of expression may be at stake — not so much on the surface level of coercion as on the subliminal level where fewer and fewer alternatives become open to individual choice. It was this realization that turned Sartre away from pure phenomenology and toward existentialism in his pursuit of self-recognition. Sartre maintained that the aesthetic object only exists outside of conscious reality, that it occurs in a dream-state like a myth.[36] It was precisely this deliberate mystification of art, as projected through the collectors, curators and investors in art objects, that helped provoke many of the Conceptualists into a political confrontation with the art establishment.

A publication of 1977 entitled *An Anti-Catalog*, partially supported by Kosuth and other second-generation members of the Art and Language group, was an attempt to sway public opinion away from accepting the Rockefeller Collection as a true representation of American art for the Bicentennial exhibition at the Whitney Museum. From the standpoint of its presentation of documents, this *Anti-Catalog* presents a significant case as to the validity of art as social context. The intent is clearly stated on the cover:

> Unlike most catalogs, this *anti*-catalog is not a listing of valuable objects or a definitive statement of what is or is not significant art. Rather, it consists of written and pictorial essays that address questions about the historical and ideological function of American art.[37]

The political emphasis of art as social context defined one of three factions that developed among artists working with Conceptual pieces around 1972.[38] In one group there were the followers of Art and Language, which continued to attract younger artists from both America and Britain. Many of these Conceptualists turned to various forms of Marxism in order to sustain their purpose in de-emphasizing the art object in favor of nonmaterial concerns.[39] Also, with the rising interest and availability of videotape porto-paks in the seventies, a number of Conceptualists turned their artistic and political interests toward television.[40] Whereas the publication of books and catalogues had been a sole source of "primary information" in the late sixties, many artists now turned back to the gallery as a source of contextual meaning and economic support.

A second group of artists, including Vito Acconci, Chris Burden, and Joan Jonas, formerly absorbed in "body art" as a medium of ontological expression, became involved with elaborate room-sized installations.[41] The influence of their work, however, was to have a minor bearing on a small group of Canadian artists known as Behavioralists.[42] Still another group, including Adrian Piper and Lynn Hershmann, began specializing in autobiographical confessions from a distinctly feminist perspective. These works often incorporated the use of video and photography into a type of performance situation.[43]

Still a third faction which grew out of the Conceptual era was the systemic artists. Of the three groups, this latter faction—including LeWitt, Hanna Darboven, Roman Opalka, Laura Grisi, Roberta Allen and On Kawara—seemed to hold most consistently to their respective methodologies in working with various forms of seriation.

With the exception of such artists as On Kawara, who persisted in documenting "each day alive,"[44] and Douglas Huebler, who persisted in photographing "everyone alive," few of the Conceptualists still consider their work in terms of documentation. The spirit of investigation into the question, "What is Art?"—so prevalent in 1967—has left few remaining vestiges. One example would be On Kawara who continues his ongoing project of "date paintings" (since 1966). His determination to reify art in relation to everyday life has enlarged the significance of Conceptual Art today.

What has not gone entirely political in its pursuit of a more suitable context for making art (as anticipated in the sixties by the Rosario group in Argentina) has tried to integrate itself into conventional forms of painting and sculpture;[45] in most cases, the force of the idea, as a stated proposition concerning the nature of art, has been weakened to such an extent that its manifestation is left without any support—either aesthetic or social. The worst of post–Conceptual art is embittered through a desperate apprehension that it cannot cope with its indulgence, whereas the better work continues to touch the source of experience as related to shifting ideological parameters that relate to institutional critique, yet without diminishing a pursuit of a phenomenology of self.

If aesthetic experience can be redefined phenomenologically, it might be referred to as a higher sensory cognition. If the appreciation of an artwork involves a higher sensory cognition—as suggested in Husserl's terms, *cognitatio*[46]—it might be that the investigation of

experience as art is both the direction and objective of Conceptual Art. The American pragmatist John Dewey alluded to this possibility in the following:

> Experience in the degree in which it is experience is heightened vitality. Instead of signifying being shut up within one's own private feelings and sensations, it signifies active and alert commerce with the world; at its height it signifies complete interpenetration of self and the world of objects and events.[47]

More in line with issues of multiculturalism today, Kosuth argues that differences in culture influence the social context in which art objects are seen; therefore only a very private segment of artwork is representative of human culture. The ideas inherent within this private segment (white, upper middle class) may not be as faulty as the push for standardization behind it, which tends to isolate the context. Opening up the ground rules for the availability of art as information may indeed transform the aesthetic notion of quality, but it also has the potential of satisfying those who exit without art yet seek social acceptance on the basis of their equally refined signs and symbols.

If Conceptual Art failed as a serious challenge to contemporary art history, as the critic Max Kozloff[48] has implied, then it surely succeeded in pointing out the limitations of contemporary culture as a foundation for evaluating "good art." On the other hand, the extremist position of *The Fox* has managed to confuse the absence of art production with normative art history in order to substantiate premises for social change. The fact is that real social change is immune to the narrow rhetoric of art. The inevitable stuffiness of such reverberating polemics tends to be overbearing. At a time when Conceptual Art has been so completely absorbed into the academic mainstream, it would seem that a greater challenge exists for artists than the kind of cultural high-jumping that has appeared in various theoretical journals over the past few years.

Nonetheless, the first phase in the development of a Conceptual Art has been achieved. It has extended the basic Duchampian notion with regard to alleviating the pseudomystical (economic) attitudes given to static objects in contemporary art. One short-term effect of Conceptual Art was that myths, involving aesthetic discrimination as

Opposite: **On Kawara, *Installation View*, 1986. Photo courtesy Sperone Westwater.**

an entity detached from the actual perception of objects, was for a time repudiated. Consequently, the role of the appreciative viewer changed to that of active participant—not merely within the context of art, but through a heightened awareness towards self-inquiry. Hence, the reality of ideas became a source for renewed awareness directly linked to autobiographical concerns. Any art that reflects the limitations of a shrunken value system tends to reflect the deeper experiences of individuals as they question their relationship to it. By the mid-1980s, however, this perception was obliterated in favor of big money concerns and secondary marketing in art. Conceptual Art as a patent force in the art world was over.

Chapter VI

What Is Conceptual Art — Post or Neo?

It would be presumptuous to attempt to write a history of Conceptual Art. Not only is it questionable that a "movement" so loosely defined could have a central core of significance, but it is pretentious to assume that one could embrace the enormous scope of the project at this juncture in history without leaving out essential components — that is, specific artists and their works — from the linearity of its development. This would seem to be a problem not only in writing a narrative account of Conceptual Art, but in writing about any relatively recent artistic development.

First one must consider the national bias of the writer. Take the history of Pop Art as an example. From a British standpoint, Pop Art begins in the mid–1950s as a direct confrontation with Formalist artists and critics like Victor Pasmore, Ben Nicholson, and Herbert Read. In the United States, Pop Art emerges in the early 1960s after a surly proto–Pop period, often referred to as Neo-Dada, exemplified by Rauschenberg, Johns, Ray Johnson, and others. The fact that Pop Art — a term borrowed from the British critic Lawrence Alloway after "New Realism" seemed journalistically inadequate — evolved suddenly in America as the most effective challenge to the inwardness of Abstract Expressionism is important from an American standpoint, but less important from a British one. In the case of the latter, it must be argued that the British got there first for reasons not entirely unrelated to the American situation.

Conceptual Art requires certain cultural delimitations in order to recognize its achievement. One might say that there are many histories of Conceptual Art — all of which are verifiable. Yet it would seem that the clarification of this task has something to do with designations of where some of the factions of Conceptual Art were initially

presented and how they came to be what they are today. The follow-
ing inquiries must be posited: How does the apparent revival of Con-
ceptualism, more than two decades after its variety of enunciations
and philosophical proclamations were issued, enter into the art-world
discourse? Why has it suddenly become popular again? Is it merely
another marketing ploy, another revivalism? Is there any substance in
the work of artists associated with Neo-Conceptualism? And finally,
what is the connection between the earlier Conceptualists who denied
the object and the recent Conceptualists who embrace it? What is the
linkage?

Last season there were a number of exhibitions that provoked
these questions, ranging from the kinky and exorbitant decadence of
Jeff Koons to the utterly refined word canvases of Robert Barry; from
a retrospective glance at the objects and films of Yoko Ono to the pro-
foundly elusive works of Henry Flynt; from the walking piece of the
demure Dutch Conceptualist Stanley Brouwn to the crafted low-brow
cartoons of Sherrie Levine; from the large-scale photo-montages of
Barbara Kruger to the rarefied early photographs of James Welling.
The list could go on and on. Some of these artists acknowledge their
connection to or early roots in Conceptual Art; others do not. The
point is that the territory of ideas is vast and the interpretations for the
most part are isolated discussions that revolve around specific artists.
Drawing connections between artists is a difficult and unpopular task
for a critic to undertake, simply because of the judgments involved in
writing a history or in giving the proper weight to one artist as com-
pared with another. Again, through all of it, there is the question of
national bias—the view that Conceptual Art is centered within the
New York scene as it was originally conceived, particularly by Euro-
pean and South American artists and critics in the sixties. Now this
view of an international, open linguistic code of art has been largely
subsumed, quelled by the familiar mainstream marketing system. It is
no wonder that some artists' documents were transformed back into
objects around 1973 in order that Conceptual Art in New York could
be more visual and therefore salable.

The 1968 essay by Lucy Lippard and John Chandler entitled "The
Dematerialization of Art"[1] was important in identifying a tendency
among certain artists, but the title was misleading in that it suggested
not the absence of the object, but rather the absence of the material.
It was in fact the art object that had disappeared—a semantic correc-
tion that was later made in Lippard's anthology of documents pub-

lished some five years later. Yet most observers will still point to the beginnings of Conceptual Art as an identifiable phenomenon, originating somewhere between 1965 and 1967. The term came into wide use with the publication of Sol LeWitt's "Paragraphs on Conceptual Art" in *Artforum* (Summer 1967). In this essay he stated,

> I will refer to the kind of art in which I am involved as conceptual art. In conceptual art the idea of concept is the most important aspect of the work. When an artist uses a conceptual format it means that all of the planning and decisions are made beforehand and the execution is a perfunctory affair.[2]

Two years later Joseph Kosuth would write in "Art After Philosophy, Part II" (published in the November 1969 issue of *Studio International*) the following:

> The purest definition of Conceptual Art would be that it is inquiry into the foundations of the concept "art," as it has come to mean. Like most terms with fairly specific meanings generally applied, Conceptual Art is often considered as a tendency. In one sense it is a tendency of course because the definition of Conceptual Art is very close to the meaning of art itself.[3]

In either case, with LeWitt or Kosuth, the definition of what was "conceptual" in art evolved from a fairly mainstream relationship to the art of the sixties, namely Pop and Minimal Art. It was in Conceptual Art, not Pop Art, that New York artists and critics found their opportunity to rival the prevailing Formalist doctrines of the preceding decades. The term Conceptual Art is generally and historically acknowledged to have come out of American Minimal and Pop Art — perhaps as a means of defining a necessary contra–Formalist position. It was a shift from a visual to a linguistic Formalism, indebted less to the lineage of Clive Bell and Roger Fry and more to the model set forth by the Russian poets and painters of the twenties, specifically Velimin Khlebnikov and Victor Shklovsky. The relationship to the Russian model was scarcely known or acknowledged in the sixties. Rather, the obsession of artist writers. Kosuth, in particular, was to defeat Formalism as an aestheticizing device. He was actually using language to defeat visual stimulation as an end in itself, exemplified in Color Field painting.

So Conceptual Art as a term and as a phenomenon in the New York art world of the late sixties was a mainstream affair. On the other

hand, the term "concept art" comes from an entirely different vantage point, much earlier on, a point which has been acknowledged in the eighties by Sol LeWitt. The Fluxus movement, largely instigated and organized through the efforts of George Maciunas between 1961 and 1963, is where the earlier notion of "concept art" took hold. It was defined in an essay bearing the same title by a mathematician qua art-ist named Henry Flynt in 1961. Flynt's essay begins:

> Concept art is first of all art of which the material is concepts, as the material of e.g. music is sound. Since concepts are closely bound up with language, concept art is a kind of art of which the material is language. That is, unlike e.g. a work of music, in which the music proper (as opposed to notation, analysis, etc.) is just sound, concept art proper will involve language.[4]

Flynt's description of "concept art" sounds very much like what would eventually be defined several years later as a rebuttal to For-malist painting and sculpture. Flynt, however, was never a part of the mainstream art world. His connections to the Fluxus group came ac-cidentally through his association with musicians who were doing highly experimental work at the time, namely La Monte Young, Philip Corner, and Terry Riley. Eventually he came into contact with Walter de Maria, who had moved from San Francisco to New York around 1959. Then there was the perennial and infectious influence of John Cage, who in many ways was the major ideological force, along with Marcel Duchamp, in the formation of Fluxus. This is not to suggest a cause and effect relationship, but some major Conceptualists, when pressed, have admitted that Fluxus did constitute a protoconceptual movement. Fluxus, in many ways, borrowed from "concept art" in a similar (though not exactly parallel) way to Conceptual Art's evolution from Pop and Minimalism.

More specifically, the ideologic underpinning of Fluxus was largely influenced by Maciunas's interpretation of Neo-Dada, as the underpinning of Conceptual Art was largely influenced by the gram-mar of Minimal Art. To progress from the materiality of "specific objects"—to borrow Judd's term from his 1965 essay—to the immater-iality of concepts seemed like a necessary maneuver, a natural and logical step.

"Concept art"—though largely misinterpreted as Fluxus—devel-oped by way of the teachings and writings of John Cage, in both his book *Silence* (1961) and his classes in Zen Buddhism at the New School

for Social Research. Many artists who later became involved with Fluxus attended these classes—among them Dick Higgins, Yoko Ono, Alison Knowles, Nam June Paik, and Allan Kaprow. Cage's understanding of the concept in art was much less Westernized than that of Henry Flynt. Flynt, after all, was a mathematician, "fresh from Harvard, who came to New York in search of a musical/artistic career." Flynt had not been schooled in the visual arts, but being a mathematician he had a close affiliation with philosophy. Reading Flynt's essays, especially his collection of writings published in 1975 and called *Blueprint for a Higher Civilization* (Milan: Multipla Edizioni), is not an easy task. The essays alternate between highly innovative and dense mathematical theory and autobiographical meanderings, letters, analyses of dreams, complex diagrams, and studies in psychology and "parascience." The book has an aesthetician's overtone; the phenomena being discussed are examined from the outside as if in the pursuit of scientific investigation. The descriptions of concepts are very dense and tightly woven. Unless one is familiar with the history of science, mathematics, and Western philosophy, the text is difficult to follow.

Flynt's exhibition (January 27–March 4, 1989) at the Emily Harvey Gallery consisted of works derived from his scientific reasoning, yet in conversation he acknowledges the separateness of his art-making activity from his investigations in science. For Flynt, art and science parallel one another, and neither should be made to illustrate the other or to perform an ancillary or secondary role.

Flynt's writings, such as his interview with the mathematician Christer Hennix entitled "Philosophy of Concept Art" (*Io* #44, edited by Charles Stein), serve to clarify his investigations, but they are not necessarily intended to explain his art.[5] The work of Henry Flynt deals with concepts more than with art. Art is only one aspect of his investigations. In the same volume there is a mathematical study called "The Apprehension of Plurality" in which Flynt examines "stroke numerals" as they relate. Here he is discussing a notational system in which a two-dimensional representation of a cubical frame is repeated as a problem solving device instead of numerals.[6] Flynt's "stroke numerals" were shown at the Emily Harvey Gallery and in some ways resemble the wall drawings and prints of Sol LeWitt. With Flynt, however, the shapes are meant to signify specific concepts; with LeWitt it is more the operation of the shapes within a morphology that defines a system.

Flynt also showed two large paintings done in the tradition of Neo-Plasticism. *Grey Planes* functions as an independent pictorial construction alluding to registers on the harmonic scale through the positioning of rectangles painted in varying tones. The other painting, called *Poem 4*, works as a component along with a diagrammatic chart on one side and a recent poem lettered directly on the wall on the other side. According to Flynt the work is a "text-construct." The composition of squares in blue, yellow, red, and green on a white field divided into four panels translates the implicit verbal meaning of a text into a series of nonobjective shapes. The poem, in turn, translates the abstraction back into verbal language. This work is reminiscent of the experiments conducted by members of the Linguistics Circle in Moscow, such as Kruchenykh and Khlebnikov, in response to paintings by Malevitch and Matuishin. Curiously, Vladimir Mayakovsky was an important figure in these early Cubo-Futurist experiments and it is the poet Mayakovsky whom Flynt hails in one of his essays as the liberator from art through its conscious destruction.

This anti-art position, once advocated by Flynt, suggested an attempt to get beyond the constraints of making art as a defined activity. One reason Flynt was so enamored of the teachings of Cage was that they offered a way out of this bind. For example, the concept of aleatory painting was directly based on the technique of aleatory composition in music developed by Cage. Flynt's initial experiment with this form was done in 1960, and a re-creation of the work was done for his 1989 show at Emily Harvey.

Flynt saw a direct, intrinsic relationship between mathematics and musical notational systems—although he addresses certain unique distinctions in his essay "Concept Art." The "chance operations" of Cage immediately appealed to Flynt, and he wanted to apply his concept of musical composition to painting. After placing a small canvas horizontally on a table, he began to apply pigment by using a set of parameters corresponding to the throw of dice or other chance procedures. Flynt did not want the performance of the work to end up like a Pollock, looking like an all-over painting. The display of the canvas under a glass vitrine was his way of allowing the viewer to arbitrarily enter the structure of this apparently non-structured work. Flynt's performances, which would also include lectures, demonstrations, and serialized fiddle playing (transformed through his use of electronic tape), were "actions" or "events" that offered parallel investigations to his more involved scientific research and writing.

Another Fluxus artist, Yoko Ono, was also involved in "concept art," but from an entirely different perspective. In her exhibition of objects and films at the Whitney Museum (February 8–April 16, 1989) Ono showed a relationship between her earlier Fluxus objects and her later bronze castings of those objects, thus maintaining the concept of the piece (in one sense) but changing the material. Ono's work represents an action performed in accordance with an idea; Flynt's, meanwhile, is an investigation enacted in relation to a concept. From a philosophical point of view a concept is a complex composition of ideas, something that is formulated according to a hypothesis, a sort of proposition that incites a method. An idea, on the other hand, is less complex, more spontaneous.

In the early sixties Yoko Ono began to have a lot of ideas, many of which would be translated into actions or events or, in some cases, objects. Her approach to art allowed Ono to work between media, in contrast to sticking to one particular medium, material, or idea. In many cases, her objects were actually artifacts or documents from a performance. For example, a piece from 1966 called *Cleaning Piece* consisted of a Plexiglas cube with a rag. Instructions were printed on the cube: "Clean it." In this case the object and the performance became inextricably bound to one another; the idea combined with the action. In her 1988 version of the same piece — testifying to the intermedia aspect of the work — the cube is cast in bronze with the same instructions.

Using a similar approach, *Apple* (1966) involved placing the actual piece of fruit on a table or pedestal and inviting members of the audience to take a bite at various intervals. In the cast bronze version, one bite is visible, but the action itself is impeded by the aestheticizing of the fruit. In the Whitney show, the bronze version was placed beside an empty Plexiglas base, suggesting that the original apple had already been consumed.

Zen was an important aspect on Ono's pre–Fluxus actions. In this regard she was closely aligned with Cage and Merce Cunningham. Fluxus artist and publisher Dick Higgins was helpful in defining the term "intermedia" as a modus operandi, a kind of synaptical leap between the idea and the action(s). The musician/composer La Monte Young was also important to Ono's career as the organizer of a series of experimental music concerts at her Chambers Street loft in 1960. Ono was a socially viable artist from the outset. Her work has always demanded audience participation. In 1968 her marriage and artistic

collaboration with pop singer John Lennon served to expand many of
her earlier ideas, including her filmmaking activities, into the realm of
mass culture. The Zen influence in her art is apparent in a small book,
Grapefruit,[7] originally published as a limited edition in 1964 and then
printed in a large edition, with additional material, by Simon and
Schuster in 1970. One piece, dated 1964, called *Water Piece* carries
below the one-word notation "water" what is possibly, along with
works of Young and George Brecht, the most reductivist work of the
Fluxus sixties. Her film *Bed-in* (1969), a collaboration with Lennon,
documents a staying-in-bed marathon that she and her late husband
did as a statement for world peace. The idea was a simple one, yet what
became interesting was the day-to-day publicity that the event at-
tracted. Its popularity in the press gave *Bed-In* a spectacle status which
seemed at odds with the Fluxus ideology from which it evolved. Even
so, the references to Zen still lingered as the perception of intimate
reality was transformed into a metaphor of yin-yang, a cosmic unity
within the structure of the mundane.

Whereas the "idea art" of Ono and the "concept art" of Flynt were
more or less tied to a Fluxus aesthetic, other Conceptual artists of the
mid-sixties were becoming increasingly involved in problems of time
and serialization in a way much more tied to the structuring found in
Minimalism. Some of these artists included On Kawara, Hanne Dar-
boven, Art & Language, Robert Barry, Sol LeWitt, and numerous
others. One of the most committed and fascinating of these serial or
systemic artists is the Polish/French artist Roman Opalka, whose most
recent New York exhibition was at John Weber (March 4–25). In 1965
Opalka began a painting project for which he outlined a set of specific
delimitations. It was to be a lifelong project. He chose a uniform-size
canvas on which he would paint numbers in sequence. Beginning with
a black surface, Opalka applied white paint in the upper left corner
and moved free-hand across the upper edge of the 77 by 53 inch sur-
face using a number 0 brush. He continued marking the numbers until
it became necessary to reapply paint to the brush. The process con-
tinued, moving from left to right across the canvas, progressing from
the upper left to the lower right corner. When he reached the lower
right corner the "detail" (as he referred to each canvas) would be com-
plete. The next "detail" would begin with the number following the
last digit placed at the lower right of the preceding canvas.

While engaging himself in this painting and counting process,
each being synonymous with the other (as well as simultaneous, in that

Opalka records his voice speaking the numbers as he is painting them), he concentrates obsessively on the procedure. He wants the art-making process to become a real-time activity, a system, to be enacted and re-enacted, day after day. At the end of each eight-hour work day Opalka photographs himself, his face only. Thus the self-portrait is also an ongoing process within the predetermined structure of moving from one to infinity. Each black and white photograph marks a work day and therefore measures the passage of time from one day to the next and from one year to the next. For an exhibition of his "details" Opalka will select one photograph to accompany each canvas, regardless of how many days or weeks the single detail may have taken to complete.

In 1969 the artist decided that he would begin reducing the black ground of his canvases by lessening the tonality by one percent. Thus by the early seventies (Opalka began exhibiting at the John Weber Gallery in 1974) it was apparent that the ground had become gray. It was also apparent that the ground of the "details" would remain gray, in gradually lightening tones, until the formula reached whiteness — which, according to Opalka, has been calculated to occur when he is in his seventies; he is now in his late fifties. What he is striving for is not white on white, but white/white. Opalka makes this distinction in order to avoid confusion in relation to the early Suprematist gestures of Malevich. White/white means, for Opalka, that the numerals painted on the white field will eventually become totally indistinguishable. It is at this point that the material aspect of the work will enter the infinite.

Although this goal sounds mystical — an attribute shared by Malevich, though on a non-systemic level — Opalka's problem is really quite literal. He is one of the most pragmatic painters working today. In his writings, however, there is a curious blend of the pragmatic effort of painting these numbers each day (or drawing numbers with ink on sheets of typing paper in the event that he is traveling) and the existential meaning and moral equivalence of the work. He sees his decision back in 1965 as a crucial one. The task of following it through within the course and duration of his life he sees as fulfilling an obligation. It is moral in the sense that he is taking complete responsibility for his action. Everything that happens in and around the task of painting these numbers is part of his existential dilemma. In an unpublished text by Opalka, entitled *Rencontré par la Séparation* (1987), he states:

I was quite struck by the potential held by this idea, even before I actually undertook its implementations; I knew the rationale and the infinite dynamics of numbers, but knowing is not quite understanding; yet, it is the reason for which all consciences live, for failing this, it would have been pointless to start and to pursue what sooner or later will have necessarily come to an end; the paradoxical reason for embarking upon my mad enterprise stems from this apparent meaninglessness.[8]

In an important text on Opalka's work written by the poet David Shapiro (John Weber Gallery, 1978), the point is made that the thought of infinity can be terrifying—"That man might be dissolved in the fluidity of infinity is necessarily the chief ornament of that concept."[9] Opalka's hyperawareness of the infinite through the daily task of moving slowly toward it finally becomes an existential act. The real-time system—to borrow a term from the critic Jack Burnham—is completely rational, yet its motivating force is completely irrational. For Opalka the completion of each "detail" is a measuring device in time—his own time and his own sense of life's duration. Each "detail" carries the compression of time as an actual document. Here the Minimal and the Conceptual are fused with the pragmatic and the existential nuances of everyday reality.

In the second section of Barthes' *Mythologies*,[10] there is an important discussion about how the linguistic order of the signifier and the signified becomes elevated into the form of a sign. The sign becomes the new basis for semiotic operation, and this new self-contained code demands interpretation in conjunction with like signs of the same order. This system of signs, in turn, forms its own hierarchy of subtextual meanings and regenerative coding systems.

The whole thrust of current revisionism in New York art has a great deal to do with the establishment of a self-contained sign system as a given order—an order that is begging for some reaction or response. Contrary to the Pluralism of the former decade, which for the most part denied any linguistic source other than its Formalist intentionality, New York art in the eighties had to regress into the origins of Modernism in order to emerge as having a hierarchy of subtextual meanings—in essence, a code which can in fact be deciphered. It would then make perfect sense that the philosophical writings of a thinker like Baudrillard would emerge to redefine deconstruction or interpretation as "reproductions without originals"—that is, as a system of floating signifiers (dematerialized signs) beyond aesthetic grasp—indeed, beyond the reach of significance!

It is interesting that with the emergence of a new "conceptual" awareness, which progressed internally within the art world during the eighties, there has come the external, more emphatic pressure of marketability. As the new avant-gardism has appropriated nearly every style available in the modernist lexicon—including Expressionism, geometric abstraction, Minimal Art, Pop Art, and Surrealism—the system of signs has been grounded firmly in place. Categories and styles have imploded so that, other than the discourse attributed to them, there is now virtually no distinction among them. What matters is the look of the object, the immediate impact of the text. Artists are asked to function, for the most part, on the level of imprints or designations.

In that the issue of style has been generally understood as being transparent, consumed by the sign system, it does not matter how closely an artist follows the imprint as long as its presence is felt somewhere in the work. Changing one's style is still acceptable, but changing one's sources or designations is not. The code requires an allegiance to the imprint, and the market requires that the code is ready-made for interpretation, even if the category or the style exists as a simulacrum, as for example in the appearance of Neo-Conceptualism.

The beginning of this year's season at the galleries brought both vestiges of Conceptual Art, including Post-Conceptualism among younger artists who have obtained the predigested, academicized version of the originals or who have invested their sources of information back into objects, more popularly understood as "commodities." These investments of ideas into commodifiable objects have been termed "commodity Conceptualism" or "Neo-Conceptualism." If one examines these two terms closely, however, one can find some necessary distinctions. But whatever the distinctions between those who invest ideas in objects and those who set up a critical relationship with objects, such as Louise Lawler, Paul McMahon, or even Komar and Melamid, the prefix of "neo" seems more generally appropriate than that of "post."

Yet there are historical problems as well. For example, all of these artists evolved their concerns during a period in the early seventies when artists such as Joseph Kosuth, Lawrence Weiner, Robert Barry, and Douglas Huebler were already being absorbed into the antitheoretical reportage of Pluralism. Paul McMahon is an interesting case in this regard. Originally from the Boston area, McMahon went

to art school in Southern California at Pomona College in the early seventies where he came in contact with John Baldessari, David Salle, Matt Mullican, and James Welling, who were at the California Institute of the Arts. He returned to the Boston area and began doing a series of weekend installations and performances at a space in Cambridge called Project, Inc. In 1975 McMahon continued to produce art of a "Post-Conceptual" style — that is, "idea" art instigating a series of "night clubs" where he played songs on his electric guitar. In his 1987 exhibition at White Columns, McMahon showed, among other things, a series of planks painted with red polka dots on a white surface. The show was well-received in the art community, which suggests; that McMahon has suddenly emerged as a Neo-Conceptualist when in fact his work emerged from a Post-Conceptualist sensibility.

Peter Downsbrough, another artist who showed at White Columns at the same time, is now in the his mid–40s and has been showing work of a Conceptual genre since the heyday of Conceptual Art in the late sixties. Downsbrough's work was at one time almost exclusively concerned with small books that carefully delineated the structure of the pages in reference to a continuously repeating double-lined mark. Eventually Downsbrough's books started to incorporate photographs and split words which carried a political commentary in reference to the dominant power structure; in other words, he too moved from the purely epistemic denotations of formal marks to a type of resemblance in which the sign carried specific qualitative references. In his recent show, Downsbrough set up a series of 13 vertical pipes from ceiling to floor in a straight line with the word "freedom" split in half on one wall. Other propositions in Downsbrough's room installation included the words "as," "is," "to" and "from." Again, Downsbrough's work is being received as Neo-Conceptualist when it has been around since even before the advent of Post-Conceptualism — that is, art narrative in structure.

So at last we arrive at the question of who is really Neo. When Brian Wallis mounted the "Damaged Goods" exhibition at the New Museum of Contemporary Art in August 1986,[11] artists such as Allan McCollum, Haim Steinbach, and Gretchen Bender appeared Conceptual but in a way quite distinct from either the first generation of Conceptualists or the Post-Conceptualists of the seventies. What distinguished these artists (Vaisman and Koons would, of course be included) was the fact that they indulged in the commodity, supposedly from a critical vantage point. Corporate glut — a concept clearly

synchronous with the eighties — became the raw material for these artists in one form or another, and corporatism suggested power.

In September 1987 another Conceptualist, Richard Ogust, came on the scene with an installation at the Postmasters Gallery. Like Downsbrough, Lawrence Weiner, and others, Ogust does books; the purpose of the show was to address "questions of reference, interpretation and the use of information which are coming up in more visual formats and by an analogous strategy." Walking into the gallery space, the viewer was confronted with a shelf of three of Ogust's books: *IBHR, IBHR-I* and *IBHR-4* (the titles are abbreviations of the International Bill of Human Rights). Further into the gallery were two curtained booths that invited the viewer-reader to stand or sit inside and read the books. For those who preferred to read in a more homogeneous or atavistic environment, there were silver spray-painted folding chairs against one wall. That was the whole of the installation, a near throwback to galleries of the late sixties.

Ogust's show, called *IBHR (ART AS TEXT AS TEXT)*, was indeed a reference to a series of sixties shows by Joseph Kosuth called *Art as Idea as Idea* in which the latter exhibited negative photostats of word definitions with references to Modernist discourse so prevalent at that time. No mention was made of Kosuth, however, in Ogust's show; nor was there any mention of the famous catalogue show organized by Seth Siegelaub under the rubric *January 5-31, 1969*, which signified the duration of the exhibition. Kosuth was included in the Siegelaub show along with Barry, Weiner, and Huebler. The works were printed in a modest catalogue, copies of which were set out on a coffee table with a sofa and reading lamp.

One could make the argument that Ogust's show was about the appropriated content in his books as taken from the documents and other sources, many of which read like the early purloined aphorisms made by Jenny Holzer and Peter Nadin as in *Eating Through Living*[12] (Tanam, 1982). While Ogust may appear Neo, given the fact that he is a "new" artist, the work itself is based on old ideas or simulationism gone stale.

All of this raises another question or series of questions that do not appear to be in the process of being solved. If the recognition of a style or an imprint from the point of view of marketability immediately legitimizes the work under scrutiny as belonging to art history, this would seem to lead to an almost instantaneous overdetermination within the new order of signs. This overdetermination would

convolute, as it always does, and impress the art world as remarkably new from the aspect of its critical potential or its intentionality. Neo and "new" art are no longer about historical advance but about publicity, sales, and the categories necessary to legitimize their entrance into the code of signs. It would seem that with the re-emergence of Conceptual Art in the New York scene we are faced with an inevitable confrontation between history and its inevitable simulacra. The problem is that the aura of fashion that promotes the simulacra makes the actuality of art historical events seem out-of-fashion or obsolete. Yet if qualitative value is to be retained in art—whether Conceptual or Formalist—the memory of these events is important. The contextualizing of art as an idea-based structure had its moment—and that moment continues to have an impact, for better or for worse. One may aspire to understand Conceptual Art—at its best—as a necessary statement capable of articulating forceful ideas in a world where invisible systems seem to prevail. This is what makes Conceptual Art significant.

Notes

Chapter I

1. Terry Atkinson et al., "Introduction," *Art-Language: The Journal of Conceptual Art,* vol. 1, no. 1 (May 1969), p. 2.

2. Marcel Duchamp, *Salt Seller* (Marchand du Sel), ed. Michel Snaiouillet and Elmer Peterson (New York: Oxford University Press, 1973), p. 123.

3. Calvin Tomkins, *The Bride and the Bachelors* (New York: Viking Press, 1965), p. 13.

4. *Ibid.,* p. 11.

5. Kenneth Coutts-Smith, *Dada* (New York: Studio Vista, 1970), p. 52.

6. Jack Burnham, "Unveiling the Consort: Part II," *Artforum* (April 1971), p. 46.

7. Duchamp, *Salt Seller,* p. 141.

8. Coutts-Smith, pp. 59–60.

9. Duchamp, pp. 26–71.

10. *Ibid.,* p. 32.

11. Octavio Paz, "The Ready-Made" in Joseph Mashek, ed., *Marcel Duchamp in Perspective,* Artists in Perspective Series (Englewood Cliffs, N.J.: Prentice-Hall, 1975), p. 88.

12. Rudi Blesh, *Modern Art U.S.A.* (New York: Alfred A. Knopf, 1956, p. 102.

13. Georges Charbonnier, "A Conversation with Claude Levi-Strauss" in Mashek, Marcel Duchamp, pp. 80–81.

14. Edmund Husserl, *Ideas,* trans. W.R. Boyce Gibson (New York: Collier, 1962), pp. 99–100.

15. Martin Heidegger, *Discourse on Thinking,* trans. John M. Anderson and E. Hans Freund (New York: Harper Colophon Books, 1966).

16. *Ibid.,* p. 69.

17. Coutts-Smith, p. 54.

18. Hans Richter, *Dada: Arts and Anti-Art* (New York: McGraw-Hill, 1966), pp. 81–100.

19. Jean-Paul Sarte, *Being and Nothingness,* trans. Hazel E. Barnes (New York: Washington Square Press, 1956), pp. 238–298.

20. Composer John Cage became interested in this idea, less from a

Lacanian or Sartrean point of view, and more connected with Oriental mysticism, Zen Buddhism, in particular. See Tomkins; pp. 69–144.

21. Arturo Schwarz, "The Alchemist Stripped Bare in the Bachelor, Even," in *Marcel Duchamp,* exhibition catalogue, ed. Anne D'Harnoncourt and Kynaston McShine (Museum of Modern Art, New York, and Philadelphia Museum of Art, 1973), p. 89.

22. Bruce Boice, "The Quality Problem," *Artforum* (October 1972), pp. 68–70.

23. Coutts-Smith, p. 53.

24. For a complete analysis of this Duchampian phrase within a theoretical and historical context, see Thierry de Duve, *Pictorial Nominalism: on Marcel Duchamp's Passage from Painting to the Ready-made,* trans. Dana Polan. Minneapolis: University of Minnesota Press, 1991.

25. Arturo Schwarz, "Marcel Duchamp: The Great Inspirer" (excerpts from *The Complete Works of Marcel Duchamp,* 3rd rev. ed.), in *Tema Celeste* #36 (Summer 1992), p. 3617.

26. John Cage, *Silence* (Cambridge, Mass.: M.I.T. Press, 1961), p. 39.

27. John Cage, ed., *Notations* (New York: Something Else Press, 1969), unnumbered.

28. D.T. Suzuki, *Zen Buddhism,* ed. William Barrett (Garden City, N.Y.: Doubleday, 1956), pp. 157–226.

29. Yasuichi Awakana, *Zen Painting* (Tokyo: Kodansha, 1970), p. 15.

30. Suzuki, pp. 186–194.

31. Cage, *Silence,* p. 176.

32. The cultural appeal of Zen Buddhism to artists and intellects in the United States during the fifties and sixties may be attributed largely to Suzuki's teachings and the writings of Alan Watts. See Alan W. Watts, *The Way of Zen* (New York: Mentor Books, 1957).

33. Michael Kirby, *The Art of Time* (New York: E.P. Dutton, 1969), p. 77.

34. Cage's influence fed directly into Happenings and Fluxus events of the early sixties with which these artists were associated. See Jackson Mac Low and La Monte Young, eds., *An Anthology of Chance Operations,* 1963; reprinted by Heiner Friedrich, 1970.

35. See Michael Kirby, "Introduction" in Happenings (New York: E.P. Dutton, 1966), pp. 9–42.

36. Allan Kaprow, *Untitled Essay and Other Works,* a Great Bear Pamphlet (New York: Something Else Press, 1967), p. 3.

37. Boice, p. 70.

38. De Maria, "Meaningless Work," in *An Anthology,* ed. Mac Low and Young, 1963.

39. Flynt, "Concept Art," in *Anthology, ibid.*

40. Sol LeWitt, "Paragraphs on Conceptual Art," *Artforum* (Summer 1967).

41. Flynt, n.p.

42. Joseph Kosuth, "Art After Philosophy, I and II," in Gregory Battcock, ed., *Idea Art* (New York: E.P. Dutton, 1973), pp. 70–101.

43. Flynt, *Anthology,* Mac Low and Young.

44. Boice, p. 70.

45. Joseph Kosuth, *Protoinvestigations and the First Investigation (1965, 1966–1968),* Leo Castelli Gallery, New York City.

46. Pierre Descargues, "Yves Klein," in *Yves Klein* (January 25–March 12, 1967); catalogue Jewish Museum, New York, pp. 15–26.

47. Yves Klein, "The Monochrome Adventure," ed. Marcelin Pleynet, trans. Lane Dunlop, in *Yves Klein, ibid.,* p. 35.

48. Descargues, p. 10.

49. Germano Celant, *Piero Manzoni* (Turin: Sonnabend, 1972), p. 8.

50. Descargues, p. 19.

51. See *Piero Manzoni* (November 8–December 1, 1990). Hirschl and Adler Modern, New York. Catalogue.

52. In the "Preface" to *Six Years: The Dematerialization of the Art Object,* Lucy Lippard states: ". . . in New York, the present gallery-money-power structure is so strong that it's going to be very difficult to find a viable alternative to it. The artists who are trying to do non-object art are introducing a drastic solution to the problem of artists being bought and sold so easily, along with their art" (New York: Praeger, 1973), p. 8.

53. Dick Higgins, *foew & ombwhnw* (New York: Something Else Press, 1969), pp. 95–125.

54. *Ibid.,* p. 123.

55. Lippard, *Six Years,* pp. 6, 258–259; also taped conversation with Peter Frank, New York City, January 2, 1978.

56. Higgins, *foew,* pp. 11–29.

57. Geoffrey Hendricks, *Between Two Points (Fra Due Poli)* (Reggio Emilia: Edizioni Pari and Dispari, 1975).

58. Geoffrey Hendricks, *Ring Piece* (New York: Something Else Press, 1973).

59. Hendricks, *Ring Piece;* also, his use of the diary is evident in a number of publications where it becomes the basis for the text and description of the performance. Much of this information is based on a taped conversation with the artist, New York City (December 29, 1977).

60. Gene Youngblood, *Expanded Cinema* (New York: E.P. Dutton, 1970), pp. 366–371. Also see Carolee Schneemann, *More Than Meat Joy: Complete Performance Works and Selected Writings,* ed. Bruce McPherson (New Paltz, N.Y.: Documentext, 1979).

61. Carolee Schneemann, taped conversation, New York, Dec. 1977.

62. *Ibid.*

63. Carolee Schneemann, *Cezanne, She Was a Great Painter* (New York: Kitch's Garden Press, 1975).

64. Lucy Lippard, *From the Center: Feminist Essays on Woman's Art* (New York: E.P. Dutton, 1976), p. 126.

65. See *Ad Reinhardt* catalogue, Museum of Contemporary Art, Los Angeles, and Museum of Modern Art, New York. New York: Rizzoli, 1992.

66. Allen Leepa, "Minimal Art and Primary Meanings," in *Minimal Art*, pp. 200–208.

67. Ad Reinhardt, "Three Statements," *Artforum* (March 1966), p. 34.

68. Seth Siegelaub, "On Exhibitions," in Gregory Battcock, ed., *Idea Art* (New York: E.P. Dutton, 1973), pp. 165–173.

69. Seth Siegelaub in conversation with Ursula Meyer, September 27, 1969, in *Conceptual Art* (New York: E.P. Dutton, 1972), p. XIV.

70. Reinhardt, "Writings," in Gregory Battcock, ed., *The New Art* (New York: E.P. Dutton, 1966), pp. 200–202.

71. Herbert Spiegelberg, *The Phenomenological Movement: A Historical Introduction*, 2d ed., Vol. I (The Hague: Martinus Nijhoff, 1969), p. 134.

72. Reinhardt, "Writings," p. 205.

73. *Ibid.*

74. Statements and commentary on each of these artists can be obtained in Battcock, ed., *Minimal Art*; the term "hard-core" was selected by this author in order to describe a particular orientation that is by no means held in isolation of other critical views.

75. Ludwig Wittgenstein, *Philosophical Investigations*, 2d ed. (London: Oxford University Press, 1963).

76. Henry Geldzahler, *New York Painting and Sculpture: 1940-1970* (New York: E.P. Dutton, 1969), p. 45.

77. The Baltimore Museum of Art, *Mel Bochner: Number and Shape* (October 5–November 28, 1976); curated with catalogue essay by Brenda Richardson, p. 21.

78. The term "romantic" was used in reference to Minimal Art by Dan Graham in a conversation with the author, New York City, June, 1976.

79. Battcock, ed., *Minimal Art.*

80. Geldzahler, p. 108.

81. Robert Morris, "Notes on Sculpture," in Battcock, ed., *Minimal Art*, pp. 222–235.

82. *Ibid.*, pp. 225–228.

83. Jack Burnham, *The Structure of Art* (New York: George Braziller, 1971), pp. 136–137.

84. This piece was initially executed at the Heiner Friedrich Gallery in Düsseldorf in 1968; the author saw a re-executed version of the piece at Heiner Friedrich's Wooster Street gallery in October, 1977, New York.

85. Molly Barnes Gallery, Los Angeles, 1969.

86. For a complete survey of Hesse's work see Lucy R. Lippard, *Eva Hesse* (New York: New York University Press, 1976).

87. See *Eva Hesse: A Retrospective*, ed. Helen A. Cooper (New Haven: Yale University Press, 1992).

88. Diane Waldman, essay, in Solomon R. Guggenheim Museum, New York, *Guggenheim International Exhibition* (1971) catalogue, pp. 16–17.

89. *Ibid.*, p. 16.

90. Harold Rosenberg, *The DeDefinition of Art* (New York: Collier, 1972), p. 59.

91. "Discussions with Heizer, Oppenheim and Smithson," *Domus* (November 1972), p. 70.

92. Lippard, *Six Years*, pp. 263–264.

93. See Germano Celant, *Arte Povera* (Milano: Mazzotta, 1969).

94. Rosenberg, p. 28.

95. The New York Cultural Center, New York City, *Conceptual Art and Conceptual Aspects* (April 10–August 25, 1970), Organized by Donald Karshan. Catalogue with statements by the artists, p. 47.

Chapter II

1. This study slightly extends the time-boundaries of Lucy Lippard's *Six Years* (London: Studio Vista, 1973) which designates the years 1966 to 1972; although indebted to Lippard for her chronology of related Conceptual Art activities, there are important works which fed directly into "Conceptual Art" prior to 1966.

2. *Ibid.*, p. 5.

3. Artists who immediately come to mind include the Art Language group, Bernar Venet, Joseph Kosuth, Agnes Denes, Donald Burgy, Christopher Cook and Douglas Huebler.

4. See taxonomy in David W. Ecker, "Teaching Art Criticism as Aesthetic Inquiry," *New York University Educational Quarterly*, vol. III, no. 4 (Summer 1972), pp. 20–26. Professor Ecker maintains that all art criticism must refer directly to the art object or event in order to justify the making of an aesthetic judgment. Therefore, if the artwork itself denotes a critical posture in relation to other works, then any criticism about it becomes "metacritical." If the artist sets forth a definitive idea about the nature of art, his statement becomes "theoretical." At the top

of the ladder, one finds a category known as "meta-theory" in which the examination of other theories about art becomes apparent. The implications of Professor Ecker's taxonomy are closely related to what many Conceptualists have attempted to put forth, particularly in relation to Kosuth and the Art and Language constituents in England.

5. The Museum of Modern Art, New York. *Information* (July 2–September 20, 1970), org. Kynaston McShine; catalogue essay, p. 141.

6. One reason for this might have been the difficulty which relatively unknown artists had at the time in securing the use of technical equipment; financially it was a problem unless the artist was sponsored through some type of art school or other educational or cultural institution. It is also significant to recall that video porto-paks did not receive popular distribution until the seventies. Film, in most cases, was too expensive for purposes of documentation, and distribution was far less likely through film than through the reproduction of still photographs. Most films made by artists were either collaborative, as with Nauman, or used less expensive 8 mm or super-8 stock. During the "Information" (MOMA, 1970), exhibition, a viewing system was designed by Ettore Sottsass, Jr., for the viewing of artists' films and videotapes. This material was limited, however, in comparison with the other types of documents available for presentation at the time. McShine makes considerable note of the importance of these "live" media in delivering "information" for public view.

7. Lippard, *Six Years*, p. 11.

8. Dan Graham, *Two Correlated Rotations* (1969). Two super-8 film loops. (Collection of the artist.)

9. *Avalanche* 6 (Fall 1972).

10. Ecker, "Aesthetic Inquiry," pp. 20–26.

11. Jack Burnham, *Beyond Modern Sculpture* (New York: George Braziller, 1968), p. 168.

12. *Ibid.*, pp. 167–168.

13. Joseph Kosuth, "Art After Philosophy" in *Art After Philosophy and After: Collected Writings, 1966–1990*, ed. by Gabriele Guercio (Cambridge, Mass.: The M.I.T. Press, 1991), pp. 13–32.

14. *Ibid.*, p. 76.

15. *Ibid.*, pp. 70–101.

16. Ursula Meyer, *Conceptual Art* (New York: E.P. Dutton, 1972), p. viii.

17. Joseph Kosuth, "Introductory Note by the American Editor," *Art-Language*, vol. 1, no. 2 (1970).

18. Kosuth, "Art After Philosophy," pp. 70–101.

19. *Ibid.*, pp. 82–83.

20. Susan Sontag, *Against Interpretation* (New York: Dell Publishing, 1969), p. 20.

21. Clive Bell, *Art* (New York: Capricorn Books, 1959).

22. Clement Greenberg, "Modernist Painting" in Gregory Battcock, *The New Art* (New York: E.P. Dutton, 1966), p. 109.

23. Michael Kirby, *The Art of Time* (New York: E.P. Dutton, 1969), p. 13.

24. *Art-Language: The Journal of Conceptual Art,* vol. 1, no. 1 (May 1969); after first issue, editors dropped the sub-title of the publication.

25. Sol LeWitt, "Sentences on Conceptual Art" in *Art-Language* (May 1969), pp. 11–13.

26. *Ibid.,* p. 11.

27. Kosuth, "Art After Philosophy."

28. Ortega y Gasset, "On Point of View in the Arts" in *The Dehumanization of Art* (Garden City, New York: Doubleday Anchor Book, 1948), pp. 119–120.

29. *Ibid.,* p. 119.

30. Edmund Husserl, *Ideas,* trans. W.R. Boyce Gibson (New York: Collier Books, 1962), pp. 99–100.

31. Edmund Husserl, *The Idea of Phenomenology,* trans. William P. Alston and George Nakhnikian (The Hague: Martinus Nijhoff, 1964), p. 15.

32. Husserl, *Ideas,* pp. 111–113.

33. *Ibid.,* p. 112.

34. *Ibid.,* pp. 112–113.

35. *Ibid.,* p. 113.

36. Husserl, *The Idea of Phenomenology,* pp. 56–57.

37. Husserl, *The Idea of Phenomenology,* pp. 52–60.

38. Two essays in which this principle follows would include Martin Heidegger's "Memorial Address" in *Discourse on Thinking,* trans. John M. Anderson and E. Hans Freund (New York: Harper Colophon Books, 1966), pp. 43–57; and Maurice Merleau-Ponty's "Cezanne's Doubt" in *Sense and Non-Sense,* Northwestern University Studies in Phenomenology and Existential Philosophy, trans. Hubert L. Dreyfus and Patricia Allen Dreyfus (Northwestern University Press, 1964), pp. 9–25.

39. Sol LeWitt, "Paragraphs on Conceptual Art," *Artforum* (Summer 1967).

40. Douglas Huebler in a conversation on tape, Truro, Massachusetts, August 15, 1976.

41. Eugene F. Kaelin, *Art and Existence: A Phenomenological Aesthetics* (Lewisburg, Pennsylvania: Bucknell University Press, 1970), pp. 82–83.

42. Sol LeWitt, *Brick Wall* (New York: Tanglewood Press, Inc., 1977).

43. Husserl, *The Idea of Phenomenology,* pp. 52–60.

44. Huebler, conversation.

45. Marcel Duchamp, "The Creative Act," in Gregory Battcock, *The New Art* (New York: E.P. Dutton, 1966), p. 25.

46. Stedelijk Museum, Amsterdam, *Robert Barry* (September 13– October 20, 1974); catalogue no. 565.

47. Van Abbemuseum Eindhoven, *Lawrence Weiner* (1976); catalogue with commentary by R.H. Fuchs; p. 6.

48. Lawrence Weiner, *Tracce/Traces* (Turin: Sperone, 1970).

49. Assuming that the basis for communication in any culture is through language signs, the exchange of ideas in relation to a designated artwork in conceptual form must still occur to sustain its function. See Victor Burgin, *Two Essays on Art Photography and Semiotics* (London: Robert Self, 1976).

50. "Documentation in Conceptual Art," *Arts Magazine* (April 1970), reprinted in Gregory Battcock, *Idea Art*, pp. 174–183. The foregoing discussion is made in reference to this issue.

51. This statement had previously appeared in the catalogue for *Konzeption/Conception* (1969) at the Museum Leverkusen, curated by Conrad Fischer and Rolf Wedewer, and it appeared in the *January 5-31, 1969* catalogue, New York.

52. Lawrence Weiner in conversation with the author, New York, June 1976.

53. Laszlo Moholy-Nagy, *Painting Photography Film* (1925). Trans. Janet Seligman in Kostelanetz, *On Innovative Art(ist)s* (Jefferson, NC: McFarland, 1992), p. 128.

54. The Baltimore Museum of Art, *Mel Bochner: Number and Shape* (October 5–November 28, 1976), org. with catalogue commentary by Brenda Richardson.

55. LeWitt, "Sentences," p. 11.

56. Battcock, *Idea Art*, p. 174.

57. Seth Siegelaub, "On Exhibitions and the World at Large," Studio International (December 1969) in Battcock, *Idea Art*, p. 168.

58. In 1970, Lucy Lippard stated: "The only sure thing is that artists will go on making art and some of that art will not always be recognized as 'art'; some of it may even be called 'politics.'" Reprinted from *Arts Magazine* (May 1970) in Battcock, *The New Art* (revised 1973), p. 154.

59. Siegelaub, *Idea Art*, pp. 167–168.

60. John Berger, *Ways of Seeing* (London: British Broadcasting Corporation and Penquin Books, 1972), pp. 7–34.

61. Lippard, *Six Years*, p. 71.

62. Quotation by Joseph Kosuth in Siegelaub, "On Exhibitions," p. 173.

63. Lippard, *Six Years*, p. 51.

64. Meyer, *Conceptual Art*, p. 133.

65. Corcoran Gallery of Art, Washington, D.C., *Agnes Denes: Perspectives* (December 6, 1974–January 7, 1975), org. by Roy Slade; catalogue essays by Slade, Lawrence Alloway, and Susan Sollins.

66. Lawrence Weiner in conversation with the author in New York City, December 1977.

67. Lawrence Weiner, *Statements* (New York: Seth Siegelaub, Louis Kellner Foundation, 1968).

68. Roland Barthes, *Mythologies*, trans. Annette Lavers (New York: Hill and Wang, 1972), p. 114.

69. Barthes, *Mythologies*, p. 114.

70. M.O.M.A., New York, *Information*, p. 141.

71. Terry Atkinson and others, "Introduction," *Art-Language*, pp. 1–10.

Chapter III

1. This issue has come to the author's attention on numerous occasions and has been the basis for a great deal of misunderstanding about "Postmodernism" in photography. Largely basing its ideas on the work and teaching of such Conceptualists as Douglas Huebler and John Baldessari, a whole generation evolved in the late 1970s and 1980s that presumed to appropriate the image from various sources in popular culture—to isolate the image from its normative context within what was presumed to be deconstructive frame. For the most part, artists like Sherrie Levine, Richard Prince, Cindy Sherman, Louise Lawler and Barbara Kruger all borrowed heavily from earlier strategies of image representation, but moved into their own venues of commentary. The cynicism embedded in much of the latter work suggested a shift in content orientation away from Conceptualism and into "Postmodernism."

2. Blaise Cendrars, *Selected Writings*, ed. Walter Albert, trans. Henry Longan Stuart (New York: New Directions, 1966), p. 241.

3. Walter Benjamin, *Illuminations*, ed. Hannah Arendt, trans. Harry Zohn (New York: Schocken Books, 1969), p. 224.

4. *Ibid.*, p. 221.

5. Ben Clements and David Rosenfield, *Photographic Composition* (Englewood Cliffs, New Jersey: Prentice-Hall, 1974).

6. Susan Sontag, *On Photography* (New York: Farrar, Straus and Giroux, 1977), p. 22.

7. Werner Haftmann, *Painting in the Twentieth Century*, Vol. I, trans. Ralph Manheim (New York: Praeger, 1965), p. 97.

8. Clement Greenberg, "Modernist Painting" in Gregory Battcock, *The New Art*, revised ed. (New York: E.P. Dutton, 1973), pp. 66–77.

9. Volker Kahmen, *Art History of Photography*, trans. Brian Tubb (New York: Viking, 1974), pp. 11–24.

10. Henry Holmes Smith, "Across the Atlantic and Out of the Woods:

Moholy-Nagy's Contribution to Photography in the United States" in Leland D. Rise and David W. Steadman, *Photographs of Moholy-Nagy* (Claremont, California: The Galleries of the Claremont Colleges, 1975), p. 14.

11. Sam Hunter, *Modern American Painting and Sculpture* (New York: Dell Publishing, 1959), pp. 41–61.

12. A.D. Coleman, "The Directoral Mode," *Artforum* (September 1976), p. 55.

13. Smith, "Across the Atlantic," p. 13.

14. Laszlo Moholy-Nagy, *Painting, Photography, Film,* trans. Janet Seligman (Cambridge, Mass.: M.I.T. Press, 1969), p. 28.

15. Sontag, *On Photography,* p. 186.

16. Center for Inter-American Relations, New York, *About 30 Works by Michael Snow* (November 15–December 31, 1972), org. The National Gallery of Canada, Ottawa; catalogue, pp. 15–17.

17. Douglas Huebler, taped conversation, Truro, Massachusetts, August 15, 1976.

18. Michael Kirby, *The Art of Time* (New York: E.P. Dutton, 1969), pp. 217–223.

19. Lippard, *Six Years,* p. 143.

20. An interview with Smithson in *Domus* (November 1972) reveals the sculptor's concerns with photographs. Also, see Robert Hobbs, "Smithson's Unresolvable Diabetics," in *Robert Smithson: Sculpture* (Ithaca, N.Y.: Cornell University Press, 1981); pp. 19–30.

21. Maurice Merleau-Ponty, *Sense and Non-Sense,* trans. Hubert L. Dreyfus and Elizabeth Allen Dreyfus (Chicago: Northwestern University Press, 1964), p. 51.

22. Dan Graham, "Photographs," in Gregory Battcock, *Minimal Art* (New York: E.P. Dutton, 1968), pp. 175–179.

23. What may seem paradoxical to the general intent of Conceptual Art is the emphasis on "seeing." This term is phenomenological, however, and plays an important role in the thinking of Merleau-Ponty as noted in *The Phenomenology of Perception,* trans. James M. Edie (Chicago: Northwestern University Press, 1964).

24. The presentation of documents in Conceptual artworks allows "conceptualization" to occur in the mind of the viewer/receiver whereupon the form of the piece is reconstructed. The photographs of Douglas Huebler would be a classic example.

25. Thorton, conversation, September 26, 1976.

26. Meyer, *Conceptual Art,* p. 34.

27. An example would be Vito Acconci's shift from his earlier conceptual activities, using the camera (1968–1969), to his more explicit body works for which he recorded on film and later videotape. See *Avalanche* (Fall 1972).

28. Klaus Honnef, "Douglas Huebler" (*Art and Artists*, January 1973), pp. 22–25.

29. Christopher Cook, "Afterword," in Museum of Fine Arts, Boston, *Douglas Huebler*, org. Christopher Cook in association with Institute of Contemporary Art, Boston, 1972; catalogue.

30. This work, *Variable Piece No. 70 (in Process)*, *Global* has been the structural basis for most of Huebler's conceptual mythological narratives throughout the seventies and eighties.

31. Huebler, taped conversation, August 15, 1976.

32. "Discussions with Heizer, Oppenheim and Smithson," *Domus* (November 1972), p. 70.

33. John Weber Gallery, New York City, *Cayuga Salt Mine Project* (May 1976); reconstructed from exhibition at the White Art Museum (February 1969), org. Tom Leavitt; notes.

34. Smithson, *Domus*, p. 70.

35. See Lawrence Alloway, "Sites/Nonsites" in Hobbs, *Robert Smithson: Sculpture* (Ithaca: Cornell University Press, 1981), pp. 41–46.

36. Smithson, *Domus*, p. 55.

37. Edmund Husserl, *Ideas*, trans. W.R. Boyce Gibson, German ed., 1913 (New York: Collier Books, 1962), p. 133.

38. Smithson, *Domus*, p. 162.

39. Lippard, *Six Years*, p. 258.

40. *Ibid.*

41. P.D. Ouspensky, *In Search of the Miraculous* (New York: Harcourt, Brace and World, 1949), p. 27.

42. Allen Leepa, "Minimal Art and Primary Meanings" in Battcock, *Minimal Art*, pp. 200–208.

43. Sol LeWitt, lecture, Museum of Modern Art, New York (February 11, 1978).

44. Sol LeWitt, conversation, New York City, June 14, 1976.

45. Museum of Modern Art, New York, *Sol LeWitt Retrospective* (February–April, 1978); catalogue.

46. David L. Shirey, "Impossible Art," *Art in America* (May-June 1969), p. 42.

47. Lucy R. Lippard, *Changing* (New York: E.P. Dutton, 1971), p. 162.

48. Sol LeWitt, *Incomplete Open Cubes* (New York: John Weber Gallery, 1974).

49. Edmund Husserl, *The Idea of Phenomenology*, trans. William P. Alston and George Nakhnikian (The Hague: Martinus Nijhoff, 1964), p. 50.

50. Rosa Esman Gallery, New York City, *Photonotations* (May 1976).

51. Sol LeWitt, *Photo-Grids* (New York: Paul David Press and Rizzoli, 1977).

52. Kahmen, *Photography*, pp. 13–24.

53. Sol LeWitt, *Cock Fight Dance* (New York: Rizzoli and Multiples, 1980).

54. *The Xerox Book* (New York: Jack Wendler and Seth Siegelaub, 1968).

55. Franz Erhard Walther, "First Workset" in *Avalanche* (Spring 1972); and Allan Kaprow, taped interview, Pasadena, California, July 22, 1976.

56. Kaprow, interview, July 22, 1976.

57. Allan Kaprow, *Routine* (no place of pub., 1973).

58. Allan Kaprow, *Echo-Logy* (New York: D'Arc Press, 1975).

59. Kaprow, interview (July 22, 1976).

60. Ed Ruscha, taped interview, Los Angeles, California, July 23, 1976.

61. *Ibid.*

62. Ed Ruscha, *Various Small Fires and Milk* (Los Angeles, self-published, 1964).

63. Ruscha, interview (July 23, 1976). Since this interview it is fair to point out that the artist has apparently changed his mind. In 1991 the Robert Miller Gallery in New York exhibited a series of *prints* from the 1962 publication *Twenty-Six Gasoline Stations*, obviously with the permission of the artist.

64. Ed Ruscha, *Colored People* (Los Angeles: self-published, 1972).

65. Ed Ruscha, *Twenty-Six Gasoline Stations* (Los Angeles: self-published, 1962).

66. Ed Ruscha, *Nine Swimming Pools and a Broken Glass* (Los Angeles: self-published, 1968; 2d ed., 1976).

67. Ruscha, interview (July 23, 1976).

68. The New York Cultural Center, New York City, *Conceptual Art and Conceptual Aspects* (April 10–August 25, 1970); org. Donald Karshan; catalogue, pp. 1–2.

69. See Jan Dibbets. Essays by R.H. Fuchs, M.M.M. Vos, and Martin Friedman. Walker Art Center, Minneapolis, 1987.

70. This idea has been driven into the ground by Formalist and Modernist painters; hence, the author's speculation as to Dibbet's use of irony.

71. Husserl, *Ideas*, p. 124.

72. *Ibid.*, p. 127.

73. Wilson's major contribution to Conceptual Art was his conversations or oral communication in which the exchange of language determines the object. See Meyer, pp. 220–221.

74. Victor Burgin, *The End of Art Theory* (Atlantic Highland, New Jersey: Humanities Press International, 1986).

75. Victor Burgin, *Between* (London: Basil Blackwell and the ICA, 1986).

76. Victor Burgin, "Situational Aesthetics," in *Guggenheim International Exhibition,* New York (1971). Catalogue statement, p. 21.

77. Lippard, *Six Years,* p. 65.

78. Burgin, "Situational Aesthetics," p. 21.

79. Alice Aycock, "Four 36-38 Exposures," *Avalanche* (Spring 1972), pp. 28–31. Quotations by the artists are taken from the accompanying text.

80. Eadweard Muybridge, *The Male and Female Figure in Motion* (New York: Dover Publications, 1984).

81. Joan Murray, "Photographs in Sequence," *Artweek* (October 4, 1975), p. 13.

82. John Baldessari, taped interview, Santa Monica, California, July 23, 1976. He was briefly associated with a group of artists at the John Gibson Gallery in the mid-1970s, including Peter Hutchinson, Bill Beckley, Mac Adams, Jean LeGac, Dan Graham, and Dennis Oppenheim.

83. See essay by Jane Livington in *William Wegman,* Los Angeles County Museum of Art (May 22–July 1, 1973). Catalogue.

Chapter IV

1. See Dan Graham, *For Publication* (Los Angeles: Otis Art Institute, 1975) and *Vito Acconci, A Retrospective: 1969–1980* (Museum of Contemporary Art, Chicago, March 21–May 18, 1980); catalogue essay by Judith Russi Kushner.

2. "Yvonne Rainer," *Avalanche* (Summer 1972); pp. 46–59.

3. Robert Pincus-Witten, *Theatre of the Conceptual: Autobiography and Myth in Postminimalism* (New York: Out of London Press, 1977); pp. 186–198.

4. Allen Kaprow, "The Education of the Un-Artist, Part I" in Gregory Battcock, ed., *New Ideas in Art Education* (New York: E.P. Dutton, 1973), pp. 73–90.

5. Allan Kaprow, "The Happenings Are Dead—Long Live the Happenings!" *Artforum,* vol. 4 (March 1966), pp. 36–39.

6. *Ibid.* (quotation from article, 1961), p. 38.

7. Pierre Descargues, "Yves Klein," in The Jewish Museum, New York City, *Yves Klein* (January 25–March 12, 1967); catalogue, p. 20.

8. *Ibid.,* p. 21.

9. *Ibid.,* p. 19.

10. Duchamp entered into several agreements with peers and collectors concerning the "readymades." Some of these included his sister and her husband Jean Crotti; Man Ray; and Walter Arensberg.

11. Benjamin, *Illuminations,* pp. 223–224.

12. Descargues, "Klein," p. 19.

13. Lawrence Weiner, *Statements* (New York: Seth Siegelaub, Louis Kellner Foundation, 1968).

14. Dick Higgins and Wolf Vostell, eds., *Fantastic Architecture* (New York: Something Else Press, 1968), pp. 29–30.

15. Ernst Cassirer, *Language and Myth*, trans. Susanne K. Langer (New York: Dover, 1946), p. 25.

16. Husserl, *Idea of Phenomenology*, p. 10.

17. Stedelijk Museum, Amsterdam. *Robert Barry* (September 13–October 20, 1974); Catalogue No. 595.

18. Cook, *Huebler*.

19. Subsequently, this work incited Huebler to publish an artist's book, entitled *Secrets* (New York: Printed Matter, 1977), which he directed more specifically towards people in the art world.

20. Cook, *Huebler*.

21. Kaprow, interview, July 22, 1976.

22. *Ibid.*

23. Allan Kaprow, "Travelog," *On Site On Energy*, 1974, pp. 49–51.

24. *Ibid.*, p. 51.

25. *Ibid.*

26. Kaprow, interview, July 22, 1976.

27. Allan Kaprow, presentation, College Art Association, Washington, D.C., January 1975.

28. Dan Graham, conversation, New York City, June 17, 1976.

29. *Ibid.*

30. M.C. Richards, *Centering* (Middletown, Connecticut: Wesleyan University Press, 1962).

31. Baldessari, interview, July 23, 1976.

32. John Baldessari, *Throwing Three Balls in the Air* (Milan: Giampaolo Prearo/Galleria Toselli, 1973).

33. Baldessari, interview, 1976.

34. John Baldessari, *Throwing a Ball Once* (Irvine, California: University of California, 1975).

35. Edmund Husserl, *The Phenomenology of Internal Time-Consciousness*, ed. Martin Heidegger, trans. James S. Churchill (Bloomington: Indiana University Press, 1964), p. 60.

36. "Twelve Pictures" (The Theatre, New York; May 1969) reproduced in *Avalanche* (Fall 1972), pp. 44–45.

37. Robert Hughes, "The Decline and Fall of the Avant-Garde," *Time* (December 18, 1972), pp. 111–112.

38. "Les Levine Replies" in Battcock, *Idea Art*, pp. 194–203.

39. *Avalanche* (Fall 1972).

40. In many of Acconci's works, documents provided the sole access to the performance, including primitive video and 8mm films.

41. Vito Acconci, conversation, New York City, June 26, 1976.

42. *Avalanche* (Fall 1972), p. 2.

43. Each of these was reproduced in the special *Avalanche* issue on pages 54–55 and pages 62–63 respectively.

44. *Ibid.*, p. 62.

45. Alanna Heiss, *Dennis Oppenheim: Selected Works, 1967–90* (New York: Abrams and P.S.I. Museum, 1992). Work is illustrated on page 62.

46. This is transcribed in Marcel Duchamp, "The Creative Act," in Battcock, *The New Art* (1973), rev. ed., pp. 46–48.

47. Germano Celant, *Piero Manzoni* (Turin: Sonnabend, 1975), p. 5.

48. Rosemarie Castoro, conversation, New York, November 6, 1976.

49. Leo Castelli Gallery, New York City, *Bruce Nauman* (January 27–February 17, 1968); catalogue. Also see *Bruce Nauman: Drawings, 1965–1986*, Museum für Gegenwartskunst, Basel, 1986.

50. During the seventies Nauman films and tapes were available through Castelli-Sonnabend Videotapes and Films, New York City.

51. Lucie-Smith, *Modern*, pp. 270–271.

52. David Ross, "The Personal Attitude," in Ira Schneider and Beryl Korot, *Video Art* (New York: HBJ, 1976), pp. 252–267.

53. Willoughby Sharp, "Videoperformance," in Schneider and Korot, pp. 252–267.

54. Meyer, pp. 172–173.

55. Beuys' work was not exhibited in the United States until 1972—and not in New York, but Boston's Harcus-Krakow Gallery; this choice was in protest of America's involvement in the Vietnam War.

56. Lucie-Smith, pp. 272–273.

57. Museum of Modern Art, New York City. *Drawing Now* (1976); org. with text by Bernice Rose; catalogue, p. 16.

58. Both magazines came out of New York; Willoughby Sharp and Liza Bear published *Avalanche*; Walter Robinson and Edit DeAk published *Art-Rite*.

59. *Avalanche Newspaper* (May 1974), p. 7.

60. Rose, *Drawing Now*, p. 19.

61. Walter Robinson, "The Chorus Line," *Art-Rite* #10 (Fall 1975).

62. Lucie-Smith, pp. 269–270.

63. Hughes, "Avant-Garde," *Time* (December 18, 1972).

64. *Art-Rite* #10 (Fall 1975).

65. "Yvonne Rainer," *Avalanche* (Summer 1972), p. 54.

66. *Ibid.*, p. 55.

67. "Howard Fried," *Art and Artists* (January 1973), pp. 26–31.

68. *Flash Art* (28–29), (December 1971-January 1972), p. 8.

69. Howard Fried, interview, San Francisco, California, July 1976.

Chapter V

1. See Joseph Kosuth, "Art After Philosophy," in *Art After Philosophy and After: Collected Writing 1966-1990*. Edited by Gabrielle Guercio (Cambridge, Mass.: The M.I.T. Press, 1991), pp. 13-32.

2. Joseph Kosuth, "1975," *The Fox* 2 (1975), p. 94.

3. Kosuth, *Protoinvestigations and the First Investigation* (1965, 1966-1968); texts by M. Ramsden et al. (Leo Castelli Gallery, New York).

4. Joseph Kosuth, *The Second Investigation* (1968); texts by M. Ramsden et al.

5. *Ibid.*

6. *Ibid.*

7. Kosuth, "1975," p. 90.

8. Victor Burgin, "Socialist Formalism" in *Two Essays on Art Photography and Semiotics* (London: Robert Self, 1976), p. 18.

9. *Ibid.*, p. 24.

10. Ad Reinhardt, "Writings" in Gregory Battcock, ed. *The New Art* (New York: E.P. Dutton, 1966), p. 209.

11. Burgin, "Socialist Formalism," p. 24. The term "bourgeois culture" has perhaps a different context of meaning in Britain from in the U.S. From an American perspective, art has such minor importance in comparison with fashion, food and property that it hardly qualifies.

12. See Clement Greenberg, *Art and Culture* (Boston: Beacon Press, 1961).

13. *Ibid.*, p. 17.

14. Jon Hendricks et al., "Towards a New Humanism" in Gregory Battcock, ed. *The New Art* (New York: E.P. Dutton, 1966: rev. ed., 1973), pp. 78-83.

15. *Ibid.*, p. 79.

16. See Marshall McLuhan, *Understanding Media* (New York: The New American Library, 1964).

17. Lucy Lippard, "The Dilemma," in Battcock, *The New Art* (revised), pp. 143-154.

18. Harold Rosenberg, *Artworks and Packages* (New York: A Delta Book, 1969), p. 127.

19. Jack Burnham, "Real Time Systems," *Artforum* (September 1969), pp. 49-55.

20. *Ibid.*

21. Douglas Huebler, taped conversation, Truro, Mass. August 15, 1976. Huebler studied of Zen Buddhism for several years. Although Huebler attests to the "suspension of the visual element" in his work, he relies heavily upon the camera as a "recording device" in order to document the activity designated by a particular language construct.

22. Museum of Fine Arts, Boston, *Douglas Huebler,* org. by Christopher Cook in association with the Institute of Contemporary Art, Boston (1972); catalogue. Statement on inside cover.

23. Sol LeWitt, "Paragraphs on Conceptual Art," *Artforum* (Summer 1967).

24. Betite Vinklers, "Hans Haacke," *Art International* Vol. XIII, no. 7 (September 1969), pp. 46–47.

25. Vinklers, "Haacke," pp. 44–47.

26. See Brian Wallis, ed., *Hans Haacke: Unfinished Business.* Cambridge, Mass.: The M.I.T. Press and New York: The New Museum of Contemporary Art. Exhibition Catalogue, Dec. 12, 1986–Feb. 15, 1987.

27. Jack Burnham, "Steps in the Formulation of Real-Time Political Art," in Hans Haacke, *Framing and Being Framed,* The Nova Scotia Series—Source Materials of the Contemporary Art, ed. Kasper Koenig (New York: New York University, The Press of the Nova Scotia College of Art and Design, Halifax, 1975), pp. 133–134.

28. Vinklers, "Haacke," p. 45.

29. Burnham, "Steps," p. 132.

30. Ursula Meyer, *Conceptual Art* (E.P. Dutton, 1972), p. 135.

31. Carl Andre, statement made at "Art and Class Forum," Artists Space, New York, April 9, 1976.

32. Lucy Lippard, ed. *Six Years: The Dematerialization of the Art Object* (New York: Praeger, 1973), pp. 227–229.

33. *Ibid.,* p. 229.

34. Kosuth, "1975," p. 96.

35. Dan Graham, *For Publication* (Los Angeles: Otis Institute, 1975).

36. Jean-Paul Sartre, "The Unreality of the Esthetic Object" in Matthew Lipman, ed., *Contemporary Aesthetics* (Boston: Allyn and Bacon, 1973), pp. 148–154.

37. Rudolf Baranik et al., *An Anti-Catalog* (New York: Catalog Committee of Artists Meeting for Cultural Change, 1977).

38. The author has designated 1972 as the year in which three distinct sectors became apparent, all stemming from Conceptual Art; although Lippard designates her *Six Years* as 1966 to 1972, she does not include 1972; however, the retrospective of Douglas Huebler's Conceptual work in 1972 at a major museum (Museum of Fine Arts, Boston) was a significant event in terms of aligning the reality of Conceptual Art to the rest of the art establishment; Kosuth's *Investigations* were still actively in progress; also, Meyer's book *Conceptual Art,* published in 1972, announced most of the major artists working in this genre.

39. The Art and Language group has been particularly influential in this regard; the American constituency, led by Kosuth and Ramsden, published *The Fox* in 1974; Lawrence Weiner has indicated that he follows

an American hybrid of Marxism (conversation, New York, June 1976), and Kosuth as well ("1975," *The Fox* 2).

40. See Ira Schneider and Beryl Korot, eds., *Video Art* (New York: Harcourt, Brace, Jovanovich, 1976).

41. Castelli-Sonnabend Galleries, The Kitchen Center for Video and New Music, The Institute for Art and Urban Resources, P.S.1 have all been active in presenting "installations" since 1971. Other Conceptualists would include Kosuth, Weiner, Oppenheim, and Acconci.

42. Reindeer Werk, "The Last text; Some notes on Behavioralism," *Art Communication Edition*, no. 4 (1977).

43. Lippard, "Making Up: Role-Playing and Transformation in Women's Art" in *From the Center* (New York: E.P. Dutton, 1976), pp. 101–108.

44. Meyer, pp. 144–149.

45. Lippard, "Postface," in *Six Years*, p. 263.

46. Husserl, *The Idea of Phenomenology*, trans. Alston and Nahhnikian (The Hague: Martinus Nijhoff, 1964).

47. John Dewey, *Art as Experience* (New York: G.P. Putnam, Capricorn Books, 1934), p. 19.

48. Max Kozloff, "The Trouble with Art as Idea," *Artforum* (September 1972); pp. 33–37.

Chapter VI

1. Lucy Lippard and John Chandler, "The Dematerialization of Art," *Art International* Vol. XII, No. 8 (February 1968), pp. 31–38.

2. Sol LeWitt, "Paragraphs," *Artforum* (Summer 1967).

3. Kosuth, "Art After Philosophy, Part II," Cambridge, Mass.: M.I.T. Press, 1991.

4. Flynt, "Concept Art," *An Anthology*, 1963.

5. Flynt and Hennix, "Philosophy of Concept Art," *Io* #41 (ed. Charles Stein), 1989; pp. 155–182.

6. Flynt, "The Apprehension of Plurality," *Io* #41 (ed. Charles Stein), 1989; pp. 191–228.

7. Yoko Ono, *Grapefruit* (New York: Simon and Schuster, 1964, 1970).

8. Roman Opalka, "Rencoutré par la Separation," (unpublished manuscript), 1987.

9. David Shapiro, *Roman Opalka*. (New York: John Weber Gallery, 1978).

10. Barthes, *Mythologies*, op. cit., 1957.

11. Brian Wallis, ed. *Damaged Goods*, New York: The New Museum of Contemporary Art (June 21-August 1986), Exhibition catalogue.

12. Peter Nadin and Jenny Holzer, *Eating Through Living* (New York: Tanam Press, 1981).

Appendices

A. *Interview with Hans Haacke*

(December 28, 1979)

Robert Morgan: Is it possible to hold a non-ideological position and work within the context of political art?

Hans Haacke: Before we talk about that I think it is necessary to clarify the term "ideological."

I personally don't use it in the normal Marxist sense, where ideology is a set of beliefs and practices that covers up the real situation and constitutes "false consciousness," although, no doubt, this is indeed what ideology often does. When I use the term I merely mean — without judgment — that system of beliefs, goals, assumptions, aspirations that determine how society and we ourselves shape our lives. I do not assume that there is such a thing as "correct consciousness." For that to exist would require an ability to view the world from the outside, unconstrained by historical contingencies. It would be a bit like playing God. Back to your question, obviously, there is no non-ideological position.

Non-ideological art is therefore an impossibility.

It is impossible, because we are all working with what we have learned and what we have internalized as unquestioned assumptions about the world. There is no objective position.

I guess I was thinking in terms of the institutional use of the term today. The fact that experience is subjugated to an institutional framework which neutralizes personal experience.

Of course, I also mean the experience one has with and through institutions; the family, school, religion, the press, government, the art world, etc., unavoidably they are all ideological agents. The personal

Originally published in Real Life Magazine #13 *(Autumn 1984).*

is to a considerable degree affected by what is believed by the group one happens to belong to. It is not really that personal at all.

So would a non-ideological position be the same as an a-political position?
There is no non-ideological position! Those who would like to exempt themselves from politics, or who in normal parlance are a-political, nevertheless act politically. Abstentions also affect the outcome of a vote or, for that matter, leave a power vacuum that is filled immediately by the bully on the block.

There are simply those who are more aware of their political maneuvers. Perhaps we can say that some artists are more tuned in to ideology in terms of their work.
That is true. Some deliberately work with it. Others are not aware of it. However, unwillingly or not, their ideology also transpires in their work and affects the ideological climate of the consciousness industry.

"Conceptual Art" was a popular term back in the late sixties, do you in any sense consider yourself a Conceptual artist now, in the eighties, or would you prefer not to carry that with you now?
"Conceptual Art" is a heavily burdened term. It has so many interpretations. I never presented myself as a Conceptual artist. For that matter, I didn't present myself as anything. It is other people who sometimes call me a Conceptual artist or pin all sorts of other labels on my work. And I resent this because it often associates me with things with which I don't have much in common. It can distract from viewing my work on its own terms.
I may happen to use language more than artists who are not likely to be called Conceptual, but I don't think this is such a significant feature. What might be significant is a sense of rationality — for example, I detect a rational approach in Sol LeWitt's work. I like that a lot — no mystification. But Sol's work, even though he coined the term "Conceptual Art," is not typical of the artists who are usually grouped under that label.

I see. Greenberg talks about rational self-criticism as the basis for Modernism. That seems to be quite different from the kind of rational approach that you're involved in.

I don't really know what he means when he uses the term "rational." Generally I find his theories very irrational. I have no patience with the mystification of purported disinterestedness. Art making is just another part of the consciousness industry that reflects the time in which it occurs, and the ideological persuasions and mundane constraints put on the work force.

Often the economic and political concerns that you're involved with don't enter into art critical discourse. Some artists willfully deny this kind of reflective activity as part of the aesthetic process in which they're involved. But you're using economic and political systems as a basis for the content in your work. And because of your position as an artist, you're seeing these systems quite differently from those who are actually embedded within the corporation hierarchies.

Obviously I'm not so much interested in the bottom line that the corporation reports to its shareholders. I'm more interested in how the corporation functions in contemporary society and what consequences this has for all of us. Multinationals in particular shape, to a great extent, the way we live and perceive the world. They are quite successful in their campaign of persuasion.

The explicit use of language—do you feel that it is necessary in the identification of political art?

I don't know if it is necessary, but for me it has been quite handy because I found that complex social situations are very difficult to lay bare in purely visual terms—through imagery alone.

By explicit use of language, what I'm getting at is the literal use of language as opposed to maybe something metaphorical. I don't believe that your work deals with metaphorical language so much.

No, not much. But I hope it is thereby strengthened in terms of accessibility and clarity. Metaphoric language can be so ambiguous that it interferes with communication. When that occurs the text becomes a playground for interpretation. Of course, this is a favorite ploy for the building of myths and the laundering of crypto-fascist ideas.

Does the language become more formal in such instances?

No. It allows you to wallow in the language and to forget about its implications. However that does not mean that I'm proposing a dry,

annual report type of thing. That would be boring as hell. I also don't want to be understood as saying that metaphor is an absolute no-no, or that ambiguity is in all cases to be avoided.

You have said that the earlier works, such as the condensation pieces and the aerodynamics pieces, were not involved with formal problems, but were rather concerned with natural cause and effect relationships. Has that position changed since those earlier years?

No, I don't think it has changed. The form I choose is derived directly from the job it is supposed to perform. So, if I deal with corporate policy, for instance, I try to emulate the corporate look. I do not only quote the words of corporations, I also quote the visual presentation with which they approach the public. I appropriate styles, I don't create them. And I hope that that also helps to reveal the mechanics of appropriated styles.

The formality is implicit to the actual structure that you're dealing with. You're not imposing anything from the art world upon it.

I'm not interested in discussions about the edge of a painting, or if it should be a floor piece, a hanging piece, or this or that. I choose what is appropriate for a particular job. It was the same with physical and biological things I was working with before. It had to come out of the peculiar characteristics of the phenomena.

In the art world right now there are very different points of view about the use of photography. There is Ansel Adams who had a big retrospective at MoMA, and then there are people like Victor Burgin or Conrad Atkinson, who use the photograph in a much different way. What is your relationship to photography? I know you've used photographs.

Wherever the medium of photography is useful for a particular task, I use it. If another medium is more suitable, I use that. For instance, I would not exclude painting with brush and paint, if that seemed the best means for getting a certain message across. I believe very much that materials and the modes of representation — photography, painting, print processes, etc. — can all act as signifiers.

In the Aesthetic Dimension, a book that came out shortly before his death, Herbert Marcuse argues that the mere existence of art in a society is evidence that a dialectic is in progress between the individual and the state. This further implies that the ideological

content of art is a more implicit undertaking than it is an explicit form of production. Marcuse is interested in establishing the viability of the creative arts within the context of society. But apparently he forgot about the way in which art can be used in advertising, for example, or stored away in warehouses for investment purposes.

He probably forgot about tax shelters also.

Probably. What do you think, can art change the ideology of the state?

When it comes to art Marcuse is an idealist like Marx. The arts as such are seen as something good, like motherhood, and therefore deserve to be sponsored, no matter by whom. If you are really interested in changing the way people look at society, and how they organize their relations, I think art as such needs to be questioned. One has to examine carefully whose interests are promoted, implicitly or explicitly, by particular kinds of art. I'm a little wary of any kind of general love of art.

So you would not agree that the mere existence of art is capable of inciting praxis at some point?

It certainly doesn't do that. Art can solidify the *status quo* in a given society, or it can help shake it up. Wherever art is controlled by governmental or other institutions like the church or business, it serves to bolster the powers that be. I cannot believe that Marcuse thought that the mere existence of, say, the blood and earth art under Hitler promoted the kind of social change that Marcuse was looking for.

Things become more clouded when we talk about non-dictatorial circumstances. In this country, for instance, we generally do not feel any censorship, any direction from above. But it is quite clear that certain products of the consciousness industry are promoted and get big exposure, while others are not. This occurs without any well planned conspiracy, or a minister of propaganda setting switches. One should inquire though, whose ideas about social relations are boosted and whose are left out, and what reasons lie behind this selection. Increasingly the need of art institutions to receive corporate funds in order to stay afloat will set limits of a particular kind. Irving Kristol, the neo-conservative Godfather, and his followers, are getting through to their friends in big business that they better get busy to shape the public's perception of the world. Mobil's culture campaign is a prototypical example.

Ideological control in a non-dictatorial society has to be subtle. Punishment for deviant behaviour is relatively mild, that is, it is restricted to economic sanctions and difficulty reaching audiences, but nevertheless it seems to guarantee a high degree of conformity within a given range. People adjust more out of instinct than under pressure. Nobody wants to be a loser.

What do you think of the term "Postmodernism" as it applies to the visual arts? What do you think it represents?

I really don't know. Labels like this mean so little. I have a hard time understanding what distinguishes Modernism, so I really don't know what Postmodernism means. I don't care either. Labels are good for packaging but absolutely unsuitable for an intelligent analysis of the works under discussion.

Then what is the criteria for political art given its non-aesthetic base?

That's a hard one. When all is said and done, it probably boils down to intelligence, like with purportedly non-political art.

It would seem to me that a relationship with the academic structure is very important to somebody involved with political art.

For me it's extremely useful. My type of work obviously doesn't sell well. Right from the beginning, before I even got into political things, I determined that I should never strive to live off the sale of my work. That would make me dependent upon the market. So there had to be another source of income. Teaching seems to be the most convenient, and I do enjoy it, it's not a burden.

I do too. I can sympathize with that. Where do you see the audience for political art?

My audience is predominantly the same audience as that for supposedly non-political art.

Is that effective in terms of your goals, what you're trying to achieve?

Well, there's a sort of division of labor. Some people address other audiences, say union members, minority groups, straphangers on the subway, or whatever it may be. That is fine, I don't quarrel with that. I personally feel more comfortable in the established art world. I grew up there, I know the people, I know how it functions, I know its sore points. I believe the public of the art world — sociologically speaking —

is to a considerable degree identical with the segment of society that makes the decisions today, that determines what we think. If one has a bit of influence there, it might be of some importance.

People that are attracted to art are obviously involved in these other concerns. Art becomes a vehicle to get the point across, if I'm understanding you correctly.

Yes, absolutely. In a way my opponents in this game have understood this for some time. The funding of cultural programs by big corporations is done with this express understanding. Political problems for big business do not come from the left in this country, for here the left is nonexistent as far as political effectiveness goes. Trouble comes primarily from the liberal end of the political spectrum. So business has to convince these troublesome liberals that corporations are not out to exploit, but that they, in fact, stand for a clean environment, for health, good citizenship, peace in the world, etc. One way of doing that is by associating the company name with cultural programs. I'm dealing with the same public the corporation is trying to reach. My assessment of the situation is pretty similar to theirs. It's just that we have opposite points of view.

A curious phenomenon occurred as a result of the recession of the seventies. Around 1973 several galleries began closing in New York, Los Angeles and San Francisco, because they couldn't sustain themselves. People weren't buying art. This happened during the first oil crisis, when oil doubled in price. In any case people weren't buying art like they had in the sixties, and this put a lot of Conceptual artists in real trouble. In response some of them began to make more elaborate documents, relics and other artifacts for sale. Objects and images were produced with a much stronger visual appeal. Is it possible that a highly experimental art form like Conceptual Art needs a certain economic climate in order to survive? After all, if this proves to be the case, we are faced with a contradiction—an art form that emphasizes a political position by being against the commodity fetish approach to the art work that can only thrive during an upswing in the capitalist cycle?

I don't quite subscribe to your description of the history. I think the material artifacts coming from Conceptual artists preceded the recession by a number of years. You could buy Joseph Kosuth's definitions quite early on.

No question about that. But at the outset there was a movement away

from the material object towards a more reduced, ephemeral state-
ment. Photographs by artists appeared everywhere, photographs
which documented performances and installations that very few peo-
ple had actually witnessed. These were relatively inexpensive, throw-
away things that took on an importance by being referential signifiers
of a sort. Then all of a sudden the documents became more objec-
tified, more decorative, more visually appealing, and more concerned
with material. I began to see this shift of thinking around 1972. I felt
there was a parallel between what was happening in the economic
sphere and how economics was affecting galleries and how galleries,
in turn, had a certain impact upon artists in terms of the kind of work
they chose.

I don't believe it had such a close relationship to the economy of
the country. I think it had more to do with the economic situation of
the individual artist. Obviously, if you produce art it costs some
money, and you also have to live. If you don't have an independent in-
come, you are always looking for some way to make money. So these
artists, like everybody else, irrespective of the prosperity or decline of
the national economy, had an interest in eventually selling work.

I can agree with that, but wouldn't you also agree that part of the effec-
tiveness of Conceptualism back in the late sixties was that it rejected
the necessity of the material object as a support system for the concept
of art?

It rejected the material object, yes. But I think the claims made
for non-collectibility were not always genuine. It certainly had an ex-
otic appeal among followers of the art world, because it contradicted
the way people normally act. But then the market in relics blossomed.

Let's talk more specifically about presentation. How do you feel about
your own work in terms of presentation? The Good Will Umbrella,
shown at the John Weber Gallery in 1977, struck me as being in-
credibly visual. I remember walking into the space and just getting this
visual flash of Mobil logos running down the wall. I felt it was very
effective, just as an installation, like a piece of good advertising. I felt
the flash before I got into the content of the piece. I didn't feel you
were trying to disregard the visual apparatus, or to downplay its
impact.

No, I'm not against visual appeal at all. I'm very fond of Bertolt
Brecht, who said, in 1932, in an essay about the radio, that one has to

represent interests in an interesting way. People should enjoy going to
the theater or looking at visual art. Otherwise one loses the audience.
I'm not an asensual person myself. I also like to get pleasure out of it,
I'm part of the audience.

Your work appears to have very little division between the interior and
the exterior components. Simply looking at the Mobil piece or the
more recent Tiffany piece was a real lead-in to the substance of the
work.

Since reading the entire text could have been very tedious I did
not adopt the standard "conceptual" mannerism, typewritten pages on
the wall. That would have been absolutely devastating. For me, like
other people, it is quite painful to read off a wall, particularly if it is in
small print. So I deliberately printed the panels very large. The form
was inviting, and it alluded to Mobil gas station signs — therefore, the
printing on plastic, the round corners, the quoting of the Mobil logo.

Obviously, I work within a contradiction. Part of my message is that
art should have a use-value rather than be seen as the commodity pro-
duced by an entrepreneur. But in order to publicize this as well as
other ideas for mental use in the most appropriate way, one must be
able, financially to produce the work. And then one has to get it out
of the studio to the art public, which, for reasons that I explained, is
the primary audience. So one needs the commercial channels of the
established art world — the galleries, museums, magazines, etc. If the
work stayed outside this network nobody would get to see it. The
issues it raises would not be talked about, and for all practical purposes
it would not exist. It would be cut off from the communications net-
work that I'm trying to influence. So, by necessity, I'm in the contradic-
tory position of playing the game while criticizing it.

I have always felt that the gallery was a necessary component. It's not
that the gallery presents a contradiction to your intentions, but that
you're establishing that art can only really function in that context.

Obviously the context in which my works are seen is an integral
part of the material I work with. Outside of the intended context one
reads them differently and some even become meaningless.

There are artists who change the function of objects by bringing them
into the gallery. Then there are those who take objects out of the
gallery in order to change their function in the world. I think you do

both. Duchamp, of course, was one of the first — if not the first — artists
to make this kind of transition explicit in his readymades. He drew at-
tention to the fact that everyday objects could operate as signs in their
own right just as words can be elevated to this kind of question. Oc-
tavio Paz once said that an early indication of social transition is the
investigation of language by artists and writers. Language doesn't have
to have direct political connotations, but the fact that its function is
being reconsidered, this becomes political. Do you feel the current in-
vestigations of language by artists has any kind of relationship to
political praxis, and if so, is there a cause and effect relationship that
we can identify?
 I strongly believe that an unmasking of language, whether it's ver-
bal or visual, would help a great deal. All these fantastic buzz words —
"free enterprise," "deregulation," the "marketplace of ideas," "individ-
ualism," "deterrence," and so forth. They usually mean something
totally different from what a naïve listener might think. In effect they
serve to disguise the forces at work in the political arena.

Indeed they do. It would seem that the art world has its own peculiar
set of buzz words too. That being the case, who checks the signifi-
cance of political art?
 It's just the same as with any other type of art, a general consensus
of all those who are called culturally powerful — critics, artists, gallery
people, museum people, to some extent even art students and art
schools. If somebody who is perceived as producing so-called political
art gets a grant and is invited to prestigious exhibitions, that legiti-
mizes the work. But as I said, that holds for other types of art as well.

I wonder if a critic like Hilton Kramer could deal objectively with your
art?
 There are no universally accepted qualifications.

It gets back to the problem of criteria, doesn't it?
 Yes, Kramer has revealed his ideological bias quite blatantly. He
has never reviewed a show of mine. Nor have any other critics of *The
New York Times* written reviews while he has been editor of the arts
section. I must have had about half a dozen shows since he's been at
The Times. On at least one occasion this black-out was obviously
deliberate. That was when I had a show at John Weber's together with
Nancy Holt.

Is that when you showed the Tiffany piece?

Yes, and that is a piece, of course, which made fun of supply-side economics, which Kramer, as a card carrying neo-conservative, fervently supports. Kramer wrote a very favorable review of Nancy Holt's work, but did not even mention my show in the large room in the gallery. That must have been a deliberate ommission. Given his New Right bias he must loathe my stuff. Criticizing it in public, though, would give it status, and that is something he obviously does not want to give me.

Yes, indeed. So the creation of a negative social space can be a very powerful weapon.

Yes. It is probably not accidental that since my problem with the Guggenheim, not a single New York museum has invited me to show.

Is that true? What about museums in Europe?

It varies from place to place. I had a problem in Cologne. You might have heard about it—the Manet story.

What happened?

I was asked by the Wallraf-Richartz-Museum to produce a new work for an invitational group show, called *PROJEKT 74*, in celebration of the museum's centennial. I chose to present the history of ownership of a still life that played a prominent role in the museum's collection. Towards the end of the provenance I listed the biography of Herman Josef Abs, the head of the Deutsche Bank and chairman of the museum's Friend's Committee, which had donated the major part of the funds to acquire the painting for the museum. He is a very powerful person in post-war Germany—and happened to have a fantastic career during the Nazi period. Although he was not a Nazi party member he became the chief of the foreign division of the Deutsche Bank, and towards the end of the war he was on the board of over 50 companies. With only a brief interruption shortly after the war, he continued his career in banking, and began a new one in the political world of post-war Germany. He is obviously a very intelligent man. Anyhow, I listed his biography along with the biographies of the other owners of the painting. The museum couldn't stomach it, and censored the piece.

So then I showed it, at the same time as the museum show, at Paul Maenz's gallery in Cologne. We opened the same day as *PRO-*

JEKT 74. Alongside the piece, I also made my correspondence with the museum people public. One of the nuggets from this was a statement by the director that said, "The museum knows nothing about economic power, however, it knows about spiritual power." Daniel Buren, who had also been invited to take part in the big show asked me if I could give him a photo facsimile of the original piece, and during the opening he pasted the facsimile over his own stripes. So in effect it became a collage of his work and my photo-copy.

I've wondered about that. I've seen that photograph of the installation many times and I've always thought it was the original piece, a collaboration or something.

No, that's not the original. The next morning the museum director came around and had my offensive stuff pasted over. Two layers of typewriter paper were pasted over it.

Daniel had produced something that, in art historical terms, one would call a collage. Part of that collage was destroyed by the museum — an act of vandalism. Quite a scandal. Several artists pulled out of the show in protest. Daniel put up a poster next to it that read, "Art Remains Politics," which was a paraphrase of the official sub-title of the show which was, "Art Remains Art."

I had no problems with other things that I produced in Europe that referred to specific local situations. Last January I did a show in Eindhoven at the van Abbemuseum. I presented two works dealing with the Philips company. Philips is the fifth largest multi-national in the world, outside of the American multi-nationals. Their world headquarters is in Eindhoven. They are the largest private employer of the Netherlands and the main employer in Eindhoven. Almost every family has at least one member working for Philips. Both of my works were very critical of Philips' policies in South Africa and the Shah's Iran, yet there was never any hint that the museum would reject these pieces. The van Abbemuseum is a municipal museum and the show was widely covered in the press — all favorable. I also did something in Britain on British Leyland and its operations in South Africa, also in a publicly funded museum, this time in Oxford, and again, there was no problem. The difficulty I see here in the U.S. is structural. The boards of trustees of most museums in this country are predominantly composed of the segment of society that I criticize, primarily people in big business and finance. And then curators in the U.S. don't have tenure, often they don't even have a contract. They can be fired from one day

to the next. The same is true for the directors—we have seen two go from the Museum of Modern Art. So naturally curators wouldn't dream of proposing shows of extremely critical works to their board, they would be putting their job in jeopardy. So we see few challenging shows in American museums.

B. Interview
with Lawrence Weiner
(December 31, 1979)

Lawrence Weiner: I'm very angry about the decay in the art world. And I don't mean people not doing what I like.

Robert Morgan: Explain what you mean.

I don't like people using the art world as a platform for any kind of application. If art is about the relationship of human beings to objects and objects in relation to human beings, then it should all be gotten up front.

It's like the big difference between the social writing of Chomsky and that of Piaget. They're both rather decent human beings. But when Chomsky writes about contemporary affairs, he writes about them the same way Sartre does—in relation to his being what he is, a citizen as well as a professional, with no apologies. When Piaget writes about things he writes only as a professional, and so he no longer has any chance of changing anything. This is exactly the problem with most artists today, they only make art in relation to their professional lives. They bring their work into the real world only after it has been stultified. This means that nobody outside this professional grouping can look at it and say, "Ah-ha." And if art doesn't provide a point of interest to people outside, then it has no right to exist within society. It doesn't have to be a point of interest of immediate use, but does have to be a point of interest.

Then is it possible for an artist to hold a non-ideological position and yet be addressing political and social issues?

No. The whole point is that work implies an ideological commitment. Only a lunatic would do work with no ideological commitment.

Originally published in Real Life Magazine, *Winter 1983.*

The ideology can be a belief in the system. Heaven knows what the ideology could be. But the ideology is an integral part of everybody's activity, every day of their lives. If it's not an integral part of their activity every day of their lives, then I'm terribly sorry, it becomes lunacy.

The way I understand it, ideology is the projection of ideas or attitudes into an institutional framework of some type.
 Oh no, ideology is an essential basis for doing something.

How do you distinguish between an idea and an ideology?
 An idea is something that everybody has all the time.

But it can be identified.
 It can be reified, which is different from identified. The reification of an idea places the emphasis more on making this information useful for other people, rather than just for yourself or your own politics.

So if an idea can be reified, then an artist could do that without necessarily making it into an ideology.
 The minute he presents it as an artist, he presents ideology. Because we've accepted art.

But I thought culture institutionalized art.
 No, art institutionalizes itself. Art is part of the culture, so how could you say culture does something to art? Culture is not a bugaboo.

I feel that art is identified through the culture, and culture establishes a certain framework by which the art is understood. I don't feel art exists in a vacuum. I feel that culture identifies it.
 Oh, in no way does it exist in a vacuum. That doesn't mean that it doesn't exist within the context of the culture.

Well, it does exist with that context. But I'm disagreeing that it institutionalizes itself.
 It does by placing itself within the context of what we call art. But I don't consider that bad. In institutionalizing itself it changes from being art to becoming art history. History is something we learn from, art is something we use.

To be understood in retrospect — with antecedents and so forth — that becomes a form of institutionalization. Does that aid and abet the cause of art's raising of political issues?
 Isn't every issue that's raised a political issue?

If it deals with the organization of events into some meaningful form, it deals with politics. What I'm concerned about is how to identify a political art. I don't believe that art is just political. I think that artists make art political according to their own means. I don't feel that this particular form or genre has a particular, superficial appearance. I don't look at work and say, "Ah-ha, that's political." I think that there's a strong idea base for saying it's political, according to how the artist is dealing with it. I'm wondering if the idea base of such work is the same thing as carrying an ideological position. For example, Mark Tobey professed the Ba'hai faith. That would be an ideology that would infuse itself into his work, and so we can assume that all his statements have something to do with that particular ideology. Other ideologists are working with feminism, or with various hybrids of Marxism. Others, whether they know it or not, are out and out capitalists. But what about this case? Gyorgy Kepes showed me a fantastic photograph of a Sam Francis painting that had been installed in that museum by the Berlin Wall. There's a plate glass window facing onto the Wall, and the Sam Francis literally covered it. It was used as a form of covering to disguise the discomfort of the situation, so you wouldn't be bothered when you were looking at the exhibition, which was a big international show including works by Henry Moore, and the Abstract Expressionists and such. That's a manipulation of the art work for political ends. Do you think that Francis is responsible for the ideological mis-use of his painting?
 No, you can't ignore it. Sam Francis' aesthetic ideology is not at all reactionary: what it is is an acceptance of the status quo idea of art.

The acceptance of that status quo idea is, if I understand you correctly, an institutional framework he's involved in.
 It's an institutional framework he's dependent upon. So his political position, his ideological position is a passive one.

I'd like to move on to another question. Is the explicit use of language a necessary tool in the identification and production of political art?

Lawrence Weiner in his New York studio, 1976.

For me, yes. Absolutely. Besides the fact that language allows a total materialist reading, there's a *double entendre* in all language: all material terms have been converted into meaning something. When I use language, I present work that does not impose my take on things, but imposes my perception and my research on an object in a pure art context. This can be used as a metaphor for a cultural reality and a cultural placement.

I think *The Level of Water* (published in *LAICA Journal*, February-March, 1979) is a very clear example of what you're saying.
 Yes, I think so too, quite frankly. Obviously, I'm in a state right now where I am not pleased with the society. As an artist, I see there are certain clear and present dangers involved that are not being answered by art, and they should be.

What is the responsibility of the artist?
 A complete one. The artist should at all times figure out how to cover his art. That's his responsibility. I don't think that responsibility should be left with anyone else. Nor do I think that you should just decide someone is stupid if he misinterprets your art. If somebody really doesn't understand the art's placement within contemporary society, then there comes a point where you can cut off your responsibility. But if it turns out that he does understand it, only in a completely different way than you do, then you have a different kind of problem. And you're going to have to deal with it in a more responsible way than simply calling names.

As I understand metaphor, it's never a direct assimilation of something.
 Not at all, it's a representation of something, rather than an illustration.

But I think of metaphor as being like an asterisk: it expands in several directions at the same time, rather than being an equation moving from one field to another. Do you know this book by Marcuse, *Critique of Marxist Aesthetics*?
 Yes, I do.

Well, in the book Marcuse is stating that the mere existence of art in a society is evidence that a dialectic is in progress between the indi-

vidual and the state. This means he wants to endow artists with the potential of inciting praxis through their work, which implies that the ideological content in art is more an implicit undertaking than it is an explicit form of production. So Marcuse is advocating a need for artistic creativity, rather than indicating a means or recommending a means whereby works of art can be used as political tools. For example, he says nothing about the fact that artistic products are sublimated or subjected to advertising gimmicks, are placed in warehouses for investment purposes, and so on. He says little about what happens to the product—the work of art—beyond those conditions that directly encompass its creation.

But that's the mistake of Marcuse. Marcuse has a European attitude toward art. What happens to the product is absolutely explicit in its production. When you produce the product you know how it can be used. You have to then decide how you will deal with that. I don't think there is anything wrong with people speculating in art. Why not? You just have to make art that, even if locked in the basement of a bank, can still function in its time. That's one of the things about using language. I've responded to this problem about explicit and implicit ideological content in the kind of work I make. The Museum of Modern Art can acquire a piece of mine, show it for a year, and then put it in the basement. But, at the same time, the work can be shown in five or six other places. I always retain the right to be allowed to put any work of mine in any collection of work. I'll give credit to the people who bought it, but it is public art, it must remain at my disposal. And there has been no problem with that. Now, if you make a unique object the buyer, the new owner, can put it in the basement and so basically buy it out of circulation. There has been art bought off in this way because its ideological content was either paranoidly or legitimately contrary to some industrialist's beliefs.

Can you give us an example of something bought off in this way?
Let's just say it has been done often. The same thing happens in science—patents are bought up and thrown in bottom drawers. Good prices are paid for these parents, so nobody gets cheated.

It's the responsibility of the artist to deal with the society he's going to be placing his art in. If he doesn't, then he's responsible.

The issue of production is the responsibility of the artist in terms of the implicitness of the statement.

Yes, but don't you realize that there's a big error in Marcuse's standpoint in refusing to accept that within a Marxist context. My contention is that perhaps we have to accept that art has become a service industry, rather than a production industry. The reason that artists never seem to get it together when they talk in terms of their role in society is that they don't realize that they might be part of a service industry.

A service industry to the extent that it's commenting upon the political and social context?

Its content is its reason for existing, rather than its product. The content of the product is its reason for existence. Marcuse is just refusing to accept the fact that art can be made by people who are not of the dominant class. Production implies that people are put in a productive capacity, and this implies capitalization. Capitalization is another word for class within pseudo-liberal bourgeois communism.

Absolutely. But what about the statement that the mere existence of art provides a kind of dialectic with the state — that it's necessary for social praxis?

I'd have to accept that. But I genuinely think it is one of those trite, obvious things that we no longer can use. It's not saying anything, or not saying anything more than something like there's been art since cave painting. I can't find a use for such a statement. Maybe someone else can, but I can't. And Marcuse never did.

What are the criteria for political art, given its non-aesthetic base? If we can assume that political art is not dependent upon aesthetics in order for criteria to evolve...

That would be like saying that The Internationale was not dependent upon being able to be sung. You can't take the aesthetics out of art. Art is essentially the use of aesthetics, either for metaphorical purposes or for pure materialist purposes. To talk about art without talking about its aesthetics means you're not talking about art.

It's interesting that you say that because one of Kosuth's essays back in the sixties identified aesthetics as a purely Modernist concern.

Yes, but that was because he was, at the time, misinformed. He still basically remains that way as far as aesthetics and philosophy go. In most philosophy departments of any merit you will notice that

ethics and aesthetics are treated synonymously. There is no way to break apart the aesthetics of contemporary society and the ethics of contemporary society. If you do not become an academic. When you become an academic you no longer function as an artist. An artist is someone who uses the research of the academy for aesthetic presentation of some sort.

The effective survival of Conceptual Art was dependent upon a social structure that was tolerant of non-material systems of belief. It is possible that the Postmodern strategies we are seeing emerging are a result of Conceptualism's failure to generate an adequate economic base. Is this new manifestation indeed a reaction to a lack of economic support for non-material art?

That's putting it on a pretty crass level, but—and this is something that I will have to qualify as not even an opinion—from what I've heard from a lot of artists who are career-wise younger than I am, it has a lot to do with it, yes. They don't want to spend their lives getting patted on the back and having smoke blown up their asses being told how interesting and useful it is and someone turns around and makes a print from it. So yes, the Postmodern movement does seem to be a reaction to the difficult economic viability of non-material art. I wouldn't say it's impossible, because I'm surviving. In a sense the Post-modernists are reacting against what they see as a romantic position. They don't want to be romantic, they just want to be artists.

Is Postmodernism a fail safe mechanism that maintains a separation between art and political events, thus holding art in abeyance from every day affairs?

It does seem to function that way, but I don't know if that is inherent in the art or inherent in the society, or if it just worked out that way. Postmodernism implies a rejection of certain kinds of advances that artists of my generation made. When we made it clear that an artist was essentially a professional person within society who didn't do anything but make art, we broke apart a lot of dreams. I think the Post-modernists want to put those dreams together again, they have a certain respectful attitude to art that I find unfortunate.

You're saying that it is reactionary?

I think it is extremely reactionary. But it is also a phase that might be necessary for a lot of people to clear their heads. I had to work

through Abstract Expressionism as a younger artist. I *had* to work my way through certain things, so I can't say that everybody who is making what they call the new image or whatever is by necessity a reactionary person. But they are certainly reacting to the work of the generation before them, as perhaps they should. I don't like the stuff. I don't find any use for it. But I don't think it is the big bugaboo everybody thinks it is.

Happenings were seen as a very reactionary move by the Abstract Expressionists, because they were seen as non-legitimately expressionistic. Happenings allowed the audience to participate, instead of overwhelming them with the artist's emotions. The audience had to participate in order for the work to exist. That was a very important point, and a point that was to be important to us later. So maybe what I see as reactionary will have a point later.

Is there a distinction between the Conceptual Art of the late sixties and what has been called political art in recent years?
Recent political art has used some of the stylistic and structural presentations of the so-called Conceptual Art. I see it as a reasonable continuum.

Who checks the significance of political art?
The culture itself. Mondrian becomes political by virtue of Mies Van der Rohe finding use for that kind of break up of space. Mies' idea of living space doesn't work any more, but at that time it was quite an advancement to give people a clear, well-designed space within a block. That's the politicization of art. When it's used, it becomes political, that is, when it has entered the culture.

In *Critique of the Pyramid*, Octavio Paz argues that one of the first signs of a social revolution is the investigation of language in the various forms of literature and the arts. Do you agree?
I would be silly to disagree, but I wouldn't give it as much prominence as he has. That would be giving the same prominence that Saussure, Lacan, and Barthes give it. At this point that has already been shown to be not working, since they can't write anything that doesn't utilize the totally dominant structure of the French bourgeois language in order to say they don't want to utilize it. Paz says the same thing in Spanish. He utilizes a language he's not allowed to change because it's an academic language. Most of these people are full of shit

unless they write in languages like Dutch, Japanese, or American English that have no academy, that can take any change in grammar, any change in language that might be necessary. The minute these writers have to go through an academy or an academic structure, it's all bullshit, it's all placation.

That reminds me of a statement that Jean Genet made. He said that whenever he picked up his pen and tried to write in a bourgeois context, he froze. But the minute he went into the underworld he became fluid.

Yes, losing the restrictions of grammar as we know it, learning from people who don't know the language well enough to be intimidated by grammatical structure.

What is the most effective language for stating one's intentions in making a political form of art: literal, metaphorical, neither, or both.

Both. If you can't use both, then you shouldn't use language.

C. Interview with Allan Kaprow

(February 23, 1991)

Robert C. Morgan: Let's talk about your work over the last five or ten years. Let me preface that by saying that there are two kinds of areas that I've followed in your work going back 30 years or so: the more public art events, which you designated as "Happenings," and then the more intimate art events, to which Michael Kirby attributed the term "activities." And in the last decade or so some of the work you've done seems to have been more publicly oriented and some of it has been more privately oriented.

Allan Kaprow: It's fairly simply. Some of the work is publicly oriented because it derived from earlier publicly oriented work in the form of remakes. That is, environmental pieces of some early "Happenings" that indeed involved, in some transitional way, a public that was asked to be participatory and that after 1962 or 1963 was no longer a public at all but just invited participatory groups. Some of those, in fact, were very few in number compared to the larger public invited to the earlier stuff. So what you're talking about is the historicists' view of contemporary art, which is to organize lots of shows around the world based upon earlier models, which they are attempting to bring together and review in the spirit of historical research. Those are the kinds of works in a remade, highly charged present form that you have been talking about. But the private work, which is the primary concern, continues.

How do you mean, it continues? From where does it begin? What is the origin of the more private work?

I would say around late 1961 to 1962, right around there, somewhat unevenly and sort of spottily, I began to do pieces that were based upon a short text of actions that only involved a handful of

Originally published in the Journal of Contemporary Art *4:2 (1991).*

friends or students at some specific site—a site that was not marked as an art site, a ravine somewhere, or a roadway, or somebody's apartment, or the telephone, that is, the places of everyday life, not designated as sites of art. And the work itself, the action, the kind of participation, was as remote from anything artistic as the site was.

When did you begin to make this distinction between lifelike art and artlike art?

From about then. I didn't use those words then. I chose the word Happening from its normal language usage somewhat earlier for that philosophical reason, but I didn't categorize that as lifelike until much later. But in fact, looking back, that's exactly what Happening meant.

You've been very critical of work that only stays within an aesthetic purview. What is your reasoning for this?

Well, it's a love-hate criticism, of course. I shouldn't say *of course* because not everybody would know that I really am quite concerned about the art that I seem to repudiate. But it is more about the present situation than it is about past art. And to try to answer as specifically as I can, the problem with artlike art, or even doses of artlike art that still linger in lifelike art, is that it overemphasizes the discourse within art, that is, art's own present discourse as well as its historical one. Peripherentiality is loaded so much in art that the application to, the analogy to, the involvement in everyday life is very difficult. So what I am primarily interested in is the kind of activity, like the brushing of my teeth—whether associated with Happenings or not—whose reference to other art events is very, very remote, if indeed possible to make at all.

In a talk that I gave a couple of nights ago at the School of Visual Arts, I described what a friend and I did in Germany one time to do something nice for each other. And that nice event was to clean each other's kitchen floors. And so we arranged to trade keys, only it was decided that the way to do this event was going to be a little unusual. Instead of the usual mops and cleanser, we were going to use Q-tips and spit. Without going into it too deeply, what happened there was an apparently obsessive act, but one that was decided upon, not compelled. Both of us had the freedom to stop.

It was an agreement, a contract, so to speak.

Let's do something very, very unusual, while seeming to ac-
complish something rather kindly toward each other that was needed
to be done anyway.

There are certain recurring themes in your work. I remember a 1973
piece that involved fluids.

Precious bodily fluids are a humorous reference to Stanley
Kubrick's film 2001, where, as the world is about to break apart, the
general of the high command of the armed forces is bemoaning the
possible loss of his precious bodily fluids in a great soliloquy of fear.
And so this thought remained that was very, very funny, that bleeding,
spitting, urinating, and so on are all leakages of sorts, and you can at-
tribute meaning to that as you wish, be it negative, positive, or
humorous as in my case. I thought it could be very interesting to use
as a cleaning fluid that which is normally thought of as unclean.

A lot of your work has dealt with assumed prohibitions in relation to
society. This whole idea of fluids seems to be about prohibition and
perhaps relates to Andres Serrano's photographs in the kind of ranker
that has been stirred in relation to the Piss Christ image, for example.

I had never thought of the Andres Serrano thing as a connection,
but indeed it is, just as there is a connection to Kubrick's film, and
there's also a connection to much psychoanalytic literature, which I
may or may not have read. The use of an image of something that is
deemed private and sometimes, because it's part of human waste,
even offensive in Serrano's work is definitely the same as much of the
sort of things over the years that I've done myself. But one big
difference is that I don't take that activity, that reference, and make
it public as he did. Nor do I join it with sacrosanct imagery or belief
systems in such a way as to set up a conflict the way he does. My guess
is that he could have put as much piss in a show as he wanted had it
not been associated with Jesus Christ and he wouldn't have aroused
the concern that it has. So his must have been a very conscious disrup-
tive decision calculating on its shock value, and that hasn't been my
concern. While our interest may seem superficially the same, I think
that his concern is probably used up right there, that he will probably
not be concerned with bodily fluids very much, if at all, after this.

Shifting back to this thing about lifelike art, I remember an interview
you did several years ago with Kate Horsefield for the Video Data Bank

in which she asked you what you were thinking about in your work. Your very interesting response was that you were thinking about "subjective things." I know that you've written articles in *Artforum* recently that describe various kinds of intimate behavior that for the most part are totally without any kind of object orientation. It's an event, but even the event is elusive. It's difficult to define the event. It has that kind of sensibility or linguistic twist maybe that Duchamp's ready-made would have where once you take the bottle-drying rack out of its normal usage, it ceases to have that definition because objects in our culture are defined according to their use value. And once we take the use value away, then the object is suspended in a kind of alien relationship to culture. A lot of the subjective things you are dealing with are very much about suspending normal human operations in such a way that they appear or seem very alien.

Well, I think the analogy is a good one. I must have learned that sort of function of displacement from Duchamp. You reveal something and its oddness by removing it from its normal usage. But about the harder described activity of something going on in these events that I engage in or lay out . . . I don't think they're so hard to describe, it's just that they seem odd because of the way they're framed.

Well, perhaps that's what I was getting at, the whole contextual problem. But even the piece you described with the Q-tips cleaning the kitchen, you can communicate that to an audience or whoever, and people get the idea, but it seems that there is a whole experiential frame that the piece is really about.

Of course. I use those very simple kinds of points of departure simply to get going into something else. Here's an example: a colleague of mine from the music department and I decided that we had too much administrative work at the university and we would do pieces for each other. For a period of weeks we did just that, for a couple of hours each time. And they were simply exchanges of certain kinds with each other. One week I offered the following: that we would go out to a ravine at the outer edges of the campus, chaparral all over. The sun was out at that time, and the objective of our interaction was taking off on the idea of "follow a leader." We would decide by chance which one of us would follow the other one in walking through a chaparral up and down the ravine for as much time as we had. And the way we would do it was, instead of literally following one another, the one who was following would follow the shadow of the one in front,

endeavoring to step on that shadow no matter how fast and in what direction the person was walking. That meant sometimes, because the sun was high in the sky, that you would virtually step on the heels of the person in front of you. But what was interesting about it was that depending upon in which direction you went up and down and through the chaparral, your shadow would swing around, so 360 degrees of activity took place. And if you were going up the ravine and the sun was on the other side of you, it would be a much shorter shadow than if you would go down the ravine on the other side when the shadow would lengthen because of the angle on the ground. So the shadow was swinging around, shortening and lengthening, and an effort to constantly step on that as mode of following the leader resulted in some very, very humorous near-accidents that in many cases meant breaking the contact. All this time we were free to exchange conversation about anything we wanted, so we were talking about the department while trying to do that.

There was a displacement of focus going on right there; at the same time, an absurdity, which provokes the question to me right at the moment, as much as to anyone else to whom I describe this, why was I doing this sort of thing?

The relationship between language, that is, the conversation that you were having with this man about the administrative affairs in the department, and the activity sets up a kind of dissemblance. I remember, in a conversation with you a number of years ago, we got into a discussion on the theater of the absurd. You mentioned Eugene Ionesco as somebody who you really admired...

The early work.

...where, in fact, there was this kind of dissemblance of language. And many of these events would deliberately set up parameters, where there is bound to be some kind of breaking apart of expectations in terms of how we predict behavior, or how we predict the course of events. This issue of chance is very strong in your work, even though there are still fixed parameters that you're dealing with.

Well, the absurd is a way of stopping to rethink what's going on. If something seems absurd, the first question that comes up is, why is this occurring? Why have I been responsible, if I have been, for this absurdity? What am I learning from it? Now, unless I'm a professor while I'm doing this sort of thing, which I am not, I generally don't

know the answers so that it becomes an experiential rather than intellectual matter.

The one thing that you seem to have successfully overcome in your brand of performance art — I don't mean to sound disparaging at all — is a kind of overdetermination, which I think is highly problematic in much performance art. In other words, it seems as though the way you set these events up you don't end up doing what you deny, but you really take the performance to another level. You seem to avoid the academic rut of overdetermination, of overstructuring, or as Miles Davis once told me in a conversation, overarranging.

Well, you know, a lot of work nowadays tends to be illustrative of theory already written, and some of it tends to be quite consciously didactic, as if the determination is to teach somebody something. And letting that go for the moment, as far as its value is concerned, it's exactly the opposite of what I seem to find most useful, and that is to leave things open and not determine anything except the very clear form. The form is always very simple and clear. What is experienced is uncertain and unforeseeable, which is why I do it, and its point is never clear to me, even after I've done it. So that's a very, very different way of looking at the nature of our responsibility in the world.

I think that's a very significant issue in your work, and something that really needs to be dealt with more often in terms of critical responses to work. There doesn't have to be a point. There is no proof on the basis of some hypothesis. It is really the experiential dimension that reveals the form of construction. Now, that wasn't a slip of the tongue, I meant to say, form of construction because — being familiar with your work — there is a certain lexicon or vocabulary...

You're talking about a repertory of certain themes that recur and uses of those themes that recur and yet that doesn't really result in a closure.

It's the use of those kinds of things that keeps them open, or at least I try to keep them open.

Well, I think, being trained as an artist and art historian, you're very sensitive, unquestionably, to that kind of manipulation or strategy.

If you just discount the military meaning of strategy, it is a clear and conscious planning device to provide as much open uncertainty in an experience as possible, though I'm quite aware that I don't set

up situations for me or anybody else where they'll be endangered. I know enough to avoid those kinds of things without compromising the openness that, in general, I like to enhance. So you're absolutely right in seeing the lexica, so to speak, as gradually spelling itself out as a kind of kit bag of themes that recur in one way or another, certain devices that are used for bringing those in some curious displaced focus. And I was going to say at one point, when you were talking about this being in a tradition that was helped by Duchamp's displacing a found object, such as a bottle rack, from its usual context to an art context, that I don't need that kind of device because that's no longer particularly revealing, unless we jump out of the art world itself and displace certain kinds of routine and generally unnoticed human events from that condition to being unnoticed into something where I focus on them, but not, you might say, in the way that psychoanalysis or social analysis does, that is, I'm not earnest about it. I try to screw it up as much as possible. I don't point to it in the light of reason but of unreason.

This gets back to chance related to the absurd and, ultimately, to Duchamp. One thing that I credit you with is expanding contemporary aesthetics away from the purely aesthetic domain. I think this has been true right from your article "The Legacy of Jackson Pollock" (*Artnews*, 1958) down to the present. More than any other American artist, with the possible exception of Hans Haake, you have been expanding the aesthetic frame through the integration of the social sciences, primarily, and, to some extent, even the physical sciences. Now we have to deal with aesthetics more interactively, not simply as a pure phenomenon but as a kind of poststructural phenomenon, and you were doing this very consciously, as far as I know, 20 years ago.

Well, it wasn't because I was interested in structuralism or, for that matter, poststructuralism, which didn't exist then...

No, poststructuralism didn't exist then, but in many ways the way you combined these interests with art now, retrospectively, at least from a critical point of view, seems as though you predated many of the concerns of poststructuralism as it has become artistic jargon.

Well, partly that would seem perfectly reasonable given the aversion I have to the arts as models. Now I have to qualify that all the time. This is not because I don't like the arts, or that I'm not interested in the arts of other people. But as far as I was personally concerned, the unarting process was primary and, therefore, I would not find

useful any integration of social and cultural theory into art-making. That, for me, would be absolutely useless, and that's what's happened, although the use that some people have made of the social sciences, information theory for example, is interesting in their work. But I would always want it to be farther away from the art world than it customarily is found—I'm thinking of Barbara Kruger and other people whose work is interesting as long as it stays out in the anonymous world of billboards, or the early Jenny Holzer with her little tracts that were stuck up on telephone poles or peeling walls, without any name attached to it. But once that stuff is moved increasingly into the elegant world of the arts, where you might say you're always teaching the converted, then it seems to have short-circuited its possible concatenated capacity.

I understand what you are saying, and it seems as though you're searching for dialectic relationship to the social. I don't know if this would be correct from your point of view, but by avoiding successfully this overdetermination in your work, you also avoid overaestheticizing. In doing so, would you say there is a trepidation that you have about your events becoming too fetishized?

No, I don't worry about that because it doesn't last. Fetishes tend to be functional as long as you hold them in your hand.

But you can hold also an obsession.

My obsessions to the extent that I have them, are quite unconscious. To the extent that I use obsessiveness, as in that floor-cleaning piece with the Q-tips, it's italicized and intentional and usually a humoristic situation.

So again, getting back to the element of the absurd in relation to strategy, the idea that somehow the system is going to abort itself through the process of enactment.

That's an interesting word, abort, it has gravity.... You could somehow use a more humorous word, which could be something like it would collapse, or break down like a badly constructed or repaired motor, or like that wonderful event of Tinguely's, where he made a huge contraption in the backyard of the Museum of Modern Art called *Homage to New York*, which was a machine that destroyed itself in various humorous ways. It's that breakdown system along with slippages that you can't predict I find most interesting, not because I want

to make a point about society as being a broken down system or that all life is entropic — I don't, but rather that its process is unforeseeable. The insights that one might get from that may be far and in between, and you're left with huge gaps of uncertainty if you want to pay attention to that — we don't like to pay attention to that. I'm no different than anybody else in that regard, but what I do in part is to set up a game plan that forces me to pay attention to those things that I would ordinarily suppress or repress, such as the inability to plan my life...

. . . that again gets back to the reference of life in relation to art, as opposed to art in relation to life.

Yeah. So what could we say about that? It is a matter of paradox; therefore, when I say I'm interesting in "un-arting," that is to divest as much as possible in my own work what I know about art. It's a paradox because I can't do it any more than, for example, I could follow John Cage's seeming belief that I could focus on the autonomy of the sound itself, divorced from context or memory.

Well, it's a pragmatic phenomenology, the way I see it. It's a very practical, almost instrumental use of language and action that you're dealing with; at the same time, you're not imposing models from social science to the extent that it is going to dismiss any possibility, any rupture within the enactment of the piece. In other words, there is always room for slippage in your work.

There's not only room, but I insist on it.

When you talk about the absurd, or when I sense the absurd in your works, I don't see your meaning of the absurd as an existential dilemma, but as another kind of absurd that is more within the process of daily life, the pragmatics of how we actually see reality or ourselves.

Let me give you an example. You're waiting at a bus stop along with a few other people. You wait for a half hour. The bus comes along and you get on. The fare is a dollar fifty, and you reach into your pocket and you find a dollar and forty-five cents. You say to the driver, "I only have a dollar forty-five. Will you cash a twenty dollar bill?" He says, "We don't cash twenty dollar bills," and points to the sign on the coin box. And you have to get off. Now this is a typical example of what happens every day in our lives. And we often complain about these things: Why is the world this way? But what's evident to me is that 99 percent of the world is that way and there is no possible way

to change that. Maybe there's no need to change it, even though the more earnest of us and the world's leaders keep talking about control and making things come out the way they want them or they think they ought to be.

So it's an attitude toward the world that is perhaps more permissive, a little bit more humorous, more gently ironical, more accepting, even though there is the apparent magnitude of suffering. Some will find this position of mine privileged, indifferent, but, in my point of view, this is the only route toward compassion, whereas insisting on fixing the world, as we see so far, is not successful. We haven't prevented street people from being street people, or stopping the war in the gulf by the moralisms that abound today. So it's a different way of looking at the kind of life we have.

Bibliography

Historical Antecedents

Andre, Carl, and Hollis Frampton. *12 Dialogues, 1962–1963*. Halifax, Nova Scotia: The Press of the Nova Scotia College of Art and Design, 1980.

Battcock, Gregory, ed. *Minimal Art*. New York: Dutton, 1968.

Blesh, Rudi. *Modern Art USA*. New York: Knopf, 1956.

Burnham, Jack. "Unveiling the Consort: Part II." *Artforum*, April 1971.

Cabanne, Pierre. *Dialogues with Marcel Duchamp*. Translated by Ron Padgett. The Documents of Twentieth Century Art. New York: Viking, 1971.

Cage, John. *Silence*. Middlebury, Conn.: Wesleyan University Press, 1961; reprint ed., Cambridge, Mass.: M.I.T. Press, 1966.

————, ed. *Notations*. New York: Something Else Press, 1969.

Celant, Germano. *Piero Manzoni*. Turin: Sonnabend, 1972.

Cendrars, Blaise. *Selected Writings*. Edited by Walter Albert. Translated by Henry Longan Stuart. New York: New Directions, 1966.

Coutts-Smith, Kenneth. *Dada*. New York: Studio Vista, 1970.

Duchamp, Marcel. *Salt Seller (Marchand du Sel)*. Edited by Michel Sanouillet and Elmer Peterson. New York: Oxford Press, 1973.

Geldzahler, Henry, ed. *New York Painting and Sculpture: 1940–1970*. New York: Dutton, 1969.

Haftmann, Werner. *Painting in the Twentieth Century*. Translated by Ralph Manheim. New York: Praeger, 1965.

Herbert, Robert L., ed. *Modern Artists on Art*. Englewood Cliffs, N.J.: Prentice-Hall, 1964.

Higgins, Dick. *foew&ombwhnw*. New York: Something Else Press, 1969.

————, and Wolf Vostell, eds. *Fantastic Architecture*. New York: Something Else Press, 1968.

183

Kuenzli, Rudolf E., and Francis M. Nauman. *Marcel Duchamp: Artist of This Century.* Cambridge, Mass.: M.I.T. Press, 1990.

Lippard, Lucy R. *Eva Hesse.* New York: New York University Press, 1976.

Hunter, Sam. *Modern American Painting and Sculpture.* New York: Dell, 1959.

The Jewish Museum, New York City. *Yves Klein.* January 25–March 12, 1967; catalogue.

Kaprow, Allan. "The Happenings Are Dead — Long Live the Happenings!" *Artforum,* March 1966.

Kirby, Michael. *Futurist Performance.* New York: Dutton, 1971.

————. *The Art of Time.* New York: Dutton, 1969.

————. *Happenings.* New York: Dutton, 1969.

Lippard, Lucy R., ed. *Dadas on Art.* Englewood Cliffs, N.J.: Prentice-Hall, 1970.

————, ed. *Surrealists on Art.* Englewood Cliffs, N.J.: Prentice-Hall, 1970.

Mac Low, Jackson and La Monte Young. *An Anthology of Chance Operations,* 1963. Reprinted by Heiner Fredrich, 1970.

Masheck, Joseph, ed. *Marcel Duchamp in Perspective.* The Artist in Perspective Series. Englewood Cliffs, N.J.: Spectrum, 1975.

Moholy-Nagy, Laszlo. *Painting, Photography, Film.* Translated from the original German edition, 1925, by Janet Seligman. Cambridge, Mass.: M.I.T. Press, 1969.

Reinhardt, Ad. "Three Statements." *Artforum,* March 1966, p. 34.

Richter, Hans. *Dada Art and Anti-Art.* New York: McGraw-Hill, 1966.

Rose, Barbara. *American Art Since 1900.* New York: Praeger, 1967.

Sandler, Irving. *American Art of the 1960s.* New York: Harper & Row, 1988.

Schwartz, Arturo. "The Alchemist Stripped Bare in the Bachelor, Even." In the Museum of Modern Art, New York and Philadelphia Museum of Art. *Marcel Duchamp,* 1973. Exhibition catalogue edited by Anne D'Harnoncourt and Kynaston McShine.

Smith, Henry Holmes. "Across the Atlantic and Out of the Woods: Moholy-Nagy's Contribution to Photography in the United States." In Leland D. Rise and David W. Steadman, *Photographs of Maholy-. Nagy.* Claremont, Calif.: The Galleries of the Claremont Colleges, 1975.

Tompkins, Calvin. *The Bride and the Bachelors.* New York: Viking, 1965; with a new introduction and expanded text, 1968.

Wingler, Hans M. *The Bauhaus.* Edited by Joseph Stein. Translated by Jabs and Basil Gilbert. Cambridge, Mass.: M.I.T. Press, 1969.

Wollheim, Richard. "Minimal Art." *Arts Magazine*, January 1965, p. 31.

Philosophy and Aesthetics

Awakana, Yasuichi. *Zen Painting.* Tokyo: Kodansha International Publishers, 1970.

Bell, Clive. *Art.* New York: Capricorn Books, 1958.

Cassirer, Ernst. *Language and Myth.* Translated by Susanne K. Langer. New York: Dover, 1946.

Chomsky, Noam. *Reflections on Language.* New York: Pantheon, 1975.

Derrida, Jacques. *Speech and Phenomen.* Evanston: Northwestern University Press, 1973.

Dewey, John. *Art as Experience.* New York: Capricorn Books, 1934.

Dubord, Guy. *Society of the Spectacle.* Detroit: Red and Black, 1977.

Ecker, David W. "Teaching Art Criticism as Aesthetic Inquiry," *New York University Educational Quarterly*, vol. III, no. 4 (Summer 1972), pp. 20–26.

————, and Eugene F. Kaelin. "The Limits of Aesthetic Inquiry: A Guide to Educational Research." *Philosophical Redirection of Educational Research*, Seventy-First Yearbook, Part I. Chicago: The University of Chicago Press, 1972), pp. 258–286.

Gombrich, E.H. *Art and Illusion.* Bollingen Series XXXV. Princeton: Princeton University Press, 1960.

Greenberg, Clement. "Modernist Painting" in Gregory Battcock, *The New Art*, rev. ed. New York: Dutton, 1973.

Harland, Richard. *Superstructuralism.* New York: Methuen, 1987.

Hartnack, Justus. *Wittgenstein and Modern Philosophy.* Copenhagen: Gylendal, 1952; reprint ed., translated by Maurice Cranston, Garden City, N.Y.: Anchor Books, 1965.

Heidegger, Martin. *Discourse on Thinking.* Translated by John M. Anderson and E. Hans Freund. New York: Harper Colophon, 1966.

Husserl, Edmund. *The Idea of Phenomenology.* Translated by P. Alston and George Nakhnikian. The Hague: Martinus Nijhoff, 1964.

_____. *Ideas.* Translated from the original German edition, 1913, by W.R. Boyce Gibson. New York: Collier, 1962.

_____. *The Phenomenology of Internal Time-Consciousness.* Edited by Martin Heidegger. Translated by James S. Churchill. Bloomington: Indiana University Press, 1964.

Kaelin, Eugene F. *Art and Existence.* Lewisburg, Pa.: Bucknell University Press, 1970.

Keeling, S.V. *Descartes.* London: Oxford University Press, 1968.

Kubler, George. *The Shape of Time.* New Haven: Yale University Press, 1968.

Merleau-Ponty, Maurice. *The Primacy of Perception.* Translated by James M. Edie. Chicago: Northwestern University Press, 1964.

_____. *Sense and Non-Sense.* Translated by Hubert L. Dreyfus and Elizabeth Allen Dreyfus. Chicago: Northwestern University Press, 1964.

Ortega y Gasset, Jose. *The Dehumanization of Art and Other Writings on Art and Culture.* Princeton, N.J.: Princeton University Press, 1948; reprint ed., Garden City, N.Y.: Anchor, 1956.

Ouspensky, P.D. *In Search of the Miraculous.* New York: Harcourt, Brace and World, 1949.

Piaget, Jean. *Structuralism.* Translated by Chanina Maschler. New York: Harper and Row, 1970.

Richards, M.C. *Centering.* Middletown, Conn.: Wesleyan University Press, 1962.

Roth, Robert J., S.J. *John Dewey and Self Realization.* Englewood Cliffs, N.J.: Prentice-Hall, 1962.

Sartre, Jean-Paul. "The Unreality of the Esthetic Object" in Matthew Lipman, ed., *Contemporary Aesthetics.* Boston: Allyn and Bacon, 1973.

_____. *Being and Nothingness.* Translated by Hazel E. Barnes. New York: The Washington Square Press, 1956.

Speigelberg, Herbert. *The Phenomenological Movement: A Historical Introduction.* Vol. I, 2nd Ed. The Hague: Martinus Nijhoff, 1969.

Suzuki, D.T. *Zen Buddhism.* Edited by William Barrett. Garden City, N.Y.: Doubleday, 1956.

Vasquez, Adolfo Sanchez. *Art and Society.* Translated by Maro Riofrancos. New York: Monthly Review Press, 1973.

White, Morton, ed. *The Age of Analysis.* The Mentor Philosophers. New York: The New American Library, 1955.

Wittgenstein, Ludwig. *Tractatus Logico-Philosophicus.* London: Routledge & Kegan Paul, 1961 (original 1921).

_____. *Philosophical Investigations,* 2nd ed. London: Oxford University Press, 1963.

Commentary and Criticism

Barthes, Roland. *Mythologies.* Translated by Anette Lavers. New York: Hill and Wang, 1972.

Battcock, Gregory, ed. *The New Art.* New York: Dutton, 1966; rev. ed., 1973.

Benjamin, Walter. *Illuminations.* Edited by Hannah Arendt. Translated by Harry Zohn. New York: Schocken, 1968.

Berger, John. *Ways of Seeing.* London: British Broadcasting Corporation and Penguin, 1972.

Boice, Bruce. "The Quality Problem." *Artforum,* October 1972, pp. 68–70.

Burnham, Jack. *Beyond Modern Sculpture.* New York: George Braziller, 1968.

_____. *The Structure of Art.* New York: George Braziller, 1971.

Coleman, A.D. "The Directional Mode." *Artforum,* September 1976, pp. 55–61.

Eisenstein, Sergei. *Film Form.* Translated by Jay Leyda. New York: Harcourt, Brace & World, 1949.

Foucault, Michel. *The Order of Things.* New York: Vintage, 1973.

Greenberg, Clement. *Art and Culture.* Boston: Beacon Press, 1961.

Kaprow, Allan. "The Education of the Un-Artist, Part I." In Gregory Battcock, *New Ideas in Art Education.* New York: Dutton, 1973.

Lippard, Lucy R. *Changing.* New York: Dutton, 1971.

_____. *From the Center: Feminist Essays on Woman's Art.* New York: Dutton, 1976.

Lucie-Smith, Edward. *Late Modern: The Visual Arts Since 1945,* 2nd ed. New York: Praeger, 1969.

McLuhan, Marshal. *Understanding Media.* New York: McGraw-Hill, 1964.

Mumford, Lewis. *Art and Technics*. New York: Columbia University Press, 1952.

Rose, Barbara, et al. *Conference on Art Criticism and Art Education*. New York: Solomon R. Guggenheim Museum and New York University Press, 1970.

Rosenberg, Harold. *Artworks and Packages*. New York: Delta, 1969.

————. *The De-Definition of Art*. New York: Collier, 1972.

Sontag, Susan. *Against Interpretation*. New York: Dell, 1969.

————. *On Photography*. New York: Farrar, Straus and Giroux, 1977.

Conceptual Art and Related Interests

Acconci, Vito. Interview, New York City, June 28, 1976.

The Addison Gallery of American Art, Andover, Massachusetts. *Douglas Huebler*. May 18–June 14, 1970. Catalogue published.

Albright Knox Art Gallery, Buffalo, New York. *Hamish Fulton: Selected Walks, 1969–1989*. January 20–March 11, 1990. Exhibition catalogue. Essay by Michael Auping.

————, Buffalo, New York. *Jenny Holzer: The Venice Installation*. May 27–September 30, 1990. Catalogue essay by Michael Auping.

Allen, Roberta. *Possibilities: 16 Images That Could Have Occupied Any of 16 Positions*. New York: John Weber Gallery and Parasol Press, 1977.

Atkinson, Terry, David Bainbridge, Michael Baldwin, and Harold Hurrell, eds. "Introduction." *Art-Language: The Journal of Conceptual Art*, vol. 1, no. 1 (May 1969); pp. 1–10.

Avalanche 4 (Spring 1972). New York.

Avalanche 5 (Summer 1972). New York.

Avalanche 6 (Fall 1972). New York.

Avalanche Newspaper (May 1974). New York.

Baldessari, John. *Brutus Killed Caesar*. Akron, Ohio: Emily H. Davis Art Gallery, University of Akron, n.d.

————. *Fable*. Hamburg: Anatol AV and Filmproduction, 1977.

————. Taped interview, Santa Monica, California. July 23, 1976.

————. *Throwing a Ball Once to Get Three Melodies and Fifteen Chords*. Irvine: University of California Art Gallery, 1975.

_____. *Throwing Three Balls in the Air to Get a Straight Line (Best of Thirty-Six Attempts)*. Milan: Giampolo Prearo/Galleria Toselli, 1973.

The Baltimore Museum of Art. *Mel Bochner: Number and Shape*. October 5–November 28, 1976. Organized with catalogue commentary by Brenda Richardson.

Battcock, Gregory, ed. *Idea Art*. New York: Dutton, 1973.

Bochner, Mel. (Untitled Booklet.) Buenos Aires: Center for Art and Communication, 1972.

Buchloh, Benjamin. "Reply to Joseph Kosuth and Seth Siegelaub." *October* 57 (Summer 1991), pp. 158–161.

Burgin, Victor. "Socialist Formalism." In *Two Essays on Art Photography and Semiotics*. London: Robert Self, 1976.

Burgy, Donald. (Untitled Booklet.) Buenos Aires: Center for Art and Communication, 1973.

Burnham, Jack. "Huebler's Pinwheel and the Letter Tau." *Arts Magazine*, October 1974, pp. 32–35.

_____. "Real Time Systems." *Artforum*, September 1969, pp. 49–55.

_____. "Steps in the Formulation of Real-Time Political Art." In Hans Haacke, *Framing and Being Framed*, The Nova Scotia Series — Source Materials of the Contemporary Art, ed. Kasper Koenig. New York and Halifax, Nova Scotia: New York University and The Press of the Novia Scotia College of Art and Design, 1975.

The California Institute of the Arts, Valencia, California. *c. 7,500*. May 1973–February 1974. A traveling exhibition organized by Lucy R. Lippard. Catalogue published in the form of notecards.

CAPC, Musée d'Art Contemporain de Bordeaux. *Art Conceptuel*. 7 October–27 November, 1988. Catalogue essays by Jean-Louis Froment, Michel Bourel, Jean-Marc Poinsot, Robert C. Morgan, Lucy R. Lippard, Jeanne Siegel, and Benjamin H.D. Buchloh.

Center for Inter-American Relations, New York. *About Thirty Works by Michael Snow*. November 15–December 31, 1972. Organized by the National Gallery of Canada, Ottowa. Catalogue.

Centre d'Art Santa Monica, Barcelona. *Idees I Actituds, Entorn de L'Art Conceptuel a Catalunya, 1964–1980*. January 15–March 1, 1992. Generalitat de Catalunya, Departament de Cultura.

Chandler, John, and Lucy R. Lippard. "The Dematerialization of Art." *Art International*, February 1968, pp. 31–38.

The Corcoran Gallery of Art, Washington, D.C. *Agnes Denes: Perspectives.* December 6–January 7, 1975–1975. Exhibition organized by Roy Slade and Susan Sollins. Catalogue published.

Daniel Newburg Gallery, New York. *1969.* November 21–December 22, 1991. Organized by Robert Nickas.

Denes, Agnes. *Book of Dust: The Beginning and the End of Time and Thereafter.* Rochester, N.Y.: Visual Studies Workshop Press, 1977.

"Discussions with Heizer, Oppenheim and Smithson." *Domus,* November 1972, pp. 53–56, 62–67, 70–71.

"Documentation in Conceptual Art." *Arts Magazine,* April 1970, pp. 174–183. Reprinted in Gregory Battcock, ed. *Idea Art.* New York: Dutton, 1973.

Dryansky, Larisa. *Memoire de Maitrise: Art et sens dans l'art conceptuel.* Thesis UFD de Philosophie (Universite de Paris IV), 1991.

Dwan Gallery, New York. *Language to be Looked at and/or Things to be Read.* June 3–30, 1967.

The Finch College Museum of Art, New York City. *Art in Process IV.* December 29, 1969–January 26, 1970. Catalogue foreword by Elayne H. Varion; statements by the artists.

Flash Art 28-29 (December 1971-January 1972).

Foote, Nancy. "The Anti-Photographers." *Artforum,* September 1976, pp. 46–54.

Fondation Regional d'Art Contemporain, Limousin. *Douglas Huebler: "Variable," etc.* (1992) catalogue with essays by Frédéric Paul, René Denizot, Douglas Huebler, and Robert C. Morgan.

Fuchs, R.H. *Richard Long.* New York: Solomon R. Guggenheim Museum in cooperation with Thames and Hudson, 1986.

Galleria Civica d'Arte Moderna, Turin. *Conceptual art, arte povera, land art.* June 12–July 12, 1970. Exhibition organized by Germane Celant; catalogue published with essays.

Graham, Dan. *For Publication.* Los Angeles: Otis Art Institute, 1975.

Heiner, Fredrich Gallery, Düsseldorf. *Walter De Maria: Earth Room,* 1968. Re-executed in New York City at the Heiner Fredrich Gallery, October 1977.

Heiss, Alanna and Thomas McEvilley. *Dennis Oppenheim: Selected Works, 1967–90.* New York: Harry N. Abrams in cooperation with P.S. 1 Museum, Long Island City, 1991.

Hendricks, Geoffrey. *Between Two Points (Fra Due Poli)*. Reggio Emilia: Edizioni Pari and Dispari, 1975.

_____. *Ring Piece*. New York: Something Else Press, 1973.

_____. Taped interview, New York City. December 29, 1977.

Herbert F. Johnson Museum of Art, Cornell University, Ithaca, N.Y. *Agnes Denes*. 1992. Exhibition catalogue. Edited by Jill Hartz with an introduction by Thomas W. Leavitt.

Hercus-Krakow Gallery, Boston, Mass. *Joseph Bueys: Multiples*. May 1972.

Higgins, Dick. Taped interview, New York City. December 23, 1977.

Honnef, Klaus. "Douglas Huebler." *Art and Artists*, January 1973, pp. 22–25.

Huebler, Douglas. *Secrets*. New York: Printed Matter, Inc., 1977.

ICA, London and Basel Kunsthalle. *Barbara Kruger: We Won't Play Nature to Your Culture*. Traveling Exhibition. November 1983–June 1984. Exhibition catalogue; essays by Craig Owens and Jane Weinstock.

January 5–31, 1969. New York City. Exhibition organized by Seth Siegelaub; catalogue published.

John Weber Gallery, New York. *Cayuga Salt Mine Project*. May 1976. Reconstructed from the exhibition at the White Art Museum, February 1969. Organized by Tom Levitt. Notes.

Kahmen, Volker. *Art History of Photography*. Translated by Brian Tubb. New York: Viking, 1974.

Kaprow, Allan. *Air Condition*. Valencia, Calif.: California Institute of the Arts, 1973.

_____. *Blindsight*. Wichita, Kan.: Wichita State University, 1979. Catalogue with essay by Robert C. Morgan.

_____. *Routine*. Portland, Ore.: Portland Center for the Arts, 1973.

_____. "Travelog." *On Site*, 1974, pp. 49–51.

Kosuth, Joseph. "Art After Philosophy, I and II" in Gregory Battcock, ed., *Idea Art*. New York: Dutton, 1973.

_____. *Art After Philosophy and After*. Edited by Gabriele Guercio. Foreword by Jean-Francois Lyotard. Cambridge, Mass.: M.I.T. Press, 1991.

————. *Art Investigations and "Problematics" Since 1965*, vol. 1–5. Distributed by Leo Castelli Gallery, New York City.

————. *Function*. Turin: Editions Sperone, 1970.

————. "Introductory Note by the American Editor." *Art-Language*, vol. 1, no. 2 (1970).

————. "1975." *The Fox* 2 (1975), p. 94.

————, and Seth Siegelaub. "Replies to Benjamin Buchlow on Conceptual Art," *October* 57 (Summer 1991), pp. 152–157.

Kunsthalle, Bern. *Sol LeWitt: The Wall Drawings, 1984–1988*. Edited by Suzanna Singer, 1969.

————. *When Attitudes become Form*. March 22–April 27, 1969. Exhibition organized by Harold Szeeman; catalogue published with essays.

LeWitt, Sol. *Brick Wall*. New York: Tanglewood Press, Inc., 1977.

————. *Cock Fight Dance*. New York: Rizzoli and Mulliples, 1980.

————. *Incomplete Open Cubes*. New York: The John Weber Gallery, 1974.

————. "Sentences on Conceptual Art," *Art-Language: A Journal of Conceptual Art*, Vol. 1, No. 1 (May 1969).

————. "The Location of a Line (Not Straight)." *Tracks*, November 1974, pp. 38–39.

————. "Paragraphs on Conceptual Art." *Artforum*, Summer 1967.

————. *Photo Grids*. New York: Paul David Press and Rizzoli Publications, 1977.

Lippard, Lucy R., ed. *Six Years: The Dematerialization of the Art Object*. London: Studio Vista, 1973.

Meyer, Ursula, ed. *Conceptual Art*. New York: Dutton, 1972.

Millet, Catherine. *Berner Venet*. Paris: Chene, 1974.

Millman, Estera, Guest Editor. "Fluxus: A Conceptual Country." *Visible Language*, Vol. 26, Nos. 1 and 2 (Winter/Spring 1992).

Morgan, Robert C. *Commentaries on the New Media Arts*. Pasadena, Calif.: Umbrella Associates, 1992.

————. "A Methodology for American Conceptualism" in Christian Schlatter, *Art Conceptual Formes Conceptuelles (Conceptual Art Conceptual Forms)*. Paris: Galerie 1900–2000, 1990.

_____. "Robert Barry and American Conceptualism." In Erich Franz, ed. *Robert Barry*. Bielefeld: Karl Kerber Verlag, 1986.

_____. "La Situacion del Arte Conceptual Desde 'January Show' Hasta Nuestros Dias." In Juan Vicente Aliaga and Jose Miguel G. Cotes, eds., *Arte Conceptual Revisado (Conceptual Art Revised)*. Universidad Politecnica de Valencia, 1990. Translation of "The Situation of Conceptual Art," *Arts Magazine*, vol. 63, No. 5 (February 1989); pp. 41–50.

Murray, Joan. "Photographs in Sequence." *Artweek*, October 4, 1975, p. 13.

The Museum of Modern Art, New York City. *Sol LeWitt Retrospective*. February-April 1987; catalogue.

Nahan Contemporary, New York City. "Concept-Decoratif: Anti-Formalist Art of the 70's." January 5–27, 1990. Robert C. Morgan; catalogue essay.

The New York Cultural Center, New York City. *Conceptual Art and Conceptual Aspects*. April 10–August 25, 1970. Exhibition organized by Donald Karshan; catalogue published with statements by the artists.

Person's Weekend Museum, Tokyo. *Bernar Venet*. November 20, 1992– February 14, 1993. Exhibition catalogue; essay by Robert C. Morgan.

Robinson, Walter. "The Chorus Line." *Art-Rite* #10 (Fall 1975).

Rosa Essman Gallery, New York City. *Phonotations*. May 1976.

Ruscha, Edward. *Colored People*. Los Angeles: self-published, 1972.

_____. *Nine Swimming Pools and a Broken Glass*. Los Angeles: self-published, 1968; second ed., 1976.

_____. *Twenty-Six Gasoline Stations*. Los Angeles: self-published, 1962.

Schneemann, Carolee. *Cezanne, She Was a Great Painter*. New York: Kitch's Garden Press, 1975.

_____. *More Than Meat Joy*. New Paltz, New York: Documentext, 1977.

Schneider, Ire, and Beryl Karot, eds. *Video Art*. New York: Harcourt Brace Jovanovich, 1976.

Siegelaub, Seth. "On Exhibition and the World at Large." *Studio International*, December 1969. Reprinted in Battcock, *Idea Art*, 1973.

The Soloman R. Guggenheim Museum, New York City. *Guggenheim International Exhibition*. 1971. Organized by Diane Waldman and Edward Fry; catalogue essays.

Stadtischen Museum, Leverkusen. *Konzeption-Conception.* October 1969. Exhibition organized by Konrad Fischer and Rolf Wedewer; catalogue essay.

Stedelijk Museum, Amsterdam. *Robert Barry.* September 13–October 20, 1974; catalogue no. 565.

————, in cooperation with Van Abbemuseum, Eindhoven, and the Wadsworth Atheneum, Hartford, Connecticut. *Sol LeWitt: Wall Drawing 1968–1984.* Edited by Suzanna Singer, 1989.

Tisdall, Caroline. *Joseph Beuys.* New York and London: Thames and Hudson, 1979.

University of California, Santa Barbara. *Knowledge: Aspects of Conceptual Art.* Organized by Frances Colpitt and Phyllis Plous. January 8–February 23, 1992. Exhibition catalogue.

Van Abbemuseum Eindhoven. *Lawrence Weiner.* 1976. Exhibition organized by R.H. Fuchs; catalogue published with commentary.

Vinklers, Bitite. "Hans Haacke." *Art International* Vol. XIII, No. 7 (September 1969): 44–49, 56.

Walker Art Museum, Minneapolis. *Jan Dibbets.* Introduction by Martin Friedman; essays by R.H. Fuchs and M.M.M. Vos., 1987.

Weiner, Lawrence. Interview, New York City. June 23, 1976.

————. *Statements.* New York: Seth Siegelaub, Lois Kellner Foundation, 1968.

————. *Trace/Traces.* Turin: Sperone, 1970.

————. *Various Manners with Various Things.* London: ICA New Gallery, 1976.

Werk, Reindeer. "The Last Text: Some Notes on Behavioralism." *Art Communication Edition,* No. 4 (1977).

The Whitney Museum of American Art, Federal Reserve Plaza, New York. *The Power of the City, The City of Power.* Organized by Christel Hollevoet, Karen Jones, and Timothy Nye. ISP Papers, no. 1, 1992.

Youngblood, Gene. *Expanded Cinema.* New York: Dutton, 1970.

Index